KU-740-973

SWINDON
LEARNING RESOURCE CENTRE
WITHDRAWN

PRACTICE AS RESEARCH

PRACTICE AS RESEARCH
APPROACHES TO
CREATIVE ARTS ENQUIRY

Edited by

SWINDON COLLEGE

LEARNING RESOURCE CENTRE

Estelle Barrett and Barbara Bolt

I.B. TAURIS

LONDON · NEW YORK

26th June, 2009

54050000321364

SWINDON COLLEGE

LEARNING RESOURCE CENTRE

Reprinted twice in 2009 by I.B.Tauris & Co Ltd
6 Salem Road, London W2 4BU
175 Fifth Avenue, New York NY 10010
www.ibtauris.com

In the United States of America and Canada distributed by Palgrave Macmillan
a division of St. Martin's Press, 175 Fifth Avenue, New York NY 10010

Published in 2007 by I.B.Tauris & Co Ltd
Copyright © Estelle Barrett & Barbara Bolt

The right of Estelle Barrett & Barbara Bolt to be identified as the editors of this work has
been asserted by the editors in accordance with the Copyright, Designs and Patent Act 1988.

All rights reserved. Except for brief quotations in a review, this book, or any part thereof,
may not be reproduced, stored in or introduced into a retrieval system, or transmitted, in any
form or by any means, electronic, mechanical, photocopying, recording or otherwise, without
the prior written permission of the publisher.

ISBN: 978 1 84511 432 9

A full CIP record for this book is available from the British Library
A full CIP record is available from the Library of Congress

Library of Congress Catalog Card Number: available

Printed and bound in Great Britain by
CPI Antony Rowe, Chippenham, Wiltshire
From camera-ready copy edited and supplied by the editors

FSC
Mixed Sources
Product group from well-managed
forests and other controlled sources
Cert no. SGS-COC-2953
www.fsc.org
© 1996 Forest Stewardship Council

CONTENTS

LIST OF ILLUSTRATIONS

ACKNOWLEDGEMENTS

We would like to thank the contributors who kept the faith throughout the process of bringing this book to fruition. Thanks also to Susan Lawson at I.B.Tauris for her encouragement and advice and to Nicola Denny who managed the project in the final stages of production. Our gratitude goes to Mark Rashleigh for his patience and tireless attention to detail in the design and typesetting of this book. We would also like to acknowledge the assistance of the Faculty of Arts at Deakin University for supporting this publication through its Outside Study Programme. Publication of this work was assisted by a research grant from the University of Melbourne.

Melbourne
October 2006

FOREWORD

This study emerges from critical engagement and reflection on studio-based research by artists and other researchers in the field, across several creative arts disciplines. It poses the following questions: What knowledge can studio based enquiry reveal that may not be revealed by other modes of enquiry? What implication does artistic research have for extending our understandings of the role of practice-based enquiry and multiple intelligences in the production of knowledge? How can the outcomes and broader applications of artistic research enhance understandings of practice as research beyond the discipline?

The elaboration of the methodologies, contexts and outcomes of artistic research presented here, is aimed at promoting a wider understanding of the value of practice as research. Contributors have focused largely on the processes rather than the products of enquiry. They have also emphasised the dialogic relationship between the exegesis or research paper and studio practice in their respective arts disciplines—design, creative writing, dance, film and painting—demonstrating that practice as research not only produces knowledge that may be applied in multiple contexts, but also has the capacity to promote a more profound understanding of how knowledge is revealed, acquired and expressed. Successful research projects are examined as "case studies" in order to explore the knowledge and other outcomes of studio-based enquiry and assess how creative arts research methodologies may lead to more critical and innovative pedagogies in research training. The aim of this book is to contribute to such pedagogies, to provide artists with models and approaches for staging and conducting creative arts research and to situate studio enquiry more firmly within the broader knowledge and cultural arena.

Estelle Barrett

INTRODUCTION
Estelle Barrett

Art as the Production of Knowledge

This study is the outcome of extensive reflection on the training and practice of studio-based research in university Creative Arts programmes. It is aimed at extending understandings of the processes and methodologies of artistic research as the production of knowledge and assessing the potential impact of such research within the discipline and the broader cultural arena. The emergence of the discipline of practice-led research highlights the crucial interrelationship that exists between theory and practice and the relevance of theoretical and philosophical paradigms for the contemporary arts practitioner. This book also aims to reveal and identify additional criteria for assessing quality research in the field. In the final chapter of this study, I discuss Richard Dawkins' concept of the meme as a useful way of understanding the importance of replication as a measure of what constitutes robust and successful research. We propose that artistic practice be viewed as the production of knowledge or philosophy in action. Drawing on materialist perspectives, including Martin Heidegger's notion of "handlability", our exploration of artistic research demonstrates that knowledge is derived from doing and from the senses. We demonstrate further, that practice-led research is a new species of research, generative enquiry that draws on subjective, interdisciplinary and emergent methodologies that have the potential to extend the frontiers of research.

Many of the contributions to this study, constitute a third order replication of completed creative arts research projects emerging from reflection on both the studio practices and the written accounts (exegeses) of successful research projects by the artists/researchers themselves in response to the question: "What new knowledge/understandings did the studio enquiry and methodology generate that may not have been revealed through other research approaches?" The research projects to be considered cover several creative arts disciplines: Design, Creative Writing, Dance, Film/Video, Painting and Theatre. In addition, a number of chapters examine philosophical and conceptual frameworks that are specific to creative arts research as a discipline and also situate art practice as the production of knowledge within broader theoretical and research paradigms. Included at the end of this volume, is an *Appendix* to assist practitioner-researchers in the staging, designing and

writing up of their practice as research projects. This section outlines the approach to research training that underpins the pedagogy from which many of the case studies presented here have emerged.

Despite some recognition of output of creative arts research in terms of the development of national criteria and the establishment of other equivalences related to funding and higher degree by research examinations, it continues to be relatively difficult for artistic research projects to gain national research grant funding. There has also been little recognition, endorsement and validation of the processes and outcomes of studio-based enquiry as scholarly activity and research alongside other disciplines in the University. Problems arise in comparative evaluation because artists themselves have tended to be somewhat suspicious of theory and reticent in discussing their work. Moreover, creative arts research methodologies and outcomes are sometimes difficult to understand and quantify in terms of traditional scholarship. Indeed, what may be argued constitute the very strength of such research—its personally situated, interdisciplinary and diverse and emergent approaches—often contradict what is expected of research. This results in a continued devaluing of studio-based enquiry and research activities in relation to the more familiar practices of other disciplines.

A growing recognition of the philosophical and knowledge-producing role of the creative arts in contemporary society needs to be extended both within and beyond the discipline. In order to achieve this, the implication of creative arts practice in the production of knowledge and as a *mode* of knowledge production is an aspect that I believe, can be more clearly elaborated in arts education and research training and applied more generally in pedagogical approaches in other disciplines at all levels of the university. A review of the methods and outcomes of the research projects to be discussed indicates that the situated and personally motivated nature of knowledge acquisition through such approaches presents an alternative to traditional academic pedagogies that emphasise more passive modes of learning. The innovative and critical potential of practice-based research lies in its capacity to generate personally situated knowledge and new ways of modelling and externalising such knowledge while at the same time, revealing philosophical, social and cultural contexts for the critical intervention and application of knowledge outcomes.

A sharper articulation of a number of aspects of research in the creative arts may also help to establish studio-based enquiry more firmly within the broader field of research and scholarly activity. These include: the relevance that practice-based research has for extending and articulating our capacity to discover new ways of modelling consciousness and designing alternative methods of research capable of generating economic, cultural and social capital; the implication that creative arts research has for extending our understandings of the role of experiential, problem-based learning and multiple intelligences in the production of knowledge; the potential of studio-based research to demonstrate how knowledge is revealed and how we come to acquire knowledge; the ways in which creative arts research outcomes may be applied to develop more generative research pedagogies and methodologies beyond the discipline itself. It seems appropriate that these themes be

addressed through an evaluation and analysis of successfully completed creative arts projects—not only of the outcomes of these projects, but also the processes and methodologies through which the outcomes were produced.

Experiential Learning and Knowledge

Philosophies elaborating the relationship between art and knowledge, and in particular, between research, practice and alternative modes of logic and knowing also pertain to pedagogical approaches variously understood as experiential, action or problem-based learning. Moreover, methods adopted in studio-based research often correspond with the aforementioned approaches to learning and hence, may have specific application for the refinement and extension of such pedagogies. Articulation of these connections should provide clearer frameworks for research and research training in the field of creative arts.

Because the approaches of studio enquiry often contradict what is generally expected of research and are not sufficiently fore-grounded or elaborated by artistic researchers themselves, the impact of *practice as research* is still to be been fully understood and realised. It can be argued that the generative capacity of creative arts research is derived from the alternative approaches it employs—those *subjective*, *emergent* and *interdisciplinary* approaches—that continue to be viewed less favourably by research funding assessors and others still to be convinced of the innovative and critical potential of artistic research. That studio production as research is predicated on an alternative logic of practice often resulting in the generation of new ways of modelling meaning, knowledge and social relations is still a relatively foreign idea within in the wider university research community. Rather than attempting to contort aims, objectives and outcomes to satisfy criteria set for more established models of research, I believe there is a need to generate appropriate discourses to convince assessors and policy-makers that within the context of studio-based research, innovation is derived from methods that cannot always be pre-determined, and "outcomes" of artistic research are *necessarily* unpredictable. Facilitating meta-research and publication of discourses that demonstrate how the dynamics of the circulation and consumption of the art product outstrip the logic of economic exchange and conventional understandings of what constitutes cultural capital is also an ongoing concern of creative arts researchers. Publication of such discourses will contribute to a greater understanding of the philosophical dimension of artistic practice and its ineluctable relationship with philosophical and theoretical paradigms.

Because of the complex experimental, material and social processes through which artistic production occurs and is subsequently taken up, it is not always be possible to quantify outcomes of studio production. Louise Johnson (2004) suggests that there is a need to re-conceptualise and expand notions of cultural capital in order to more fully appreciate the value and impact of the arts. Drawing on the work of Pierre Bourdieu and Anne De Bruin, Johnson provides a framework for more closely aligning contexts of production, consumption and scholarly research in the creative arts. She suggests that greater emphasis on such affinities in the discourses of artistic research and in research training may lead to the development of

additional *qualitative* criteria for measuring the value of creative arts research and for understanding its approaches and methods. Johnson's elaboration of the notion of "embodied cultural capital" is specifically relevant to my argument concerning the innovative and generative potential of artistic research methodologies.

Situated Knowledge: The Subjective and the Personal in Creative Arts Research

Within the field of science, there is a growing recognition that restricting enquiry to those things that can be exactly measured would mean denying many of the benefits of alternative modes of enquiry (Eisener 1997). Since creative arts research is often motivated by emotional, personal and subjective concerns, it operates not only on the basis of explicit and exact knowledge, but also on that of tacit knowledge. An innovative dimension of this subjective approach to research lies in its capacity to bring into view, particularities that reflect new social and other realities either marginalised or not yet recognised in established social practices and discourses. Pierre Bourdieu argues that tacit knowledge and the alternative logic of practice underpins all discovery; and yet the operation of this logic is often overlooked because it is subsumed into the rational logic of discursive accounts of artistic production (Barrett 2003).

Though not explicit, ineffable or tacit knowledge is always implicated in human activity and learning (Polanyi 1969). It refers to embodied knowledge or "skill" developed and applied in practice and apprehended intuitively—a process that is readily understood by artistic researchers who recognise that the opposition between explicit and tacit knowledge is a false one (Bolt 2004). This notion of intuitive knowledge is closely related to what Bourdieu has theorised as the logic of practice or of being *in-the-game* where strategies are not pre-determined, but emerge and operate according to specific demands of action and movement in time (Bourdieu 1990). Bourdieu's theory of practice suggests that culture and material relations that make up our objective reality can only be grasped through the activity of human agents (Bourdieu 1977). The acquisition of knowledge may thus be understood as a cognitive operation or "sense activity" involving relations between individual *subjectivities* and objective phenomena which include mental phenomena—knowledge and ideas (Grenfell and James 1998: 13). Bourdieu contends that because knowledge of the condition of production comes *after the fact* and occurs in the domain of rational communication, the finished product, the *opus operatum*, conceals the *modus operandi* (Bourdieu 1993: 158). In his explanation of how the alternative logic and processes of practice are subsumed into rational analysis of the product and are thus often forgotten, Bourdieu exposes the basis upon which the ongoing privileging of positivistic and instrumentalist approaches to research persists.

In moving beyond traditional objective/subjective, empirical/hermeneutic binaries that have tended to separate the arts and humanities from the sciences, Bourdieu examines the relational aspect of knowledge and the way in which different paradigms of research imply underlying assumptions about the character of knowledge. Positivistic or empirical approaches emphasise universal laws, whilst hermeneutics acknowledges individual understanding, subjective interpretation and a plurality of

views. Both approaches and categories of knowledge have their place and co-exist. Within this schema, the researcher is required to articulate knowledge which is robust enough to be objective and generalisable, but at the same time accounts for individual subjective thought and action. (Grenfell and James 1998: 10).

In his monograph, *Material Thinking*, Paul Carter (2004) helps to extend understandings of the subjective and relational dimensions of the artistic process. He describes this process as one that involves a decontexualisation from established or universal discourse to instances of particular experience. In staging itself as an artwork, the particularity of experience is then returned to the universal. Carter suggests that "material thinking" specific to artistic research creates a record of the studio process as a means of creating new relations of knowledge subsequent to production. Another useful term for understanding the emergent aspect of artistic research and the dynamics of the circulation of artistic products, is Barbara Bolt's notion of "materialising practices" which implies an ongoing performative engagement and productivity both at moments of production and consumption (Bolt 2004). Rather than constituting a relationship between *image* and text (implied by Carter's material thinking), *materialising practices* constitute relationships between process and text—of which the first iteration is necessarily the researcher's own self-reflexive mapping of the emergent work *as enquiry*. A dialogic relationship between studio practice and the artist's own critical commentary in writing of the creative arts exegesis is crucial to articulating and harnessing the outcomes of these materialising practices for further application.

An elaboration of the subjective nature of the artistic research process can also be found in the principles of problem or action-based learning. A basic premise of such pedagogies is that knowledge is generated through action and reflection. Various approaches to problem-based learning share a number of common features, which are of relevance to creative arts research. Firstly, the acquisition of knowledge in such approaches, involves learner-centred activity driven by real-world problems or challenges in which the learner is actively engaged in finding a solution. The experiential approach (Kolb 1984) starts from one's own lived experience and personal reactions. Learning takes place through action and intentional, explicit reflection on that action. This approach acknowledges that we cannot separate knowledge to be learned from situations in which it is used. Thus situated enquiry or learning demonstrates a unity between problem, context and solution. A general feature of practice-based research projects is that personal interest and experience, rather than objective "disinterestedness" motivates the research process. This is an advantage to be exploited, since in terms of the acquisition of knowledge, artistic research provides a more profound model of learning—one that not only incorporates the acquisition of knowledge pre-determined by the curriculum—but also involves the revealing or production of *new* knowledge not anticipated by the curriculum. As such, studio-based research provides an heuristic model for innovative practice–based pedagogies at all levels of university learning—one that provides a rationale for the integration of theory and practice as a basis for research training at undergraduate level both within and beyond creative arts disciplines.

Emergent Methodologies

Subjective approaches in artistic research are implicated in and give rise to a second feature of practice as research: its emergent methodologies. Martin Heidegger's notion of "praxical knowledge" or what he theorised as the material basis of knowledge, provides a philosophical framework for understanding the acquisition of human knowledge as emergent. His work also provides a rationale for applying emergent approaches in research. Praxical knowledge implies that ideas and theory are ultimately the result of practice rather than vice versa. Drawing on Heidegger, Don Ihde extends this idea through his elaboration of "technics", which he refers to as: 'human actions or embodied relations involving the manipulation of artefacts to produce effects within the environment (Ihde 1990: 3). These "effects" broadly understood as "knowledge" emerge through material processes. Because such processes are (at least in part) predicated on the tacit and alternative logic of practice *in time*, their precise operations cannot be predetermined.

The broader concept of emergence has more recently been studied by thinkers who are concerned with understanding the relationship between physical events and mental phenomena, and who have replaced the notion of "materialism" with that of "physicalism" (Beckermann 1992: 1). Central to the work of such thinkers, is the theory of emergent evolution which asserts that as systems develop, their material configurations become more complex. A further claim of such theory is that, once a certain critical level of complexity is reached in any system, genuinely novel properties—those that have never been instantiated before—emerge. These emergent effects are not predictable before their first occurrence. (Beckermann 1992: 15-29). Irrespective of whether one subscribes to this paradigm of thought, the idea of emergent evolution provides a useful model for understanding emergent methodology in creative arts research.

It is Bourdieu however, who advances a more compelling explanation of emergent process as both an aspect and strength of the subjective dimension of research. He suggests that reflexivity in such research involves not only a focus on the validation of data and outcomes, but also the positioning of oneself in relation to other fields in order to reveal the character and sources of one's interest. In this research context, reflexivity demands that both the researcher and her/his methods be submitted to the same questions that are asked of the object of the enquiry (Bourdieu 1993: 49). Since the researcher's relationship to the object of study (material or mental) is of central concern in practice-based methodologies, they are in accord with Bourdieu's notion of reflexivity. As a result of this reflexive process, methodologies in artistic research are *necessarily* emergent and subject to repeated adjustment, rather than remaining fixed throughout the process of enquiry. We can now argue that because of its inbuilt reflexivity, the emergent aspect of artistic research methodology may be viewed as a positive feature to be to be factored into the design of research projects rather than as a flaw to be understated or avoided. This advantage will be more specifically illustrated in the reflections of artist/researchers presented in this volume.

Interdisciplinarity and Creative Arts Research

An often vexed issue in creative arts research is related to establishing the work in an identifiable location within the broader arena made up of more clearly defined disciplines or domains of knowledge. This issue has given rise to some contention in relation to visual culture. Such debates may also be applied to any of the creative arts areas. (Bal, Mitchell, Elkins, Mirzoeff et al 2003). An understanding of such debates and a grasp of just what is implied by the idea of interdisciplinary enquiry, may be crucial in the design and development of research projects as well as in terms of articulating the significance of research and maximising its outcomes and applications. Scholars—notably Robyn Stewart (2003, 2001) and Graeme Sullivan (2004)—have done a great deal to extend our understandings in relation to the former. What I would like to stress here, is that: just as the material basis of artistic research results in approaches that are necessarily emergent, the subjective and personally situated aspect of artistic research— its *relationality* or what Carter refers to as its capacity to reinvent social relations (Carter 2004:10)—results in research that is ultimately interdisciplinary. Within the context of knowledge-production, social relations are after all, implicated in almost every disciplinary field. How to fully realise and exploit, rather than apologise for this ineluctable interdisciplinary dimension of creative arts research, is a question that needs to be repeatedly fore-grounded in practice as research discourse and training. Roland Barthes' view that interdisciplinary study or enquiry creates a new object that belongs to no one (Newell 1988) provides a rationale for acknowledging the innovative potential of the fluid location and application of creative arts research approaches and outcomes. The juxtaposing of disparate objects and ideas has, after all, often been viewed as an intrinsic aspect of creativity. The interplay of ideas from disparate areas of knowledge in creative arts research creates conditions for the emergence of new analogies, metaphors and models for understanding objects of enquiry. Hence the capacity of artistic research for illuminating subject matter of both the artistic domain as well as that belonging to other domains and disciplines of knowledge.

John W. Rowe (2003) suggests that interdisciplinary research is a critical step in the evolution of research on complex issues. The myth of the solitary scientist in search of truth is anachronistic, and the absurdity of trying to solve problems with inadequate tools is driving moves towards more integrated approaches to research in the sciences and more traditional disciplines. (Rowe 2003: 2). An acknowledgement that the myth of the solitary artist attempting to solve the problems of the world is also obsolete will help to remove major barriers to understanding the philosophical dimension of artistic practice. In order to enhance this process, researchers may need to be less defensive and reticent about their practical approaches and theoretical contexts and more pro-active in inserting creative arts research discourses and methodologies into other disciplinary research arenas. We also need to be more articulate in elaborating how creative arts practice engages with, and can extend theoretical and philosophical paradigms. In summary, the task for studio researchers goes beyond generating appropriate discourses to establish the value of their activities as research to that of taking an interest in the deployment and circulation of outcomes of artis-

tic research beyond the studio process and initial points of economic exchange. This in turn, may open up possibilities for refiguring and expanding what is commonly understood as research, knowledge and cultural capital.

Beyond the Quantum: Rethinking Cultural Capital

Given that the artistic domain has tended to exceed the parameters of knowledge management, a question often raised is: "How can artistic researchers establish identifiable criteria for evaluating both the approaches and methodologies it uses and for assessing the significance and value of its outcomes as research?" Louise Johnson's (2004) investigation of the impact of the arts in so called rust belt cities, which draws on New Zealand economist Anne De Bruin's notion of embodied cultural capital, is pertinent to this question. Johnson suggests that the value of cultural capital is not only dependent on the field in which it is *produced*, but also through the institutional and social contexts in which it is *received* and *circulated*. She identifies several categories of cultural capital: objectified cultural capital, which refers to artefacts or products such as paintings, books, performances, films and other community events; institutionalised cultural capital which refers to those artefacts and activities that are published, funded, commissioned, endorsed and deployed by government and other institutions and the final category, embodied cultural capital, described as the creative abilities talents, styles, values and dispositions of individuals and communities that emerge from, and relate to artistic production and its deployment. This "intangible" form of cultural capital encompasses dynamics of reciprocity operating outside economic exchange, and includes such things as community confidence, pride cohesion and sense of identity. The reconceptualisation of cultural capital along these lines may open new ways of understanding, valuing and measuring the outcomes of artistic research in the future. Of more immediate interest, is the relevance of Johnson's work to my discussion of the features and approaches of artistic research discussed in this book. The notion of embodied cultural capital as talents styles, values and dispositions of individuals not only links contexts of artistic production with contexts of consumption, but also allows us to recast the subjective, emergent and socially relational or interdisciplinary approaches of artistic research in terms of knowledge or cultural capital that is predicated on the generative and performative dimensions of making art.

Overview of Chapters

In the first Chapter Paul Carter considers the emergence of practice-based or creative research and the problem of assessing its value within the context of what he terms "the ethics of invention." Drawing on Danish Artist Asger Jorn's assertion that invention is the science of the unknown and therefore presupposes interest or curiosity, Carter points out that interest is what invention adds when it transforms the status quo. He observes that an important question then becomes: "in whose interest is invention sponsored?" This is an ethical question that is also intrinsically implicated in practice. Drawing on a number of design projects in which he has been involved, Carter reflects on the research process within the context of col-

laboration and broader social relations; relations between the specific concerns of creative practice, *material thinking* and the more distanced and abstract discourses of government and other institutions that influence both the process and applications of invention. Carter's ethics of invention highlights the necessity for a right attitude towards collaboration and the forging of a language that will enhance the possibility of a reintegration of practice-based enquiry with other approaches to research —an integration aimed at extending understandings of the epistemological and social value of invention.

In Chapter Two, Barbara Bolt considers the relationship between studio enquiry and the meta-reflective work of the exegesis in her chapter 'The magic is in handling'. Her application of Martin Heidegger's notion of handlability demonstrates that practice or experience (sense activity), rather than theory is the basis for research and discovery. Drawing initially on David Hockney's investigation into the use of optical aids by artists such as Ingres, and then on her own painting practice, Bolt demonstrates how the "new" is not a quest to be pursued or a self conscious attempt at transgression, but rather, it is the particular understandings that are realised through our dealings with the tools and materials of production and in the handling of ideas.

In Chapter Three, Gaylene Perry's (2004) offers reflections on the studio writing research project for her PhD. This project resulted in the publication, by Picador, of *Midnight Water: A Memoir* (Perry 2004). The work, which combines autobiography and fiction, demonstrates a crucial aspect of creative writing as research. In her reflection on the development of her research, the writer's focus shifts from the tangible artefact (the novel) to what she has subsequently understood as the intangible benefits of the studio enquiry. She has found that the act of creative writing is, in itself, an agent of emotional reconciliation and change; the imaginative act confers empowerment that has real and material effects. Creative writing, permits a collapse between fiction and reality and a reconnection with real life events permitting emotions to be moulded and shaped as reparation and redemption. In this instance, Perry's writing process resulted in the remodelling of her own familial relationships.

A feature of studio-based enquiry is that the method unfolds through practice— *practice* is itself, productive of knowledge and engenders further practice demonstrating the emergent nature of the process. Perry's observations and experience raise questions about "common sense" distinctions made between objectivity and subjectivity, fiction and truth. The real transformation experienced by the writer, suggests broader applications of creative practice for dealing with grief and trauma in the community.

As demonstrated in Chapter Four, personal and subjective concerns also motivated Dianne Reid's dance/film project, *Cutting Choreography: Redefining Dance on Screen,* research completed for Master of Arts at Deakin University in 2001. The project investigates dance as an art form in which the languages and technical processes of film reflect and inform choreography. The work is an attempt to translate the kinaesthetic intimacy of dance onto the screen using montage as the site for the realisation of innovative choreographic form. Reid observes that practice makes tan-

gible the theoretical. Her practice-led research resulted in an externalisation of the dancer's ideas concerning the condition of the aging body in contemporary dance. The outcome of this research included both the development of a new hybrid dance form, as well as the revelation of new knowledge and understandings made possible through this form.

Reid's video and film editing techniques, used as instruments for closer inspection of the relationship between movement and screen space provide multiple perspectives and choices for choreographing dance. The completed work is both an artefact for performance as well as a critical discourse on society's view of ageing. Her research involved practice as a response to lived experience, the temporal, the personal and the collaborative—revealing how new subject matter requires new forms of expression and representation. The research has also shown how the role of choreographer may be extended and demonstrates the potential of film and digital technologies to revitalise choreographic form.

The knowledge-producing potential of practice is again articulated in Chapter Five, Annette Iggulden's reflections on her doctoral research project *"Silence": In The Space of Words and Images* (2003). This research involved the production of a body of paintings through investigation of illuminated manuscripts copied and embellished by medieval monastery nuns in Europe and England. The project emerged as part of the artist's personal response to what she perceives as ongoing constraints placed on women in society and her own particular experience of the imposition of silence in childhood. Iggulden's focus on the copying and visual embellishment of text and margins of illuminated manuscripts revealed a code of visual communication adopted by the monastery nuns suggesting their resistance to the imposition of silence on women in monastic orders. This has hitherto not been recognised or understood by historians.

Iggulden's practice, which initially involved an investigation of the aesthetics of the work of the nuns, resulted in the discovery of "codes" developed through the use of coloured forms abstracted from the shapes of *spaces* in the lettering of the scripts. These "shapes", often appearing in the margins of the manuscripts, have not generally been considered beyond their decorative capacity. Iggulden's research and more principally her *practice* which involved copying sections of script for aesthetic manipulation in her own paintings, also uncovered a more profound intellectual and aesthetic engagement with the contents of the manuscripts by medieval monastic nuns from silenced orders. In addition to contributing to historical knowledge and understanding of these medieval manuscripts, the project provided the artist with an alternative code and a new visual form for exploring and expressing her own gendered identity.

Of the actual research approach and methodological process, Iggulden observes that it was impossible to separate writing and research from the circumstances of her life. The process of discovery elaborated by the artist suggests that that theory is always secondary to intuitive response, and is ultimately sacrificed to the material and temporal demands of making the work and finding a means of expressing previously inexpressible psychological states. Practice-based research methods are again

shown to be emergent, moving between theory, and the changing demands of the artist's physical and psychological states as well as those of material studio processes. At each step, practice itself, determined the direction and method to be followed.

Chapter Six is a reflection by Shaun McLeod on his dance project *"Chamber": Experiencing Masculine Identity through Dance Improvisation* completed for a Master of Arts by practice and exegesis in 2002. His account reveals how the multiple levels at which creative arts research operates can produce an economically viable artefact and at the same time, generate less "tangible" outcomes that have the potential for changing social and cultural discourses and practices. *Chamber* was choreographed by McLeod and performed at Dancehouse in Melbourne in April 2002. McLeod suggests that in this instance, dance as research, is not only a form of entertainment, but can be used as a means of revealing aspects of masculine identity and of modelling internal human conditions in ways not available to other modes of enquiry. The use of improvisation as the main methodological vehicle of investigation provides interesting illustration and extension of Bourdieu's ideas concerning the relationship between institutional structures, intuition, knowledge and research. In this research, dance is used a means of the exploring and articulating experiences which give shape to nuances of masculinity. It also permits a re-embodiment of what has remained unanalysed and unspoken in institutional discourses of the male body. The significance of improvisation lies in its capacity for effecting an ongoing dialogue between the objective and the phenomenal, and mirroring the relationship between theory and practice. In this project, improvisation offered a temporary suspension of the culturally encoded masculine order, providing the performers with a way of externalising socially repressed material derived from pleasure and memory through practice. It also presents the choreographer with an opportunity to select from spontaneously generated moves and images in order to extend choreographic possibilities. Drawing on the alternative logic of practice, and allowing the private self to enact the world through dance, improvisation also extends the cultural, emotional and psychological universe of possibilities.

In Chapter Seven, Kim Vincs' revisits her PhD thesis *Rhizome/MyZone: The Production of Subjectivity in Dance,* (2003). This account emphasises the specificity of Vincs' practice as a research methodology and demonstrates the interaction of theory and practice in the production of knowledge. The project investigates dance as a process of individuation and as an alternative to "ready-to-wear" identities available in mass communication and institutional structures. In this project there is shift from dance as object of investigation, to dance as means of investigating. Dance constitutes a methodology alongside other more traditional and empirical research methods. Practice is presented as an actual method of knowledge-production and thinking.

Vincs observes that knowledge from any field is inseparable from that of other fields. In this project choreography and performance are shown to operate as fields of rhizomic structures that articulate with theoretical domains: out of dance, emerged issues that became objects of investigation; the development of new dance methodologies were subsequently needed to explore those issues. The emergent and "retrospective" methodology applied, permitted conceptual and practical applica-

tion and synthesis of the known with the new, bringing fresh choreographic perspectives and new interpretations to performance. The research reveals how dance can operate as a map connecting elements that could not otherwise be translated or apprehended in isolation. As in other artistic research projects, the personal and the subjective accompany objective processes both in the practice and the writing, conveying an inevitable continuity of the personal and the private within the research process.

Chapter Eight, one of the chapters that focuses principally on the research exegesis or writing, emerges from a direct reflection of the practice as research process by Stephen Goddard. 'A correspondence between practices' consists of metacommentary on his PhD project, *Lorne Story: Reflections On a Video Postcard*, which examines the imaginary and reflexive space of video storytelling. *Lorne Story* is an autobiographical video memoir, a hybrid form of postcard developed from the director's video notebook. It explores the interface between screen and audience. Referring to the work of Gilles Deleuze, Goddard notes that philosophical theory is a practice in itself. He acknowledges that one of the concerns of research in the discipline is to develop appropriate strategies that link established methodologies in research with emergent methodologies derived from contemporary arts practices. In this project, both studio production and writing become exegetical through their capacity to be used in analysis and interpretation of each other. Goddard shows us that the relationship between practice and reflective writing in artistic research, is not one of equivalence, but of correspondence. In this mutually reflexive process the modelling of another model of consciousness is irreducible and contains a remainder or excess. This excess is a core aspect of the studio-based enquiry. It relates to an alternative logic of practice and to the knowledge-producing capacity of practice as research.

In Chapter Nine, 'creating new stories for praxis: navigations, narrations neonarratives', Robyn Stewart explores the complex interrelationship that exists between artistic research and other research and scholarly paradigms. Mapping is again used as a metaphor to extend understandings of practice-based research methodologies and narrative methods that are appropriate for situating and articulating the research process and its outcomes. Acknowledging the emergent and subjective dimension of artistic research, Stewart describes this method as a process of continuous discovery, correspondence, contradictions, intuition, surprise, serendipity and discipline. Drawing on her extensive experience in artistic research and studio-based research training, she applies the notion of "bricolage" in her explication of approaches in practice as research. These approaches draw on multiple fields and piece together multiple practices in order to provide solutions to concrete and conceptual problems.

One of the difficulties that practitioner researchers often face is related to having to write about their own work in the research exegesis or report. In Chapter Ten, I suggest that this difficulty can be overcome by shifting the critical focus away from the notion of the work as product, to an understanding of both studio enquiry *and* evaluation of its outcomes as a philosophical process that moves between established theory and the situated knowledge that emerges through practice. I draw,

principally, on Michel Foucault's essay 'What is an author' and Donna Haraway's elaborations of "situated knowledge" and "partial objectivity" to explore how we might move from writing "art criticism" to generating a critical discourse of practice -led enquiry that involves viewing the artist as a researcher, and the artist/critic as a scholar who comments on the value of the artistic process as the production of knowledge. In order to ground my discussion in practice, I also refer to the making of Pablo Picasso's *Demoiselles d'Avignon* and a number of commentaries on this ground-breaking work.

In Chapter Eleven, Brad Haseman considers the question of how creative practitioners can take their place at the research table in a way which ensures that the primacy of practice and the embedded epistemologies of practice are respected and valued. He examines three significant innovations made by researchers who are initiating and pursuing their research through practice and draws on a successful practice as research project, Theatre Director David Fenton's Ph.D thesis, *Unstable Acts* as exemplification. Haseman suggests that whilst methodological innovations in the creative arts represent fundamentally different research procedures to those that operate in the quantitative and qualitative orthodoxies, they have significant implications for the whole field of research. These innovations include defining practice-led research, establishing multiple research methods led by practice and proposing alternative modes of knowledge representation. The chapter concludes by arguing for practice-led research to be understood as a research strategy within an entirely new research paradigm—"Performative Research". Taking its name from J.L. Austin's speech act theory, performative research stands as a third species of research which has the potential to bridge the gap between the research expectations of creative practitioners in the arts, media and design and the protocols set by the research industry and learned bodies which define what stands as research and what does not.

The importance of replication and articulation of the slippery relationship between the logic of practice and objective processes is discussed in the final chapter entitled 'The exegesis as meme'. Within the context of this metaphor, the artistic product is viewed as a vehicle for the externalisation of ideas or knowledge. The need to focus on process as well as product in studio-based research is again emphasised. In this chapter, I suggest that Richard Dawkin's criteria for evaluating the success of memes: a capacity for self-replication, fitness or likelihood of being replicated, and fecundity or speed of replication may be applied as criteria for evaluating the success of creative arts research and research outcomes. For example, the capacity for self-replication of creative arts research may be equated with how its methods and outcomes are generalised and applied beyond the particular research context within the discipline. Fitness or likelihood of being replicated may refer to the capacity of the research to be generalised and/or applied in multiple contexts beyond the discipline. Finally, fecundity—the speed of replication required to produce critical mass and stability—may be equated with publication, proliferation and the recognition of research and its broader cultural impact.

1

INTEREST: THE ETHICS OF INVENTION
Paul Carter

The problem of assessing the value of inventions is not new. Writing in 1787, in an open letter to Adam Smith, author of *The Wealth of Nations*, Utilitarian philosopher Jeremy Bentham coined the phrase "invention-lottery".[1] Referring to the mechanism of invention as art, he called those who engaged in it projectors. Two hundred and thirty years later, this vocabulary is still familiar to us. Bentham took a fairly broad view of art, probably meaning to indicate any and all the crafts that lead to the improvement of the amenities of life.

The emergence of practice-based or creative research as an overarching term to describe the nature of work across a range of fields formerly considered distinct (at least in the academy) curiously circles back to Bentham's conception. It may seem obvious that the techniques different modes of creativity use are different: the great divide between language-based and image-based arts remains. In *Material Thinking* (2004) I have questioned this distinction, arguing for a hybrid discursivity, common to both when they circulate in the public realm.[2] But in any case, we can agree with Bentham that, insofar as these different modes of imaginative projection *can* be grouped together, the property they have in common is that of invention.

In the process of invention the heterogeneous interests of the poet, the choreographer, the hip-hop deejay, the AutoCad designer and the landscape architect display their common interests. The condition of invention—the state of being that allows a state of becoming to emerge—is a perception, or recognition, of the ambiguity of appearances. Invention begins when what signifies exceeds its signification—when what means one thing, or conventionally functions in one role, discloses other possibilities. The ambiguity noticed at this time is the excess of materiality that resists semiotic distillation, the supplement of matter that haunts communication. It is the pun or homophone in language, the Freudian form in architecture, the sound in-between in musical composition, the both-and gestures in choreography. Aristotle advised the orator that there were rules of invention. Similarly, we all have techniques of invention. The poet explores the ambiguous realm between language and music; the deejay between music and the materiality of noise. In general, a double movement occurs, of decontextualisation in which the found elements are rendered strange, and of recontextualisation, in which new families of association and struc-

tures of meaning are established. This double movement characterises any concep-
tual advance. In philosophy, it is the Socratic method. The distinction of practice-
based research is to mediate this process materially, allowing the unpredictable and
differential situation to influence what is found. Technique is necessary, but in the
transformation it falls away.

In our context, this double movement of invention is not simply a matter of
praxis, it also represents the critical difference of creative research from other forms
of critical enquiry: for cultural scholars—anthropologists, sociologists, historians—
are no doubt skilled in analysing the underlying structures informing our symbolic
forms, but they cannot put back together what they have shattered. They are suspi-
cious of our reconstructions, precisely because, in incorporating self-differing quali-
ties of growth, transformation and excessive materiality, they defy a unilateral semi-
otic reduction. However different their forms, the outcomes of creative research, or
art in Jeremy Bentham's terminology, share a common belief in the epistemological
value of invention. It is not simply that they want to improve the status of creativ-
ity in the Australian research culture. They argue that invention embodies a distinct
way of knowing the world. It is a powerful, because complex and multi-sensorial,
method of real-world analysis, and its aleatory, constitutionally open, anything-goes
character, which is said to weaken its claim to rigour, is, in reality, a sign of its so-
phistication. In the present research environment practice-based research represents
a concerted attack on the institutionalised separation of the heuristic disciplines (the
Sciences, broadly) from the hermeneutical ones (broadly, the Humanities). This is
not to say that reintegration is assured: the greatest obstacle to progress is the lack of
a language that can mediate the meaning of our constitutionally localised inventions
to a community that identifies power with abstraction and the dematerialisation of
thought from the matrix of its production. It is precisely here that *Material Thinking*
seeks to make a contribution.[3]

Bentham spoke of the promotors of art as projectors. It is another term that curi-
ously anticipates our own. Those involved in creative or practice-based research usu-
ally talk about what they do in terms of projects. Their work is a speculative throwing
forward of the mind. The image of bridge-building suggests itself, but also the pros-
pect of failure. Here another of Bentham's observations will no doubt strike a chord:
'The career of art, the great road which receives the footsteps of projectors, may be
considered as a vast, and perhaps unbounded, plain, bestrewed with gulphs, such as
Curtius was swallowed up in. Each requires an human victim to fall into it ere it can
close, but when it once closes, it closes to open no more, and so much of the path is
safe to those who follow'.[4] If we modernise this metaphor, the urban landscape of
creative research remains much the same. We project our work out over abysses of
scepticism, often made wider by erosive economic considerations, and, as often as
not, our designs, instead of supplying bridgeheads to the new, stand abandoned, like
cranes on buildings whose speculators went bust. They point, but to what? I want
to come back to the metaphor of the project in a moment, but first I want to take
up this question of direction, the notion that the achievements of practice-based
research can be strung like beads on the linear rosary of national progress.

The hallmark of modernity is invention and in Australia this statement has a particular nuance. Despite the historical revisionists, it remains, in a sense, correct to say that Cook "discovered" Australia. Etymologically, *discover* and *invent* have the same root, and both mean 'to come across or upon'. As a rational speculation, the colony, which Phillip inaugurated, was the offspring of projectors borrowing against the future. The First Fleet was a bridgehead to enhanced territorial and commercial wealth. Bentham's topographical analogy, in which the advancement of knowledge and the conquest of new territories go hand in hand, is reproduced a thousand-fold in the literature of colonial exploration and survey: every explorer cast himself as a latter-day Mettius Curtius, prepared to sacrifice himself for the territorial security of those who came after him. But the economic metaphor is as strong as the geographical one. Bentham's object in defending the value of art and projectors was to combat what he saw as the prejudice against usury or money-lending. The system of lending money at an agreed interest rate was, he thought, essential to material progress. Projectors should be encouraged to borrow, usurers to lend. In a country like Britain, whose prosperity depended on sea trade, he said, this was especially important. Australia was, and continues to be, an invention of this speculative economy. The Australia invoked in school textbooks, by politicians, and even in the national research priorities of the government is an invention whose value depends on the interest it generates. It may be that these oddly speculative origins explain the perennial insecurity said to characterise the Australian psyche. In any case, it underlines the point that Australia and invention are cognate terms. As practice-based researchers, our research is not supplementary to Australia's interests—it is the interest of our inventions that secures it.

You can see, then, that a discussion about the ethics of invention extends beyond the particular uses to which particular inventions are put. Even the apparently clear-cut issues raised by the invention of the hydrogen bomb, or the progress of the genome project, cannot be understood in isolation from a larger social context. Nor do I mean by this that their social history needs to be written, or sociologies of invention produced (valuable as these are). The larger social context I have in mind does not stand outside the culture of invention but is integral to it. This is evident in the phrase "an ethics of invention", which does not mean the science that differentiates "good" inventions from "bad" ones, but refers to the custom or habit of invention. To understand the social value of what we are doing, we need to study the process of creativity, rather than its outcomes. The word *interest* does not refer to an outcome established as operationally efficient or conventionally true, but to a relationship. *Interesse* means to be between. Interest produces the desire to go beyond oneself. This is why the German philosopher Herbart identified it as the psychological precondition of educability. Education, from *educere*, to lead out. But for this desire to go beyond ourselves, we could not encounter what is not yet (for ourselves)—what scientists like to call the new but others call the other. Interest is the desire to collaborate: and collaboration is a microcosm of the new relation or worldly arrangement we desire to create. The ethics of invention reside not in the truth of what is found but in the interest of what is done. 'In the real world it is more important that a proposition be

interesting than that it be true. The importance of truth is, that it adds to interest', Whitehead observed in *Process and Reality*.[5] And, when the ideas we put forward fall on deaf ears, another of his aphorisms may console us: 'Truth is a special case of interest'.[6] This is why invention always involves an ethical question.

Interest is what matters in creative research. But we could say this the other way about: for the phrases "what is interesting" and "what matters" are synonymous. What makes creative research interesting is its attitude towards, its ethos, if you like, in regard to materials. This may seem obvious to you, but I assure you that in the abstract discourses that bear on, and sometimes bear down upon, the activities of the artist, designer, choreographer or producer, it is anything but clear. One object of *Material Thinking* is to show how this drift to abstraction, in which the study of knowledge is separated from the processes that produce it can be reversed. The re-integration of study and process involves a re-evaluation of matter— of, we might say, what matters. The power of thought in the technocratic discourses common to academe, government and business involves an algebraic reduction of language's richness. In these discourses terms are defined abstractly, in ways that detach them from the poetic matrix of their production, circulation and mutation. Inventiveness is taken out of language. Those charged with maximising shareholder profits or minimising public liability speak as if truth were the elimination of interest.

It is in this context that I speak of strong collaboration:

> When nationally valuable research is identified with scientific and technological breakthroughs yielding private industry benefits (technological applications of inventions, the awarding of patents, and so on) or public managerial benefits (information retrieval and processing in the domain of demographic trends, for example), there is no taste for complex interactions. When research is syn-onymous with problem-solving and crisis-management, criteria of success are simplification, resolution, closure. In the process of conducting research, new "problems" emerge; but these are treated in the same way. Within this model it is self-evident that a research question without a simple answer is not a proper subject for research.
>
> In contrast with these *weak* forms of collaboration, creative research, re-specting the materiality of thought—its localisation in the act of invention— has a different object. It studies complexity and it defends complex systems of communication against over-simplification. It explores the irreducible hetero-geneity of cultural identity, the always unfinished process of making and re-making ourselves through our symbolic forms. Its success cannot be measured in terms of simplification and closure. Exploring the reinvention of social rela-tions at that place does not produce a "discovery" that can be generalised and patented. It is an imaginative breakthrough, which announces locally different forms of sociability, environmental interactivity and collective storytelling.
>
> These effects *of national interest* will be missed so long as the "nearly wide open anything goes" collective desire of self-becoming is not regarded as a legitimate

research field. Creative researchers and "industry partners" (to follow the present rubric) can only broker *strong* collaborations if they share this mytho-poetic goal. Public artists, say, can have no effect on public space design if their commissioning agency segregates them from the design process as whole. Even if their material thinking *is* admitted to that larger conversation, it can make no difference unless all parties commit themselves to a process of self reinvention. That process has a technical aspect, and represents a procedural challenge, but the value of the complexity it introduces into the relation between *poiesis* and place-making is that it mirrors the complexity of the "client", who is not a committee but a more or less nebulous collectivity of heterogeneous interests representing the "unfinished" character of society at large. (Carter 2004: 13)

The act of according value to matter is not simply a precondition of your art, as Bentham put it. It is a philosophical attitude or ethos. Material thinking—what happens when matter stands in-between the collaborators supplying the discursive situation of their work—is a different method of constructing the world in which we live. Throughout the history of Western philosophy, invention has been a missing term. Resolving the great question the Greeks bequeathed us, the reality or otherwise of change, has been hampered by a disdain for what the practical arts have to teach us about the construction and reconstruction of the world we make. With distinguished exceptions (Vico and Bachelard amongst them), philosophers have ignored the ethos of materials— their tendency to combination. When Husserl, for example, wrestled with the problem of the historical transmission and development of geometry, he found the evolution of an ideal form paradoxical because he left out the interest that drove its invention and re-invention. Material is never brute matter; it is always between ourselves, hiding us from, but also leading us towards, what we may come across. But for its being interesting, there would be no reason to act at this place.

The point of these general remarks is to assert the value of invention— which, I maintain, as the distinct focus of creative research, is located neither after nor before the process of making but in the performance itself. This can be the case because the making process always issues from, and folds back into a social relation. It is this back-and-forth or *discourse*, that provides the testing-ground of new ideas, and which establishes their interest. From the point of view of creative research, materials are always in a state of becoming. They are not to be imagined as crystalline, dry or elemental but as colloidal, humid and combinatory. The good artist calibrates rates of exchange, and, in this sense, Bentham's figure of art as a mastering of abysses needs to be recognised as a peculiarly wilful and environmentally-alienated conception of innovation. As I have suggested in *Repressed Spaces* (2002), the story of Mettius Curtius, the brave young citizen who offered himself as a human sacrifice when a fissure opened in the Roman forum, may be an allegory about the engineering spirit that disregards the lie of the land and its ghosts. In any case, ours is a period when the car assembly signifiers of innovation need to undergo change. Complexity replaces simplicity; swarms, blebs, groups, degrees of randomness, qualities of asymmetrical temporality and local difference provide units of design that supersede linear quali-

ties of self-sufficiency, repetition, smoothness, symmetry and global homogeneity. It is in this way that the materiality of materials, materialised in the act of invention, assumes an ethical role in human affairs:

> Materials become material signs when, in the process of creative collaboration, they hand themselves over to each other. But it is important that the handing over occurs in the right way. There is an ethics of scattering and recombination.... A right attitude towards materials is itself a concomitant of a right attitude towards collaboration. And this combination of right handing over at a material and interpersonal level expresses the idea of a different social relation, in which people may inhabit their environment recreatively rather than destructively. (Carter 2004: 183-184)

In 2002 I had the opportunity to present these ideas in the context of developing a public space strategy at Melbourne's Docklands. A group within the property developer Lendlease had signalled their desire to break the tower-plinth approach to the design and arrangement of built structures across their site, and invited me to develop 'a robust template or ground pattern that can be used as the basis for the siting, scaling and distribution of urban and landscape design elements throughout the site'.[7] My approach was to define two principles that would allow the site analysis to take into account aspects of the site that eluded conventional recognition, and to produce a set of what I called "Descriptions" or thinking drawings, that sought to notice, if not to notate, movement forms whose traces were integral to the characterisation of the place. First, I enunciated what I called "The Argo Principle":

> Historically, the Harbour has been a site of exchange. Exchange occurs wherever a place of meeting produces change. As the focus of trade, the Harbour married movement and change. To pass through the harbour meant a change of value and state. It meant entering a zone of flux and transformation. Over time every element in the Harbour was replaced, repriced, relocated, re-invented. This principle doesn't mean ignoring what is reported in recent Melbourne Docklands Heritage Studies. It simply means looking at that information in a different light—as a legacy of appearances and disappearances. In short, a history of change. In this way attention shifts from static objects to mobile processes. It becomes possible to see the space as a dynamic, self-reinventing network of tracks, outlines, shadows, edges, sightlines and wakes—to see it as if it were reflected in the ever-changing face of the water. The Greek hero, Jason, sailed to get the Golden Fleece in the Argo. It was a long voyage, and gradually the ship's timbers rotted. By the time Jason came home, every timber of the Argo had been replaced. The Argo was a completely new ship. In this way the old ship survived through constant movement and change, completely reinvented. Hence the Argo Principle: applied to Victoria Harbour, it states that the essential mobile, changeful character of the site is best described as a heritage of invention. (Carter 2002: 7)

Second, I described what I called "The Asterisk Principle", arguing that:

> The character of the Victoria Harbour site is often found in what is left out of conventional histories. Conventional histories document the foundation of places, the growth of communities, architectural and other events of importance. By this definition, Victoria Harbour hardly has a history. Early maps either leave it as a blank space, or simply write "swamp". Foundations, of course, cannot be put down in swamps. As Melbourne grew in civic pride and self-consciousness, so the low land west of the old Batman's Hill, and north to West Melbourne Swamp, dropped out of consciousness. It was a non-place, rubbish was dumped there, and polluting industry. The Victoria Harbour site had no place in conventional histories. In compensation, it was an area where dreams multiplied. These were mainly engineers' dreams: from the earliest days of white settlement to the period of containerisation, imaginative engineers and surveyors have been drawing residential, commercial and marine utopias over the site. The Victoria Harbour is the place where dreams of other places have collected. This fact was reinforced when the swamp was transformed into Victoria Docks, becoming a port of national and global significance. The languages of the sailors, the starlore of ship's captains, the gymnastics of the wharfies, the commercial intelligence and opportunism of Melbourne's merchants: these secret knowledges are the intelligence of Victoria Harbour. Their stories form the site's mythic identity. The second guiding principle is then a commitment to recovering these neglected historical dimensions of the site. I call it the Asterisk Principle because, as an ancient scholar, writing about poetry, explained, 'The Asterisk is placed against [verses] which have been *omitted in order that what seems to be omitted may shine forth*. For in the Greek language a star is called aster.' (Carter 2002: 7)

In practice-based research, ethically-sustainable invention responds, I would suggest, to three conditions. It has to describe a forming situation. It has to articulate the discursive and plastic intelligence of materials. And it has to establish the necessity of design. There is, of course, a constant feedback between these three facets of the inquiry. By "a forming situation" I mean to evoke both the attitude of the artist and the social context in which the work (the project) emerges. To speak personally, I would say that a right attitude is characterised by a sense of an unfulfilled relation. The motivation of the artist is not to add another object to an already crowded world. It is not a positive will to reproduce (albeit with new features) what already exists. The impulse to make or invent something stems, rather, from a growing sensation of silence, of loss, lack, incoherence or absence. The need to draw together what has been scattered apart originates not in the will, but in the realm of eros; it is the frustrated desire of connection that inspires the recreative act. Evidently, this motivation originates outside the artist. The forming situation is, in this context, the environment in which that impulse makes sense. That environment may take the form of a commission (in which the client stands in for a dispersed desire of psychic

repair); it may take the form of a developing conversation leading to a collabora-
tion—which, in turn, by a kind of entrainment, creates a discursive momentum
leading to the realisation of new symbolic form.

That discursive momentum provides the interest impelling invention—and you
notice that, in this description, interest precedes invention rather than being a qual-
ity of the invention. It also produces collaboration. These human arrangements
are mirrored in the way materials are selected and allowed to "speak". In general a
kind of weak reasoning, of the kind that Italian philosopher Gianni Vattimo recom-
mends, operates in these circumstances. It is necessary to suspend the usual forms of
classification—traditional definitions of roles, techniques, functions and outcomes
need to be set aside, and a kind of "what if", anything-goes mode of speculation
encouraged. The same applies to materials, whether they are documents, images,
sites, animate bodies or the situation itself. Various poetic techniques of combina-
tion are tried out: principles of homology, convergence, and mere coincidence are
explored. Attention is paid to the overlooked or marginal, the material supplement
that semiotic convention discards. I refer to this poetic process as mythopoetic be-
cause it understands invention not as conjuring up *ex nihilo* something new but as
an act of finding 'that presupposes its existence somewhere, implicitly or explicitly,
scattered or in a mass'.[8] As Giambattista Vico argued, invention or *poiesis* involves
not only ingenuity (or wit) and imagination, but recollection. In my view, one of
the primary functions of creative research is to study, document and valorise these
periods in which the usual logic of combination is suspended. Like Jeremy Bentham,
Sigmund Freud was given to describing ideas in topographical terms. The period
preliminary to dreaming, he said, was like a country whose terrain is characterised by
a dense network of paths or unconscious wishes. The beginning of the dream proc-
ess, which occurs when the preconscious is aroused, is 'a simultaneous exploring of
one path and another, a swinging excitation now this way and now that, until at last
[the dream-wish] accumulates in the direction that is most opportune' (Freud 1960:
576). Something similar describes the discourse—the back-and-forth—of invention.
And it is precisely this exercise or gymnastic that ensures the validity, interest and
ethical sustainability, of the path at length taken.

The third condition characterising ethical invention—the necessity of design— is,
from the point of view of the artist engaged in industry partnerships of one kind
or another, perhaps the issue of primary significance. Should something be made at
all? In a constitutionally inventive culture—whose demand for change and growth
is locally instantiated in the forming situation—simple inaction is not feasible: even
the plan not to make something represents a design on the future, and it is a heritage
myth to suppose that the past is preserved in this way. In reality, all that is preserved
in this way is a myth of the past as past, rather than as the locus of the spirit of in-
vention that we follow even as we transform it. The client is, or should be, exercised
by the question of the necessity of design quite as much as the contracting artist.
There is no doubt that many government-promoted, publicly-funded infrastructure
briefs are raised in an inappropriate fashion, both too late in the design process and
too early: instead of factoring in a process of exploring one path then another, they

attempt to lay down preemptively the rules for the management of the project, as if its parameters required no further investigation. This attempt to mandate the conditions of engagement effectively removes from the artist—or architect, designer or any other collaborative consortium—the discretionary capacity to engage critically, creatively and fundamentally with the project's terms of reference. The aleatory quality of design research—which might allow invention to occur, and entirely heterogeneous symbolic, environmental and material configurations to emerge—is prohibited. It is this ignorance, or suspicion, of the social function of invention, the role its aleatory processes play in determining the necessity of design, that explain the double bind in which public artists so frequently find themselves—in which the client simultaneously demands something new and something that is not new that, despite appearances, changes nothing.

In making *Nearamnew* at Federation Square in Melbourne, we confronted all of the three conditions I have discussed: a forming situation; the intelligence of materials and the necessity of design.[9] The forming situation was obviously Lab architecture studio's commission to build Federation Square, a commission which was the visible tip of a political, cultural and civic iceberg, whose contours have yet to be fully described. My invitation to enter into a dialogue about the role public art might play was uniquely and inspiringly negative. That is, no brief had been raised, no parameters set. The sole requirement laid down by the architects was that the necessity of any intervention be proved. From my perspective, the proposed design was characterised by a lost relation. The architects drew parallels between the approach to design and the organisation of federal systems of political organisation, but I knew from my research that local instances of federal organisation existed that predated, surrounded and informed the appearance and history of the site. There is strong evidence to show that neighbourhood of Federation Square was ground all the clans forming the Kulin confederacy had ceded as part of what was, in effect, a federal covenant; granting power to the decisions made there, those signatory to them guaranteed their own liberties. Also, the earliest plans for the site clearly showed that, before the banks of the Yarra were built up, the system of billabongs, periodically-flooding marshes and chains of ponds constituted a system of water distribution that was federal in character. The public artwork was proposed initially as an invention that would recover these forgotten spatial histories and inscribe them into the present design.

The role that the intelligence of materials played can be succinctly indicated by quoting this striking description of federal systems of government:

> The federal system is not accurately symbolised by a neat layer cake of three distinct and separate planes. A far more realistic symbol is that of the marble cake. Wherever you slice through it you reveal an inseparable mixture of differently coloured ingredients. There is no horizontal stratification. Vertical and diagonal lines almost obliterate the horizontal ones, and in some places there are unexpected whirls and imperceptible merging of colours, so that it is difficult to tell where one ends and the other begins. So it is with federal, state,

and local responsibilities in the chaotic marble cake of American government. (Frenkel 1986: 62)

As I have documented elsewhere, the discovery of the Kimberley sandstone was decisive in determining the character of the artwork we made. In a sense, it translated the rhetorical argument for the necessity of designing the plaza in this way into a material possibility. I had made the rhetorical case for the proposed work—its three scales corresponding to the three "ingredients" of federal government—and you could see that the cobble whorl pattern, the distributed regional ground figures and the letter fields produced environments that, while unpredictable, and scarcely legible, from a linearist perspective, strangely incorporated neglected dimensions of the human and physical environment, thus symbolising the potentiality of federally-constituted societies to re-member themselves more inclusively. But this was nothing without the intelligence of the materials, which, in turn, made possible the materialisation of writing as lettering, and lettering as typography. It is hard to say if, in the "invention lottery", *Nearamnew* has been innovative and conventionally successful. Apart from the crude indicators of visitor numbers and anecdotally-reported interest, objective data are hard to come by. Perhaps this uncertainty is consistent with the motivation of its invention, which was not to deliver a symbolic form representing anything, but rather to construct a kind of psycho-physical flow chart whose aim is to induce in those who use it a collective performance, one that reinscribes the potential of democratically-constituted societies to create meeting places. In this sense the measure of the interest the design arouses will be the continuing discovery or invention of the place that it helps to induce.

I have tried in this chapter to show you that the practice of practice-based research opens out onto the broadest questions about the kind of society and culture we espouse and wish to inhabit and promote. Ethically-sustainable design is not a luxury fitting that we can choose not to afford: it reflects and interprets the foundations of our "art". It does this because the criteria we use to define good design are not borrowed from aesthetics, ecology, political theory or some notion of social representativeness but are internal to the conduct of the research process—that strong collaboration I spoke of before. That this appeal to what lies inside the forming situation does not mean a retreat from the marketplace of educational, civic and commercial exchange where values are decided is due to the fact that the place of invention (and the place that inventions localise) is always in origin a social relation, the renegotiation, renewal or repair of a contract with the other. It is a notable skill of practice-based research to route these socially constitutive transactions through the materiality of our lived time and space. In this sense, our local inventions always resist generalisation. They are work in Henri Lefebvre's sense, which is unique, rather than *products*, which are repeatable. Lefebvre foresees a time when this distinction will be overcome. It is in our interest to ensure that, if and when this happens, it is the heterogeneity of work that is recognised as valuable. To provide criteria of evaluation is one function of an ethics of invention.

(A version of this chapter was first published as a keynote address in *Real Time Arts,* online proceedings of the Speculation and Innovation: Applying Practice Led Research in the Creative Industries Conference, Queensland University of Technology, Brisbane, http://www.speculation2005.qut.edu.au/index. htm)

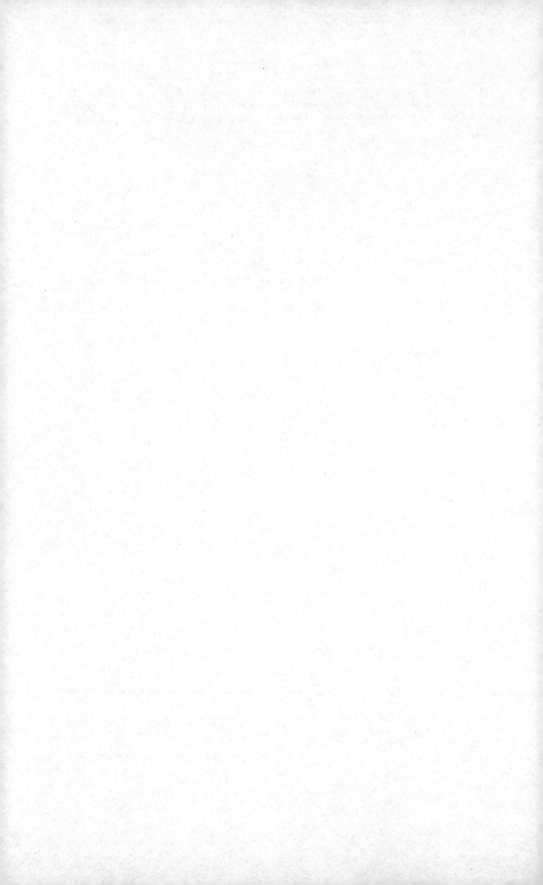

2

THE MAGIC IS IN HANDLING
Barbara Bolt

David Hockney begins his monograph *Secret Knowledge: Rediscovering the Lost Techniques of the Old Masters* (2001) by recalling the viewing experience that inspired his research for this book:

> When I went to see the Ingres exhibition at the National Gallery in London in January 1999, I was captivated by his very beautiful portrait drawings—uncannily 'accurate' about the features, yet drawn at what seemed to me to be an unnaturally small scale. What made Ingres's achievement in these drawings all the more astounding was that the sitters were all strangers (it is much easier to catch the likeness of someone you know well), and that the drawings were drawn with great speed, most having been completed in a single day. Over the years I have drawn many portraits and I know how much time it takes to draw the way Ingres did. I was awestruck. 'How had he done them?' I asked myself. (Hockney 2001: 21)

On first appearance this seems like a straight forward art historical enquiry. However Hockney makes a very critical point, pertinent to the notion of practice-led research, when he suggests that such observations and such questioning could only have been made 'by an artist, a mark-maker, who is not as far from practice, or from science, as an art historian' (Hockney 2001: 13). Here Hockney sets up a division that is not entirely valid, since many art historians are also practitioners, but his point is a critical one. It is the special kind of sight that Hockney gained through being a practitioner that enabled him to offer both original and originary approaches and insights into the drawings of Ingres. The specificity of Hockney's experience as an artist and particularly a drawer, fashioned the nature of the question, the methodology and the types of realisations that emerged from the investigation.

Hockney's research question was a very simple one. How had Ingres achieved such uncannily accurate portraits at such a small scale in such a limited time frame? From his own experience as a drawer, it did not seem possible that Ingres could have achieved the accuracy demonstrated in these drawings through direct observation and free hand drawing. In setting out his enquiry, Hockney followed his hunch

that Ingres had in fact used a camera obscura to make these drawings. In order to test this proposition, he devised a complex and idiosyncratic methodology that involved research through drawing, an investigation into optical devices and their use as drawing aids, and a visual analysis of drawings and paintings dating back to the fourteenth century.

Hockney set about making drawings using a camera lucida and compared them with drawings that had been achieved through what he terms "eyeballing" or unaided freehand drawing. He built himself a special drawing room based on the principles of the camera obscura and began a series of drawings-as-experiment. Through these drawing experiments, he observed that not only could the use of this optical device achieve uncanny accuracy, but more importantly, drawings made this way were characterised by a particular quality of drawn line that distinguished them from freehand drawing. The line was much surer and more confident than the "groping lines" of a drawer struggling to "see" and record freehand. However, in this confidence it lacked the struggle, the variation in line quality and indeterminacy of the eyeballed drawing (compare my experiments in Figure 1).

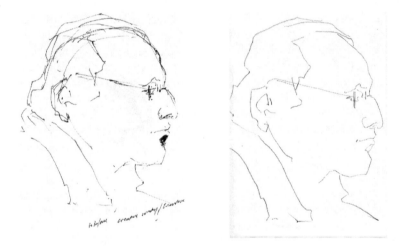

Barbara Bolt, *Drawings of Grant*, (2005). Left drawing "eyeballed", right drawing produced with the assistance of an optical device.

From these original investigations and drawing experiments, Hockney came to question an unquestioned belief in the mimetic drawing brilliance of key artists from the late fourteen hundreds to the nineteenth century. Against the generally accepted belief that artists such as Raphael, Durer, Holbein, Vermeer and Ingres possessed extraordinary drawing skills which they put to work in creating images of astonishing verisimilitude, Hockney set forth a visual argument that from the early fifteenth century Western artists had not just been aware of, but had relied on optics to create "living projections". He did not question the drawing ability of these art-

ists, but rather suggested that it was the use of optical devices that enabled them to draw and paint with such amazing verisimilitude that did and still does make people gasp in awe. Thus, he set out to argue visually, that optical devices in combination with the development of perspective, enabled the "paradigm shift" in drawing conventions that saw a movement from proto-realism to photographic illusionism within a very narrow historical time period at the end of the fifteenth century and beginning of the sixteenth century.

In this investigation, Hockney's research methodology was idiosyncratic and his research findings have been the subject of much debate and further experiment. However, it is precisely the non standard nature of his methodology that highlights the importance and relevance of his investigation for the development of methodologies and approaches in practice-led research. Firstly, the initial question that drove Hockney's research arose out of a disjunction between his understanding of the possibilities of drawing and the disbelief he experienced when viewing Ingres' (1829) drawing of Madam Godinot. Secondly, Hockney's hunch and subsequent visual hypothesis about Ingres' drawings was derived from his experience in using projection devices and photographic technology in his work. Thirdly, his experience as a drawer predicated the particular methodology he developed to test his observations in the laboratory of drawing. Fourthly, Hockney focussed on particularity, rather than a generalisation to examine his proposition. Finally, and most importantly, Hockney's visual argument demonstrates the double articulation between theory and practice, whereby theory emerges from a reflexive practice at the same time that practice is informed by theory. This double articulation is central to practice-led research.

Whilst he is probably unaware of his contribution to the developing field of creative arts research, Hockney's investigation gives form to a particular and much maligned aspect of practice as research. It introduces the possibility of the visual argument and highlights the potential of the exegesis to do much more than explain, describe or even contextualise practice. Through his visual argument, Hockney enables us (as it enabled him) to look at, and think about paintings and drawings from a different perspective. It enables a shift in thought itself. Further, in the way Hockney sets out the problem, sets up his argument and garners evidence to demonstrate his proposition visually, he offers one way of thinking about the structure, methodologies and form that practice as research research may take. In particular his thesis demonstrates the material nature of visual thinking.

Whether or not one agrees with the conclusions that Hockney makes in *Secret Knowledges* (and there has been considerable criticism of the work), his insights demonstrate a very specific sort of knowing, a knowing that arises through handling materials in practice. This form of tacit knowledge provides a very specific way of understanding the world, one that is grounded in material practice or (to borrow Paul Carter's term) "material thinking".

The concept of material thinking offers us a way of considering the relations that take place within the very process or tissue of making. In this conception, the materials are not just passive objects to be used instrumentally by the artist, but

rather, the materials and processes of production have their own intelligence that come into play in interaction with the artist's creative intelligence. Here I want to differentiate my own understanding of material thinking or what I have termed a "material productivity" from Paul Carter's (2004) explication of material thinking. Whilst Carter acknowledges the creative intelligence of materials, he tends to negate this intelligence by privileging the collaboration between artists and writers rather than the collaboration between artists and materials. For Carter, this collaboration 'is not simply a pragmatic response to increasingly complex working conditions; it is what begins to happen wherever artists *talk* about what they are doing, in that simple but enigmatic step, joining hand, eye and mind in a process of material thinking' (Carter 2004: xiii) (my emphasis). I would agree with Carter that it is in the joining of hand, eye and mind that material thinking occurs, but it is necessarily in relation to the materials and processes of practice, rather than through the "talk", that we can understand the nature of material thinking. Words may allow us to articulate and communicate the realisations that happen through material thinking, but as a mode of thought, material thinking involves a particular responsiveness to or conjunction with the intelligence of materials and processes in practice. Material thinking is the logic of practice.

Hockney's observations about Ingres' drawings arose out of a sustained and sustaining drawing practice. His particular tacit knowledge came from the experience of working with pencils, charcoals, paint, projections and the camera in realising an image—and in particular in the struggle to render reality "out there" on to a two dimensional surface with a graphite pencil. Put simply, his engagement with the tools and technologies of drawing practice produced its own kind of sight or logic.

Martin Heidegger terms the kind of "sight", through which we come to know how to draw, to paint, to dance or to write, circumspection. For Heidegger, it is through circumspection that that the "new" emerges. In this way artists gain access to the world, in what Emmanuel Levinas terms, an 'original and an originary way' (Levinas 1996: 19). "Originary" is a term rarely used, but one that seems particularly pertinent to practice-led research. It is a way of understanding that derives from, or originates in and of the thing in question. In this case, the "thing" in question is practice. It is understanding that originates in and through practice.

In *Being and Time* (1966) Martin Heidegger sets out to examine the particular form of knowledge that arises from our handling of materials and processes. Heidegger argues that we do not come to "know" the world theoretically through contemplative knowledge in the first instance. Rather, we come to know the world theoretically only after we have come to understand it through handling. Thus the new can be seen to emerge in the involvement with materials, methods, tools and ideas of practice. It is not just the representation of an already formed idea nor is it achieved through conscious attempts to be original.

Despite the best efforts of the postmodern critique of originality, concepts such as "the new" and "originality" still remain the driving force behind contemporary art practice and creative arts research. In contemporary practice, this pre-occupation has tended to take the form of conscious attempts on the part of the artist, to create

an event that shocks or puts the viewer in crisis. In creative arts research, the obsession to create the new has found a particular discursive form. Thus, a central goal of post graduate research is that students demonstrate how his/her research has made an original contribution to knowledge in the particular research discipline. As I have argued elsewhere (Bolt 2004), the quest for the new persists as a source of anxiety and obsession in both contemporary art practice and also creative arts research.

I would suggest that that the quest for the new can be a misguided objective of creative arts research that results in self conscious attempts at transgression in the belief that this somehow will produce the new. However, we can not consciously seek the new, since by definition the new can not be known in advance. Hockney did not set out to find the new, but the new arrived to confront him. The "shock of the new" is thus a particular understanding that is realised through our dealings with the tools and materials of production and in our handling of ideas, rather than a self-conscious attempt at transgression. This is material thinking.

From my argument so far, it is evident that I give pre-eminence to the material practice of art. In place of the "technologisation" of thought, that has come to characterise science as research, I have argued that "new" knowledge in creative arts research can be seen to emerge in the involvement with materials, methods, tools and ideas of practice. In this formulation, notes Don Ihde, a praxical engagement with tools, materials and ideas becomes primary over the assumed theoretical-cognitive engagement (Ihde 1979: 117). Through such dealings, our apprehension is neither merely perceptual nor rational. Rather, such dealings, or handling reveals its own kind of tacit knowledge.

Praxical knowledge takes a number of forms and it is this multiplicity that provides creative arts research with its distinctive character. Whilst the artwork is imminently articulate and eloquent in its own right, tacit knowing and the generative potential of process have the potential to reveal new insights: both those insights that inform and find a form in artworks and those that can be articulated in words. It is here that the exegesis offers a critical role. Rather than just operating as an explanation or contextualisation of the practice, the exegesis plays a critical and complementary role in revealing the work of art.

In order to exemplify this dialogical relation between making and writing I return to my own practice as a maker and writer. As an undergraduate, I spent a number of years painting landscapes in and around Kalgoorlie in regional Western Australia. I had been making landscape paintings before I went to live in Kalgoorlie, but here, on the edge of the desert where temperatures are extreme and the sun's glare fractures form rather than revealing form, I was left inadequate to the task of rendering this complex landscape in paint.

Initially, I tried to apply the rules of linear and aerial perspective to the problem, but found they were useless. The harsh and blinding glare of the sun was so intense that no form emerged. The horizon remained, but objects did not appear to get smaller in the distance, nor did distant objects become more greyed out and diminish in sharpness and chiaroscuro in the distance. In fact, the distant horizon seemed more defined and the colour was stronger than the foreground. As a consequence of

Barbara Bolt, *Kalgoorlie Landscape*, oil on ply, 1992

the reversal of the principles of aerial perspective, the background seemed to jump over the foreground, collapsing space rather than creating deep space.

In the fuzziness of practice, out in the desert, the principles foundational to my art education were no longer of much use to me. Here, the process of making a painting challenged my preconceived notions about landscape painting, linear and aerial perspective and questioned my understanding of the assumed relationship between light, form and knowledge. Light does not always shed light on the matter. Under the harsh glare of the Australian sun, light fractured form rather than revealed it.

My failure to "realise" a painting according to pre-existing principles, and simultaneously the unraveling of my preconceived notions about the relation between light, form and knowledge were enabled by a movement from logical rational thought to material thinking. Handling revealed the limits of conceptual thinking. It took the

work elsewhere. This is evidenced in the trajectory that the paintings took. However, what was as significant, was the movement in conceptual thought resulting from this failure to realise a painting. Here, writing became the critical vehicle through which to articulate and disseminate an alternative conception that emerged from this failure. Through the exegetic form, I was able to develop an argument for a performative understanding of art.

In the exegesis, particular situated and emergent knowledge has the potential to be generalised so that it enters into dialogue with existing practical and theoretical paradigms. While Hockney's research arose from a very personal and intimate encounter with a drawing by Ingres, the visual argument he developed offers a direct challenge to art historical interpretations of key artists from the late fourteen hundreds through to the nineteenth century. Similarly, whilst my struggle to render form under the glare of an Australian light was particular and probably relevant only to me, the realisations generated by and through this encounter have offered an alternative conception of the work of art. Thus, rather than operating as a solipsistic reflection on one's own practice, the particular situated knowledge that emerges through the research process has the potential to be generalised so that it sets wobbling the existing paradigms operating in a discipline. In other words, through the vehicle of the exegesis, practice becomes theory generating.

The task of the exegesis is not just to explain or contextualise practice, but rather is to produce movement in thought itself. It is these "shocks to thought" that constitute the work of art and, in conjunction with the artworks, it forms the material of creative arts research. Such movement cannot be gained through contemplative knowledge alone, but takes the form of concrete understandings which arise in our dealings with ideas, tools and materials of practice. It is not the job of the artwork to articulate these, no matter how articulate that artwork may be. Rather, the exegesis provides a vehicle through which the work of art can find a discursive form. In this way, as Nancy de Freitas (2002) argues, the exegesis provides an opportunity and a forum to reconfigure theoretical positions.

So what are the implications of this argument for practice-led research and a practice-led pedagogy? Heidegger's notion of handlability suggests an alternative teaching pedagogy to that which is paradigmatic in universities. If handlability underpins material thinking, as I have argued, then surely the way we teach must be rethought to focus on the unique form of "sight" or circumspection that makes creative arts research distinctive. If we are to begin with Heidegger's premise that we come to know the world theoretically only after we have come to understand it through handling, then how do we structure programmes to give a voice to material thinking? Theorising out of practice is, I would argue, a very different way of thinking than applying theory to practice. How does one devise a pedagogical strategy that makes "practical sense"? This question has become particularly critical at a time when art education has become so driven by conceptual and thematic concerns and where materials and processes are conceived instrumentally to be used in the service of an idea, rather than as productive in their own right.

The context in which creative arts research as a mode of enquiry and the exegesis

as a form has emerged has resulted in the negation of material production. Paul Carter is correct when he suggests that the rules of the interpretive game have denied intellectual recognition of those elements of material thinking (Carter 2004: xiii). Positivist scientific thinking has demanded observable, measurable and repeatable processes and methodologies; conceptualism has privileged the driving idea and Visual Culture, driven by a Cultural Studies agenda, has emphasised the social production and reception of art over material production. In the negation of the specificities of practice, the potential for the exegesis to do the work of art has been greatly underestimated and its validity in the research process has been (and still is), the subject of much debate amongst educators and students. In the reaction against the colonising influence of Cultural Studies on the Creative Arts, the privileged position of practice has been re-asserted and has begun to be used as a justification for promoting practice-only higher education degrees. In this thinking, art practice in itself is research.

In his recent book *Art Practice as Research* (2005), Graeme Sullivan notes that for those who argue that art making is research, the explanatory exegesis is redundant (Sullivan 2005: 92). Whilst I have concerns with the descriptive and explanatory exegesis, I would suggest that practice-only postgraduate research can disable practice-led research by confusing practice with praxical knowledge and severing the link between the artwork and the work of art. It is my contention that it is art as a mode of revealing and as a material productivity, not just the artwork that constitutes creative arts research. It is not, as Carter maintains, about 'mastering the rhetorical game of theorising what artists do' (Carter 2004: xiii). Rather it is much more concerned with articulating what has emerged or what has been realised through the process of handling materials and ideas, and what this emergent knowledge brings to bear on the discipline.

Praxical knowledge involves a reflexive knowing that imbricates and follows on from handling. Further I would argue that this reflexivity forms the locus of practice-led research's radical potential to effect movement. The task of the creative exegesis is to extend on existing domains of knowledge through its reflection on those shocking realisations that occur in practice. In the exegesis, the nature and authority of the knowledge claims that flow from practice-led research are able to be sustained beyond the particularity of a practice to contribute to the broader knowledge economy. Rather than just operating as an explanation or contextualisation of the practice, the exegesis plays a critical and complementary role in the work of art.

(A version of this chapter was first published in *Real Time Arts*, online proceedings of the Speculation and Innovation: Applying Practice Led Research in the Creative Industries (SPIN) Conference, Queensland University of Technology, Brisbane, http://www.speculation2005.qut.edu.au/index.htm)

3

HISTORY DOCUMENTS, ARTS REVEALS: CREATIVE WRITING AS RESEARCH
Gaylene Perry

My doctoral thesis consisted of a novel entitled *Water's Edge*, and an exegesis that dealt with the nexus of the creative arts and higher research (Perry 2001). The main relevance of the exegesis to *Water's Edge* is that both components of the thesis were written as part of the creative work-plus-exegesis model. I felt this model needed to be further tested and discussed. A considerable part of my discussion centered on the suggestion that creative work could be recognised as valid research within itself, without necessarily requiring exegesis. My exegesis mostly addressed the *artefact* of the creative work as being a possible site of research output, with minor focus on the *act* of writing as itself being a site of research. Here, I continue that latter discussion in order to explain how the processes of writing themselves, the studio enquiry, may lead to knowledge that is not necessarily explicitly discernible on the surface of the creative work. In this chapter, I identify examples of such moments in the writing process of *Water's Edge*.

I will begin with a simple summary of what I learned through my studio enquiry:

- In the act of creative writing, I gain personal empowerment that can effect change in my life;

- My finished product of writing: what I call the novel, is one site of what I have created, but not the only site; the rest of what I have created seems to lie just beyond or beside the novel, and for me, this is a series of autobiographical traces;

- This sense of multiplicity in my work causes me to question boundaries between fictive and autobiographical generic practices;

- Even while I am treating autobiographical traces in my creative writing, the empowerment that I gain appears to reside in the *imaginative work* that I do as a writer. However, the term and the practice of imaginative work is applicable to many genres of writing, not only the genres of fiction-writing.

From these findings, discovered via studio enquiry, I have moved outwards to consider the implications of what I have learned for the field of community writing: writing carried out by or within a group with a reconciliatory or redemptive or perhaps expressive or cathartic purpose. I refer to the practice of *scriptotherapy* (Henke 2000: *xii*) and to contemporary theories of grief to explore some possible applications for community writing projects.

Fiction and Autobiography

My novel, *Water's Edge*, has a fragmented island-like structure that resounds with its recurrent imagery and themes. The main character, Serena, is a female midnight-to-dawn radio announcer in her early thirties. She undertakes a radio station project entailing her to write and present a fictional life of one of her ancestors, a woman who emigrated from Scotland's Isle of Skye in 1854. At the same time, she learns that she has a sister who at birth was adopted out of the family but is now to re-enter the scene. The fictional life of the ancestor is moulded by present-day events. Via writing, as Serena fills a red journal with the developing story of mothers, daughters, sisters, and through displacement, she discovers a certain murderous anger that she possesses and the power that accompanies that anger.

Water's Edge is a work of fiction and nearly all of the details that I have just mentioned are fabricated. Yet I could write another synopsis consisting of a series of autobiographical details that form another layer of the imaginative work of this novel.

The autobiographical details could include information such as that islands, like lighthouses, form part of my own personal imagery in thought and in writing interests. I trace this imagery to loneliness, to a struggle with growing up in isolated, country town communities where I did not fit in and had few friends. In further information, I learn that I once worked in a radio station, as a copywriter rather than an announcer like Serena, and I was intrigued by a female midnight-to-dawn announcer of my own age. As a young adult, I learned that I had a half-brother who had been relinquished for adoption by my mother before she was married, a brother who re-entered our lives, as we re-entered his life. Also I have ancestors from the Isle of Skye, When I started writing *Water's Edge*, I knew little about them. My family had a portrait of a woman whom family members said came from Skye, but one of the first things I learned as I began my research, was that she actually came from the village of Glenelg on the mainland of Scotland, the traditional crossing point to Skye. Another set of ancestors altogether, were the ones from Skye. At a later point I did discover that the mother of the woman in the portrait had originated from Skye, so maybe the woman in the portrait aligned herself with the island, explaining how the story of the Skye connection passed down through the family as lore. It is the only sector of the family's ancestry that truly interests me, one strand of lineage going back through my mother and her father and his mother and her father and eventually his mother, who was the woman in the portrait. I suppose I have this interest because artefacts belonging to that story have remained intact. My family still has the portrait of the glaring, spirited-looking woman; we can stand by her grave in the cemetery in the small town where my mother lives; and we still own the land that

this ancestor purchased, The ruins of the house that she and her husband built are still standing. She birthed eighteen children in that house.

I mention this layer of autobiographical details because I think what I learned most from the act of writing this novel, was about the instability of boundaries between the fictive and the autobiographical, the singular experience and the collective, the personal and the political.

To begin my work, I wrote about forty thousand words of *Water's Edge*. I gave the name Marian to the character of the ancestor, and she began to steal most of my interest as a writer. I was granted a travel scholarship; I would go to Skye to carry out archival research and fieldwork relating to *Water's Edge*. I had never been to the Isle of Skye except in my imagination, yet in those forty thousand words of writing, I, along with Serena, had created a vision of it. We had begun to write Skye and to write Marian. I wanted to see whereabouts on Skye Marian came from: unlike the real-life ancestor she was based on, this fictional Marian was from Skye, and I needed to find an exact location for her. Much of the writing of Marian was prescient, more than any other element of the novel, or so it seemed at the time. It was as though Marian had always existed, this Marian, the Marian being written, the Marian coming to life under my fingers in my drafts and under Serena's fingers in her red journal.

Keeping a Journal

I kept a journal as I travelled over Skye, and I consider this journal to be part of my studio enquiry. At first I expected the journal to be a notebook for recording details such as dates and place names and historical facts, but it actually became a creative work in itself. The physical act of writing in that journal became part of the writing of the novel, although few of the words from it can be found in the text of *Water's Edge* itself. Now when I read the journal, I am again struck by prescience, by the way that as I travelled and wrote my journal entries, I seemed to strike something solid, something with its own body and mind.

The omnipresent harshness of the Skye landscape brought me a realisation about what I had already written. A grisly catalogue appears in *Water's Edge*: a collective of people in Serena's family and ancestry who have died violent or unnatural deaths. This catalogue essentially belongs to Serena's mother, Pam. As I looked at the sheer cliffs and ridges, saw the trees embattled by wind, and went to museums and learned of Skye's part in the bloody highland histories, I saw the aptness of the death catalogue. Pam is closely connected to her ancestry. It made sense for her to keep a list of death lore close to mind. Pam is a talker rather than a writer, but certainly a storyteller. In the context of all that I learned through studio enquiry for *Water's Edge*, I wonder if Pam was not seeking reconciliation of her family history and of her present-day actions as she told her family lore again and again, always in the same words, like some ancient poem laced with mnemonic phrases.

One day I wrote in the Skye journal:

I am tracing the island's interior. Glad to set the images into my blood. I feel

my way over the land. I hear hammering in the distance—renovation, con-
struction—yet it has a tribal tone. Heartbeat. (Perry 2001: 55)

I found that as I traveled I was not interested in traces of my own actual family an-
cestry. Rather, I was attuned to the traces of my fictional characters, of their origins,
of the places that rang with their familial memories.

On the north-east coast of Skye's Trotternish Peninsula, I found my historical
character Marian's home. The line between the sea and the sky was indiscernible. I felt
uncomfortably close to both of my main characters, Serena and Marian at that mo-
ment. I wanted to shake something off as though another skin had draped over me.

This is the section of *Water's Edge* that emerged from that experience and my sub-
sequent writing about it in the Skye journal:

> The Northern Lights glimmer, illuminating the sky and the sea and the satellite
> islands to a deep blueness.
> Her lungs open to the blue air of midnight and she draws up her arms, weighing,
> for the blueness has a body like breathable water. She bends to touch the granite
> lip of cliff, as blue as all else.
> The sea floats, edges diffused.
> A shadow seeps over her. She turns her head, and the shadow moves to the other
> side.
> She hears the voice sound over the water. A woman with a voice like Serena's own
> speaks in an old language.
> Serena's ancestor walks into her mind.
> She has searched for the fleshly Marian, thinking she inches closer with the entries
> written in the red journal. Here the light is enough to show a face but it is too dark
> for reading and writing. And here is Marian.
> Marian's rough skirts swing at her calves. She is small, the top of her head coming
> to Serena's shoulders. She stands close, looks out to sea, still as mesmerised as her
> twentieth century descendant. She is a girl of eighteen.
> Serena lets Marian walk around her, touch her long hair that hangs free over her
> shoulders and down her back. For a second, the smaller woman stands in front of
> her and strokes her face. Marian's fingers have the texture of water-smoothed rock.
> The voice sounds until Serena wears it, absorbs it along with the blue light, content
> to hear its resonance if she is not to understand the meaning of the words.
> Marian's face, and her eyes that are indigo rather than black, slip away into the
> night.
> Serena, her feet on familiar rock, is as light as a swimmer in a blood-warm sea.
> (Perry 2001: 315-16)

This passage, both in the act of writing it and in the finished narrative, was a kind of cel-
ebration, a reconciliatory moment for Serena but also for me. Standing on our own feet,
celebrating imagination and its power to effect change in a person and that person's life.

As I wrote of Serena writing Marian, constructing this ancestor who seemed to

come to life, at the same time that another woman, Serena's sister, walks into her life, I found a sense of something like healing in the story, in the process of writing. Yet I am uncomfortable with this word, *healing*, as it suggests a mental image of a scar closing over, becoming smooth, while what I learned as I wrote *Water's Edge* is that what is commonly called the past, does not have a sealed surface like a healed-over scar, even when work is done to address the events and issues of the past. I wonder if what Serena does through the act of writing in her red journal and what I at the same time carried out in my studio enquiry, my writing of the novel, is more like reaching out to touch a fleshly body, the body of real-life events (I say real-life, meaning the "real-life" events existing in my fictional character's life as she herself writes her fiction in her red journal, and also the real-life events of my own life as I write the drafts of *Water's Edge*.) Is *reconciling* the word for what my character and I are doing? Reaching out to physically touch emotions and troubles, sculpting and moulding them, and yet at the same time to be moulded and sculpted by them?

Serena has few facts to guide her, so she fictionalises her story of Marian. And what emerges is a very angry and brutal story of a woman whose two daughters die one day. The story of the deaths is left open; it is implied that the younger daughter kills the older one, and then the mother kills the younger one, probably accidentally, not careful enough in her grief, precipitating a fatal accident. At the same time, Serena is living through difficult times as her sister Tash colonises their mother's house. The mother, never close to Serena, focuses all of her attention on Tash. Serena remembers her saying, after watching a documentary about mothers who have murdered their children, that she believed there was no mother who had not fantasised about killing her children. When Serena writes her story of murderous anger, she has a sense of emerging strength and power within herself. As Marian's life fills the pages of the journal, Serena feels stronger. This empowerment may be referred to as a kind of healing, but not the kind that sweeps feelings under carpets: rather the kind that is about *living with* hard scenarios.

Practice and Knowledge

As I wrote, I learned my own lessons. In my enquiry, I found the autobiographical traces affecting me. I wrote Marian and her island. I wrote Serena and gave her my own fascination with islands and I began to confront my own past loneliness and its association with those islands. I started to recognise that I had angry feelings towards my own mother, feelings that needed reconciling. As time went on, I softened in regards to some of those feelings. I wrote, and through writing I felt change occurring; I found that Serena realised the brutality of what she had written; the cruel story that Marian had ended up with. I was caught up in this work. I wrote as I learned and I learned as I wrote. But it was also in the gaps in my novel that I learned much through writing. This is where ideas about redemption and reconciliation in the act of writing become murkier, but also more exciting and challenging. The mother-daughter issues involved in the writing of my novel can be spoken of in terms of reconciliation, even if only within myself and the character, Serena. However, as I have discussed above, my character and I were not seeking neat closure, there was

nevertheless a strong sense of reconciliation evident by the end of the novel. But in other parts of my work, when even darker places were visited, any attempt at emotional reconciliation would be more difficult and elusive.

Among several ghostly presences in *Water's Edge*, there is Serena's father. The first the reader learns of him is on page fifteen, as Serena remembers the portrait of her ancestor Marian:

> Marian's eyes are dark and wet even in the sepia tones beneath the thick curved glass. Serena's father also had dark eyes, and some people say that she looks like her father, their gazes distant as they try to remember his face. Since his death, nobody in the house has had dark eyes other than Serena. Now, here are the dark holes of Marian's irises. With Serena's father's eyes in mind, drowned eyes, seals' eyes, she thinks of Marian as a sea creature immersed in a deep oval of water. (Perry 2001: 15)

Next, on page twenty-eight, the reader comes across Serena's father again, in a flashback written from Serena's mother, Pam's point of view. Pam has just learned that she is pregnant with her second child and wishes she could tell her husband, who is away on a scuba diving assignment. But soon afterwards policemen come to her door to inform her that her husband is missing, presumed dead, only his diver's watch recovered. At the time of this event, Serena is four. A little later, Serena has a reverie of her father:

> The loss of her father was obscured as though by eddies and whirlpools. She knew only that he had been lost at sea in tropical waters. Sometimes she imagined his flesh bloomed into coral branches even though people said bodies only lasted a day or so in the sea. She had no memory of the day he died. If she concentrated she could call to mind a small number of fragments about him: his arms warming her, her name spoken in his voice, a strong forefinger pointing to a room encircled by a pale ring. She sensed him as a missing part, a part taken before she knew it properly, a tail or a wing, a fleshy piece she could barely remember but wished she could have kept. (Perry 2001: 56)

Serena's father appears to be a minor part of *Water's Edge*. It is evident that she misses him even though she has few tangible memories of him, and that she likes to think about him, perhaps to fantasise that he would be close to her, that she could identify with him, as she identified with the image of Marian in the portrait, particularly when she does not feel close to her mother.

Here, my writing experience separates from the character of Serena and her fictionalised writing experiences. The drowned father is my ghost, much more than he is Serena's. I could not keep this missing father out of *Water's Edge*. I focused strongly on relationships between mother and daughters, and found that through the act of writing I could enact change. I could control a story. I could control characters. Like Serena with her mother, I felt somewhat powerless in the face of my mother, and

with that in mind, I tried to exercise control and power through writing *Water's Edge*. But writing is more powerful even than that.

The missing-presumably-drowned father interests me in my consideration of the power of writing and how it appeared to write back to me, not allowing too easy an experience. I had not planned to put a father, and certainly not a drowned father, into the scheme of the novel, but there he was. And while the writing of *Water's Edge* progressed, I was also writing a paper that would become a chapter in my exegesis.

I had been reading *Camera Lucida*, by Roland Barthes (1993), and I wrote the following in response to my reading:

> My reading of *Camera Lucida* is that it addresses far more than photographs. It is a mediation on the death of Barthes' mother and his ensuing grief. That singular expression of a death is what wounds me in this book, as Barthes writes about the certain something in a particular photograph that wounds a particular spectator. (Perry 2001: 96)

Barthes (1993: 63) writes of how he sifted through photographs of his late mother, planning to write a book about her. So *Camera Lucida* is a work with at least a double life. It is a book that emerges from the efforts to write another book, yet in itself it is a book about Barthes' mother.

As Barthes reads references on Photography, he is frustrated that they fail to include the photographs he loves (Barthes 1993: 7). This sense of the singular and the personal is picked up again and again throughout the work and culminates in a statement about how he grieves not for a generic figure of the mother, but for his own mother (Barthes 1993: 75). For me, Barthes' thoughts on grief bring to mind a tragedy in my own family. When I was twenty-three, my father and one of my brothers drowned. I was very close to both of them; so close, perhaps, that I tended to grieve for them separately, with a strong focus on one at a time. Following the tragedy, I tried to read self-help books about grief, but I discarded them all, unfinished. I had no desire to read of the psychological stages of grief or even about the grieving experiences of other individuals. The book that I sought was about a butcher and his son who drowned in an irrigation channel.

Barthes discusses what he calls the "studium" and the "punctum" of photographs. The studium is that in a photograph which is enjoyable in a generic sense: the cultural or historical points of interest in a photograph, for example (Barthes 1993: 26). Of the punctum, Barthes writes: 'A photograph's punctum is that accident which pricks me' and 'bruises' (Barthes 1993: 27), is poignant to me.

Although *Camera Lucida* itself is not a photograph, I find what I will call a studium and a punctum in its pages: the studium relates to its large themes of Photography/photography and grief; the punctum is for me the moment when I am pricked and bruised by Barthes' singular sense of his grief; the way that suddenly my experience of this book transforms and I appear to be reading a book about my own, singular sense of grief. Suddenly I am reading the book that I had been *searching* for, the book about my father the butcher and his son.

Writing as Searching

"Searching" is a term used in grief discourses for a bereaved person's experience of appearing to see the deceased person everywhere that the bereaved goes, especially in the earliest stages of grief. The bereaved may catch sight of an actual person who has similar gait or hair colour or height to the deceased. The bereaved then seems to transform the person into an image of the deceased and may do a double-take before realising their mistake. In some cases, there may not even be any resemblance to the deceased.

Since the time in 1993 when I experienced my own family tragedy, I have found myself writing on one topic and when this topic is submerged in any piece, I know that I still write around its edges. The deaths of my father and brother have engulfed my writing.

In *Water's Edge* I wrote of a disappeared father. I also wrote extensively of water, especially blue water, and its healing effects on Serena and also on the character of Marian, another water-lover. The father's character is placed peacefully in 'bright water' (Perry 2001: 28), before he disappears in that same water. In real life, my own father drowned in inland water, a dull brown irrigation channel. And his body was recovered a few hours after he disappeared under that water. His brother identified the body; he even described to me the peaceful expression on my father's face.

I have a recurring fantasy that has become part of my consciousness since losing my father. Just as the grief books predicted in their describing of the *searching* activity, I see my father everywhere. I also *expect* to meet him one day, or at least that is how it is in this recurring fantasy. The fantasy varies, but it is usually some variation on the story that somehow he did not die that day; perhaps he emerged from the water, realised that his son was gone, and took himself away, disappeared himself, out of grief. Once he told me that if anything ever happened to one of his children, he would not be able to go on living. I carry that thought, although I know that his brother saw him dead, even if I did not. But that's the thing: I did not see him with my own eyes. And so, on streets, on trains, everywhere: I continue to see my father. In the early times of grief, those searching experiences were very painful, like re-opening a wound. Now, this fantasy that plays out that I will meet Dad on a street one day is comforting: it reminds me that I carry my father with me, that death is not necessarily the end, in fact not possibly the end, of a relationship with a significant other.

In the act of writing, I think that I carry out a process of searching. I search for either my father or my brother or both as I write. I also search for other significant people and events and feelings in my life. I write one surface of a narrative, and at the same time I recognise another surface, another face, in the narrative's forms, the narrative's body. The strangeness here, is that as I wrote *Water's Edge*, I could feel other layers to the book. I found myself looking for evidence of what else seemed to be being written as I wrote this one surface of the novel.

I learned that my fiction was driven by a strong autobiographical impulse, and that even when I wrote fiction, perhaps especially when I wrote fiction, I was writing as truthfully as I possibly could. What made what I was writing *fiction*? The characters' names were made up; no one character was exactly as I perceived any one person. Few

of the actual events in the story had occurred outside the pages of writing before me. Or had they? I wrote those events: they happened as I wrote them. These characters became real, and they were capable of effecting real-life change. In the first instance, they could change me. The physical act of writing changed me; it changed some of my perceptions about my own relationship with my mother, made me think about the past and about blood genealogy and spiritual genealogy. Marian effected change in my life as she effected change in the life of Serena. I started to think a great deal about what this process of writing was teaching me about boundaries between disciplines such as fiction and autobiography: where did the differences lie? Could a novel be called auto-biographical even if the events in the novel could not be said to have physically taken place except in that visceral moment of writing the events? In the process of writing *Water's Edge*, I felt myself being involved with what was happening. I felt that I lived it. I felt, effectively, that I lived at least one, possibly several lifetimes as I wrote *Water's Edge*. And that taught me about writing as a life experience, one that is a type of research, a practice that can yield results in addition to or even instead of a finished novel.

My studio enquiry and subsequent findings have led me to read life-writing dis-courses and I find some of my experiences reflected there. For Shoshana Felman, a life testimony 'is not simply a testimony to a private life, but a point of conflation between text and life, a textual testimony which can punctuate like an actual life' (Fel-man quoted in Henke 2000: *xii*). I read about the psychoanalytical practice of *scrip-totherapy*: 'the process of writing out and writing through traumatic experience in the mode of therapeutic reenactment' (Henke 2000: *xii*). But this concept of *writing out and writing through* troubles me in the same way that the apparent neatness of the term *healing* bothered me. I am not convinced that there is always an *out* or a *through* to be reached.

In contemporary theories of grief, I find something more akin to what I have learned through writing *Water's Edge*. In *Continuing Bonds: New Understandings of Grief* (Klass et al 1996), the authors discuss research findings suggesting that the concept of "getting over" bereavement is outdated and that it is more accurate to think of the bereaved as having continuing, interactive relationships with the deceased. In the book's conclusion, Phyllis R. Silverman and Steven L. Nickman summarise the col-laborative work in *Continuing Bonds* by stating that:

> Survivors hold the deceased in loving memory for long periods, often forever, and that maintaining an inner representation of the deceased is normal rather than abnormal. It also is more central to survivors' experience than commonly has been recognized. We suggest that these relationships can be described as interactive, even though the other person is physically absent. (Silverman and Steven in Klass et al 1996: 349)

Silverman and Nickman continue: 'The term paradox seems to be the best way to describe what we are dealing with: *an irreconcilable tension*' (Klass et al 1996: 351). They observe further: 'The deceased are both present and not present at the same time. It is possible to be bereft and not bereft simultaneously, to have a sense of continuity

and yet to know that nothing will ever be the same' (Klass et al 1996: 351). In these concepts, I recognise some of the issues that I grappled with in my studio enquiry. I had a sense of reconciliation, but it was uneasy, particularly relating to my own issues of grief. I see that there is a continuing relationship with the past, as one continues to create relationships with the dead and yet not dead. One quite literal way of doing this is through writing, but perhaps this work about the paradox of the dead and yet not dead has more implications for writing and workshopping practices on a personal and community level.

The Act of Writing as Revealing

As a writer, the words *irreconcilable tension* interest me greatly, but they also suggest possibilities for research and practice in the area of community writing programs. Such programs may often be about reconciliation or redemption within a community. But sometimes community writing may be about expression, or perhaps about a process of catharsis, a recognition that sometimes the act of writing, itself, can be empowering for individuals and communities, whether or not that writing leads to a product of commercial or artistic merit. Thus, a type of reconciliation is *reconciling the idea that some matters may never be reconcilable*. On a personal level, no amount of writing can bring my father or brother back to life, but in writing, I find myself able to feel strong about this fact and to find other ways to have ongoing relationships with them. In addition to this idea of *irreconcilable tension* being palpable within certain acts of writing, I would like to consider the role of *imaginative work* in writing by individuals or communities.

Notably, in *Water's Edge* it is not only the writing, but particularly the *fictionalising* of Marian's life that gives Serena her power, her drive to move on with her life and her relationships. In my own writing of *Water's Edge* it was through fiction that I noticed the significant gaps in my work, that I started to understand the power in myself that could be found through the act of writing.

Novelist and essayist, Andrea Goldsmith has recently written about the power of imaginative writing in redemption; her work specifically relates to the Holocaust. Goldsmith writes: 'Language used creatively can be dauntingly powerful. It can bolster dictators and move entire nations. It can also produce mind-altering fiction and poetry' (Goldsmith 2002: 36). She adds, 'fiction can open new corridors to understanding. Fiction dramatises and provides multiple perspectives' (Goldsmith 2002: 36). For Goldsmith, 'an imagination that knows its freedom—in either the writer or the reader—can go anywhere' (Goldsmith 2002: 36).

Goldmith's point is about imaginative power and its enormous potential in healing. Furthermore, she writes that fiction can 'open new corridors to understanding. Fiction dramatises and provides multiple perspectives' (Goldsmith 2002: 36). Arguing with writer Cynthia Ozick's insistence on keeping facts intact in relation to the Holocaust, Goldsmith writes:

> Cynthia Ozick believes that art should not tamper with the known facts of the Holocaust. But what about the unknown issues? We are still grappling to understand this mind-stretching event, and of all the human tools we have, it is the

unfettered imagination that is most likely to yield surprises. History documents while art reveals. (Goldsmith 2002: 36)

I am taking some elements of Goldsmith's work and using it along with the knowledge I gained through my studio enquiry and applying that to a community workshop scenario. I agree with Goldsmith about the extraordinary redemptive (and further, reconciliatory) power of imaginative work. However, I do move away from Goldsmith when she attributes this work exclusively to fictive genres such as prose fiction, scriptwriting and poetry, as I think that contemporary developments in memoir and related modes of creative non-fiction are very imaginative and that such genres are elastic in their boundaries and styles and forms. There is much material about the creativity involved in the construction of memory, to the point where it is almost a cliché and recent narratives show that there are few boundaries in imagining what a memoir can be.

I note that Goldsmith writes of her concern about a too-heavy reliance on survivors' memoirs in literary exploration of the Holocaust. One concern involves the skills of the survivors writing memoirs. Goldsmith points out, as one example: 'Extreme passion is easily reduced to sentiment. The artistic skills that can match the human capacity for experience are rare indeed' (Goldsmith 2002: 35). I want to respond to this in several ways, to consider the suggestion in relation to community writing projects. There is the possibility of writing workshops taking place in response to trauma, or for other reasons such as bringing together a particular interest group (such as women wishing to write about motherhood, or an isolated or rapidly changing community wishing to tell their stories), with a multidisciplinary approach taken, and some emphasis on the power of the imagination being significant in healing, redemption, reconciliation. Such groups could be taught skills in this area, and take part in focused writing exercises and workshops relating to the notion of using the imagination. An outcome of such projects would not necessarily be publishable manuscripts of the type to be expected from a professional writer. The point would be in the act of writing, and sharing, and expression. Through work-shopping and with guidance from professionals, it may be possible to achieve two things: a reconciliatory or empowering process through writing itself, and a product that is useful, firstly as a site of shared material, and secondly as an outcome having artistic and commercial worth. Another possibility could involve professional writers entering a particular community or group, and through a process of facilitating storytelling and perhaps writing, the professional could acts as a kind of interpreter, transcribing stories through a consultative process.

From the act of writing, I learned first hand about the power of writing to effect change on the writer's self and on the wider community. I found that the act of writing, the physical work of writing, and the resistance it seemed to give back, like pressing hard on flesh, even entering flesh, scarring and cutting it, could be seen as a healing process. Healing can occur through the simple act of writing something out of oneself and burying it through practice, rather in living with events and attempting to effect change in situations or attitudes that occur outside or beyond creative practice.

4

CUTTING CHOREOGRAPHY: BACK AND FORTH BETWEEN 12 STAGES AND 27 SECONDS
Dianne Reid

In choreographing for video, I am exploring mechanisms by which I can translate the kinaesthetic intimacy of dance and the body to the screen—to make my sweat bead on the surface of the screen. In doing so, I am drawing attention to the individual experience, the emotional and psychological landscape "living" in the physical landscape. The translation of these aesthetic and thematic concerns to the screen context has directed my Masters research toward the technical and communicative processes of collaboration in a filmmaking context, to the role of choreographer as editor, and to montage as the site for the realisation of the choreographic vision.

In my journal notes, I asked the question: *How do I make my sweat bead on the surface of the TV screen? My* primary concern in this research revolves around the sentiment of the afore-mentioned personal reflection. I am concerned with the translation of the kinaesthetic intimacy of dance and the body to the screen. In this chapter, I will consider the three dance video artworks—*The 12 stages of adventure, Back & Forth,* and *27 seconds*[1]—which are the primary sources driving and informing this research. As an artistic researcher, it is through my practice that I am able to make tangible the theoretical by making connections between the actual and the virtual, the objective and the subjective, the technical and the creative, the body and the mind.

The title, *Cutting Choreography—Back and Forth between 12 Stages and 27 Seconds,* aims to preface that this work deals with the "hands-on" nature of this project, with particular concern for the relationship between the editing process and the choreographic process. The *12 stages of adventure* provide the meta-narrative of my personal journey from choreographer to dance video artist. Twelve sub-headings, drawn from the structure and thematic content of this first dance video articulate the predominant issues arising from my research. These simultaneous narratives are designed to reflect the non-linear nature of my "learning"—a concept which not only refers specifically to the creative potential of editing, of cutting choreography, but also to the interplay between past and present and of the "unlearning" of my role and processes as choreographer.

The "adventure" cycle could be regarded as a metaphor for human development from birth to death; the ultimate rite of passage. The pattern could be likened to models used in some spiritual or self-developmental contexts[2] where an identifica-

tion of steps along the stages of an experience can assist in managing an experience, in learning and personal development. While I use these 12 stages to chart my technical development chronologically from the first to the third artwork, I will also use them as a framework to connect issues or creative themes "back and forth" across the research journey.

1. The Place Where You Are - Something Is Missing
Maya Deren's biographical statement, 1954 reads:

> It was like finally finding the glove that fits ... In motion pictures, I no longer had to translate. Fortunately, this is the way my mind works, and I could move directly from my imagination onto film. (Deren cited in Clark et al 1984: 57)

As an artist my practice of making art has been as much about finding the right form through which to express myself, as it has been about the personal statements I have made in my artworks. The search for the ultimate vehicle has been a process of accumulation rather than elimination. I have drawn on a range of art forms, positioned myself in a range of perspectives from which to view and comment on the individual physical and emotional condition. At this stage of my professional life I have moved beyond the average career span for a dancer and am finding the traditional dance models (with a focus on the young or emerging artist, the company structure, and the theatrical context) no longer offer me the right vehicle for speaking about and utilising my experiences as a mature artist. Nor does the small specialist dance audience provide the challenge or feedback I'm looking for. I have also found that my aesthetic attraction to the filmed image has continued to grow, encouraging me to extend my skills in cinematic production and to focus my art making in this area. Fellow dance filmmaker Tracie Mitchell connects our mutual interest in the dance film form and its relationship to our career development as dance artists stating:

> We're venturing into new territory now because we've lived half of our lives, and we're preparing for a new part of our lives, and that's what we're bringing to our work ... that's the weight of our questions now. (Mitchell cited in Reid 2001: 3)

Following Bazin's observation that 'a new subject matter demands new form' (Bazin 1950-55: 160), I have moved into an exploration of the form of dance film as a means to deal with the contemporary condition of the body and dance in the face of the telecommunications revolution. Dance, as an art form needs to address questions relating to its longevity, vocabulary, and accessibility to global audiences. The active population of the dance community now also extends to include mature performers with many dancers continuing their craft beyond the parameters of the youthful body, and in doing so addressing the changing nature of their physical bodies.[3] The dance of the mature body must resolve the (so-called) physical limits of ageing—reduced mobility and stamina, changes to skin texture and pigmentation—with the

expressive range and depth issuing from more years of experience. The challenge for the mature dance artist is public as well as personal. As Van Itallie notes, coming to terms with our own aging does not automatically alter public opinion: 'Our society denies death to the point of inconceivability, and views aging with the same shame as defecation' (Van Itallie 1994: 35). Yvonne Rainer also sees the issue of the body as an object of desire as a contributing factor to the invisibility or dismissal of the mature dancer. She suggests that we no longer find the aging body desirable because it reminds us of death (Rainer 1994).

The mature dancer could be seen to provide a metaphor for the dance film form itself. Both have the rich communicative potential that comes from the bringing together of a range of experiences or creative processes. For the mature dancer this richness comes from their extended performance history of communicating with audiences, collaborators and with their own body over time. For the dance film, the richness and diversity of two art forms coming together offers a multi-lingual statement. Dance film also has the capacity to provide a space for the mature dance voice, as it can access the detail of action and subtlety of expression of the solo dancer. The large scale of the stage (larger, whole body actions and larger numbers of dancers to fill the broader general space) to an extent denies the individual dancer because proportionally an "audible" dance statement requires an amplification or exaggeration of the body. This exaggeration threatens to caricature and consequently objectify the dancer. On screen this dominant reading of dance can be challenged, as new models of "dancer" and "dance" are made visible. The statement of power, for example, that demands a virtuosic leap or lift on the stage can be conveyed on screen with the direct point of a finger. I would argue that the finger point actually communicates greater power, as it requires less physical effort to execute it. Dance film has the potential to change the vocabulary and identity of dance, since as Rosenberg notes, 'Dance for the camera has mirrored the upheaval in the culture and ... served as a site for the discussion of...the very nature of dance itself' (Rosenberg 2000: 276).

2. The Call

> What we are pursuing at the deepest level when we respond to the Call is a
> sense of our own completion. (Moody and Carroll 1998: 109)

I am "called" to filmmaking because of the intimacy available in the form, because of its potential to connect the visual and the aural, and to connect the audience with the individual character. Films offer the performing artist longevity by capturing and preserving the intangible. It could be argued that this desire to preserve the moment and to capture and extend my life as a dance artist is related to that universal question of mortality. However, all theological discussions aside, I have recognized a synergy between the aesthetic of film and my personal aesthetic which falls into three main areas. These are the temporal (a strong relationship to rhythm, sound, and musicality); the personal (a concern with the individual's story, connecting the

physical with the emotional or interior landscape); and the collaborative (between art forms and practitioners).

The Temporal

I choreograph in a temporal sense. My movement phrases are predominantly driven by the dynamics of rhythmic structures, and I form a creative work using patterns and arrangements that most often reflect harmonic and rhythmic structures:

> I think most of my movement is driven by a sense of rhythm and timing. It is how I build all of my movements, a play on acceleration, deceleration, syncopation, and that is how I get my dynamic, from the shifts in timing…and because this piece (27 seconds) is about that, it looks at the way time distorts that, reflects those dynamics which reflect emotion. (Reid cited in Norris 2000: 11)

Choreographically, I choose to set up material that can offer multiple entry and exit points and allow shifts in instrumentation either from body to body or across one body. I try to shift the identity of the material in a way that can allude to many voices through the dance of one multi-faceted individual.

In *The 12 stages of adventure*, for example, the "grab, search, discard, measure, sob, ricochet, wait" phrase [4] contained movements which shifted mood and dynamic as they traversed the instructions inferred by the words/text. Each word contains dynamic qualities of weight, pathway and time comparable to Laban's categories of movement qualities, but with added inferences of emotion or relationship (Bartenieff et al 1970). The "grab" is sudden and pulls into the body and hints at a reflex or quick decision. "Search" is sustained, with the action travelling out in concert with the body, implying someone/thing is missing. "Discard", like Laban's "thrust" is a direct, strong, sudden movement with the added implication of a severed relationship. "Measure" is the length of the journey between two points. "Sob" has the wring[5] of the internal meeting the external: a percussive rhythm and a heavy, downward pathway of travel. "Ricochet" snaps the speed, force, and direction of movement outward and horizontally in a three-point echo from the body. "Wait" settles the focus back to the individual, to stillness and contemplation. The phrase itself is multi-faceted and, in its diverse shifts of mood, when applied to one individual, represents a longer period of time: a lifetime journey. With six versions (each dancer created their own version) of this phrase and six bodies performing in several locations, I had set up numerous permutations of the one formula.

This research, which marks my entry into the role of editor, has revealed my choreographic form and a new role in which to perform. Devices such as repetition and retrograde, manipulations of speed, and juxtapositions of text and image are now available to me in the editing suite and, rather than having to demand extreme virtuosity of my performers, I can perform these manipulations directly and with an enormous range of specificity. I can have a direct link to my audience and, in a sense, can elicit specific responses via my performance in the editing suite. With repetition

of image design or movement motifs, I aim to build a history, a familiarity between performer and audience. With changes in speed I can affect the audience on a physical level (the viewer/listener's heart rate will adjust to match the pulse of the movement/sound) effecting a kinaesthetic response and inflecting the movement content emotionally. The use of slow motion can encourage a slowed heart rate and a relaxed state and receptivity in the viewer. This is further magnified as it reveals the actual structure of movements or changes which either cannot be slowed down in actuality or whose nature would be changed by a change in tempo of performance. Rendering visible the hitherto unseen can solicit intimacy between the viewer and the subject (Deren 1960: 62). I seek out multiple connections in movement in order to connect with the variety of individuals that make up an audience.

The Personal

> ...Memory is embedded in our very act of seeing and movement seems to be a particularly potent force in unlocking memory's vivid detail. (Steinman 1986: 71)

All three of my dance works incorporate personal material from the performers involved, with *Back and Forth* dealing directly with the idea of revealing the self through the body, showing the vulnerabilities, detail and intimate space of the individual body, physically and psychologically. In sourcing my dancers' stories, I am informing my creative process as much as I am building content. My interest in their stories is my interest in and value of them as individuals. The content of the stories becomes a means to establish a relationship that can in turn create and communicate a shared story. In revealing the personal dancer, I am revealing the "personal" in the exchange between myself and my dancers, revealing myself by revealing what I value. Viviana Sacchero elaborates the benefits of such exchanges:

> We began with personal stories, which developed into phrases, which we combined with other phrases ... this allowed me to have an association with the original source, as well as with the evolution of the movement throughout the developmental process. I also found it helpful having various ways with which to engage with the material. I remember the movement as being highly textural. So, as well as executing the "steps", I had feelings, emotions, stories, contact with other dancers, text, and memories with which to engage. (Sacchero cited in Reid 2001: 1)

In most cases, the stories sourced in the studio process are a mechanism for accessing subtlety and integrity of performance, although the images, emotions and memories that then become connected to the movement do colour that movement with a perceptible sub-text. For example, while a viewer of *12 Stages* may not be able to articulate Viviana's childhood memory of following a road in an attempt to reach the sun, the sense of infinite distance and vulnerability is visible in her walking. The

intimacy of film, and its familiarity as a storytelling vehicle, allows me to explore this level of detail and subtlety in performance and to suggest personal narratives that may not be accessible for a stage audience.

The Collaborative

My artistic practice is enriched by, and inseparable from my collaboration with others. It is the social and communicative exchange of working with others, which stimulates my creative process. The culture of dance practice deals with the concept of community on a daily basis. The dance class is an interactive site where individuals must negotiate the same space and time together. Even the solo dancer must find collaboration between body parts, between body and mind, between their present performance and the history of their body's movement. This microcosm of collaboration extends out in layers in performance projects as it does in film projects, extending from performer to performer, performer with choreographer, artistic personnel to technical personnel, distributors, critics and audience. Intrinsic to every layer is communication—listening, contributing and working with a larger group's creative energy. The film project offers me the same potential to explore connections with different individuals, to find the dynamic and communicative mechanisms of that group which, like the choreographic process, is essentially a creative process. The film itself, the distillation of the entire creative process of filmmaking, becomes, for me, like my own body dancing—a single action or statement that is the "elixir" of my entire lived and danced, history. Dance film also facilitates a collaboration of art forms, a meeting of styles and narratives, which extends my choreographic vocabulary.

3. The Response to "The Call"

The 12 Stages of Adventure, the first of my Masters artworks, represents the accumulative stage of this artistic research. To examine and facilitate my choreographic shift from the stage to the screen, I began with familiar terrain of developing material with dancers in a rehearsal studio, and devoted a considerable amount of time[6] to examining my choreographic processes, my "belongings." In this way, *The 12 Stages* could be seen to represent the pre-production period for all three works.

The adventure film genre suggests both a structural and psychological framework. It suggests a universal pattern of physical behaviour and emotional response, a common series of goals or landmarks charted by different individual routes. My choice of this thematic starting point meant that I had to unpack my choreographic material to define the common temporal arrival points (a plane through space, a part of the body, a degree of effort) while building a diversity, a layering of potential alternate routes to those points. My use of six dancers provided this diversity. By directing the journey of the choreographed movement through different bodies, I could already alter the route of the pathway without altering the material itself. It was possible to build layers of material from one phrase or from one set of instructions. However, the integrity of the overall journey on screen demands more attention to the individual dancer. The particularities of screen space—the narrow foreground, the

impact of the single body in frame, the intimacy of close-up, and the dance of the moving camera—expose the detail of each dancer's physical articulation and expressive performance. To shift my work into screen space, I needed to explore processes for developing an intimacy between the performer, the material, and the camera.

By working extensively with a video camera in rehearsal, I was able to explore the relationship between the movement material and the screen space and let this "eye" inform the direction of the choreography. At the same time, I was able to personalize the camera, setting up a familiarity between it and the dancers. The dancers and the camera shared the history of the movement, a body memory of how it felt to create the movement, and to be seen performing the movement from a range of perspectives.

To reveal the personal for the viewer, I explored mechanisms for creating an intimacy between the performers and the movement material. In the early rehearsals of *The 12 Stages*, I set up particular improvisational structures and movement invention scores that gave them ownership of the material. One series of choreographic tasks, incorporating techniques drawn from my experiences of working with Lisa Nelson,[7] concentrated on kinaesthetic memory. In one case I asked dancers to traverse a difficult pathway (a stairwell) with their eyes closed, constructing it incrementally by rewinding the material in small sections before progressing. By eliminating sight, and by using an accumulative process to build the pathway, the emphasis was placed on the dancers' kinaesthetic responses and recall. The sense of touch became primary, with the dancers having to "see" through touch, and drawing an attention to their relationship to that intimate space. Recalling movement that was unseen and that had only been experienced through touch, gave the dancers' movement a particular quality—one quite similar in quality to the recollection of a distant memory or dream.

In my choreographic process, I often incorporate text as a tool for generating material with the dancers. Some of this text becomes incorporated in performance (either spoken by the dancers or incorporated in the soundtrack), but the majority of it functions as a device for finding particular rhythms and qualities in the movement and to provide imagery and a shared history for the performers. In each of my artworks each dancer has brought in a personal story of their own.

For *12 stages* there were six stories (including my own) relating a past event that had been an "adventure". *Back and Forth* used a selection of personal stories that recounted the events surrounding scars or trauma points on my body. *27 seconds* sourced nineteen accounts of events in which time distorted, where it seemed to slow down or speed up. I included these unscripted personal accounts to imbue my work with a sense of reality, to give it some documentary "truth" in that it contains recollections of actual events in the participants' own words:

> Because most of the movement material was sourced from our own stories and experiences, it was easier to re-access the "intention" of particular moments by recalling the original story/memory. (Sacchero cited in Reid 2001: 1)

4. Meeting with the Mentor

I find that I meet with my mentor (that is, I learn significant things about myself and about what I am trying to achieve) through my creative communication with others. In a choreographic context, I am interested in facilitating a creative exchange with my dancers, one which enriches my choreographic process and which can support each dancer's performance narrative.[8] In a live performance context, my artistic vision is communicated with an audience fairly directly through my dancers, albeit with their particular inflections on the choreographic language. In this dance film context there is a third party involved in mediating the artistic vision—the camera. In this research, my "need" has been to facilitate a creative and performative communication between my dancers, the camera operator, the movement material, and myself. The choreography of the camera becomes a facilitation of an interpersonal exchange.

In "choreographing" the camera, I am concerned with establishing a shared terrain between camera (viewer) and dancer, an intimate relationship in which the emotional and psychological impact of the kinaesthetic experience is revealed. This means that the camera must not only participate in the movement spatially, rhythmically, dynamically, but it must understand the nature of its interpersonal relationship with the dancer. Essentially, I am trying to imbue the camera with an identity, one which is known to the dancer and which they are prepared to trust with their personal disclosure, with their 'imperfections and frailties' (Herbertson cited in Dyson 1994: 77). Michelle Mahrer is in accord:

> For me the camera is about getting the performers so used to it, so as to create a very relaxed situation otherwise … there won't be truth in the performer. (Mahrer cited in Reid 2001: 3)

There needs to be a "play" between preparation and spontaneity from both dancer and camera operator. The accidents that happen, that is the unplanned or unexpected moments which vanish with the rehearsal or the live performance, can be captured on film. The tangibility of the filmed moment makes the shoot a creative goldmine, combining the experimentation of the rehearsal room with the immediacy of performance. What is required from camera operator and dancer is a trust and confidence in themselves and each other to, 'stay with a moment, and meet the needs of a changing moment. Then, awkward, uncomfortable moments of vulnerability and powerful moments of virtuosity become equally rich' (Warshaw 1982). The camera and the dancer, like contact improvisers, must survive a dance moment.[9]

> I think an improvisational skill is certainly required, because only so much can be captured, I think, through pre-planned ideas … the magic actually happens through mistakes and surprises. (McGrath cited in Reid 2001: 2)

To layer the variables in the relationship between the dancers and the movement material of *The 12 Stages,* I built shared variations of personal text and gesture, and of tactile, visual, and emotional memory. To set up similar variables between the camera

and the dancer I had to relinquish control over the interaction, and allow the camera and the dancer to make new choices in relation to one another, to react to changes rather than to enact a prescribed event. In some cases, when operating the camera myself, this meant disengaging my eye from the viewfinder and shifting its eye to other parts of my body—embodying the view of the event. In other cases, my body serviced the pathway of my vision, moving in and out of the floor, finding physical solutions to maintaining the smooth point fix between dancer and lens/eye.

The use of camera in rehearsal encourages the dancers to consider alternate and multiple views of their actions. They are, in a sense, made more vulnerable because they must consider the practical issues (will I kick the camera?) and aesthetic issues (the camera is focussed on my back but the action is in my leg). In the same way that improvisational tasks set up multiple variables in order to disorientate or upset control—and in doing so, access a level of spontaneity—the camera can serve to stimulate a heightened, almost three-dimensional attention in the performer:

> When you're performing for a live audience sometimes you choose to alter your gaze or change your point of focus … with your piece there were always different angles which the camera was viewing us from so you always had to be really mentally tuned into that. (McGrath cited in Reid 2001: 1)

5. Crossing a Threshold into a New World
The 12 stages of adventure was my first solo editing experience. This was the stage of the process where I learnt the most about all other aspects of working in video—in how I could improve the pre-production, the efficiency of the shoots, the quality of the sound score. Between editing *12 Stages* and editing *Back & Forth,* I volunteered to shoot and edit other people's work as much as possible as a means to hone those skills and to become as familiar and confident with that equipment and technology as I was with choreographing the body.

The movement is the continuous, unifying element for *The 12 Stages.* I was cutting choreography—re-defining screen narrative through a kinaesthetic script and re-defining the spatial and temporal constructions of my choreography through the cinematic tools of montage. I specifically used connections in colour and texture—white backgrounds in long shots (open iris for washed out background on exterior shots, and white cyclorama interiors) and the reds and purples of the dancers' costumes in closer shots—to assist the connections between places and persons.

My choices to use fast jump cuts or dissolves between shots were designed to support the rhythm of the overall narrative. The "supreme ordeal" section that is the climax of the work employs many fast cuts between bodies, which accelerate until they reach Natalie's slow fall to death. The speed of the cuts heightens the impact and urgency of the scene without altering the original dynamic and speed of the movement. The use of slow motion and dissolve for Natalie's fall further accelerates the previous shots while signalling both a denouement and suggesting a loss of control as a result of the preceding disorienting montage. In earlier sections, the longer dis-

solve serves to transport the viewer from one reality (in space and time) to another with an eased pace that might suggest the sensation of dream or memory. The dissolve between Hayden's hands and Natalie's finger-measure "pours" the viewer not only across place and person, but also across plane or dimension. Hayden's hands move toward us and frame Natalie's fingers which also trace a sagittal pathway from background to foreground, leading the movement toward the viewer and connecting the actions as measurements of time and of space from subject to viewer. This three-dimensionality is heightened by the juxtaposition of his frontal facing and her side facing. At the same time, the dissolve shifts our eye from Hayden/character to Natalie/movement, from centre to left of screen and back to centre, facilitating a sense of a change of time (present to past). The temporal ambiguity of the work is prefaced and then reiterated in the opening and closing journey up Viviana's body, the ascension inter-cut with other bodies. The repetition of this editing sequence is used to signal a continuity that extends beyond this twelve-minute event, an open-ended cycle that is, in its potential for repetition, a universal pattern.

6. Tests, Allies, Enemies

Dance, as a non-verbal bodily form, has been marginalised, "other-ed" to the privileged signifying system of language. Daly sees the cultural marginalisation of the nonverbal as deeply ingrained: 'we cannot deny our words, but we can always deny the body language with which we deliver them' (Daly 1992: 247). The subject matter for *The 12 Stages* was form itself. I was trying to contextualize or language dance through a connection to a semiotic structure. Is it that we can only read meaning in a form if we can verbalise it? If we can establish a name for the dance film genre will viewers be more willing to read the content? The dance film has tried on many names, from Deren's "cine-dance" or "choreocinema" to "dance for the camera" or "dance on screen" and, most recently, "motion picture dance". As Nascimento notes, 'this hybrid form is still looking for a room—or an identity—of its own' (Nascimento 2000: 7).

 Like Daly, I believe that although dance may not operate through normative codes of communication and may not be expressible in words, it is still meaningful ... we can still "understand" it (Daly 1992: 245). There is, as Leslie Satin suggests, a kinaesthesia, in which:

> The spectator completes the dance not only through the experience of intellectual observation, or emotional or psychological identification, but through the somatic, neuromuscular, dialogic response with the performer and the performance. (Satin 1996: 135)

I *do* want the dance film viewer to connect with this kinaesthesia, but I also seem to want the legitimisation of languaged feedback. If I can direct the viewer through the verbal and the languaged, to the kinaesthetic, and if I can merge form and content more directly, can I lead the viewer to a physical utterance? My task for my second dance video became a desire for this convergence—a direct relationship between

form and content, between spectator and performer/author, between the languaged exterior and the felt interior.

7. The Approach

> I want to communicate with people and find common symbols, which you can do by telling stories. (Wright 1999: 32)

The creative development of *Back & Forth* was done in collaboration with composer Mark Lang in 7 sessions (20 hours) over a period of 3 months. My initial concept was to create a microcosmic version of *The 12 Stages* journey, of the interior or emotional journey through a single body. I was paring back (from 12 minutes to five or six minutes) and pulling in to the body (from exterior location and six dancers, to the body as location and two dancers). I wanted to see if less *could* be more.

The autobiographical content and the choice to perform my own artistic subjectivity in this work was a mechanism through which I could balance the relationship between form and content. By inscribing both the form/structure of the work and inscribing the performed narrative/content, I hoped to draw attention to both. I sourced my own landscapes in terms of both physical presence on screen and personal, historical content. I mapped out a "trauma" journey, locating parts of my body from head to foot, which were historically associated with specific accidents or physical trauma, and a performance anecdote[10] that linked my relationship with my body as a performer. I took these ideas to Mark, along with a series of images and ideas that had a personal potency for me. The image of a drop of water travelling down the body provided both an aural concept as well as a visual anchor by which the camera (and viewer) could navigate the otherwise disorienting landscape of the body in close-up.

The approach to *Back & Forth* was to emphasise the editing. All the choreography was determined by the creative collaboration of the soundscape. Not only did it predetermine the picture editing structure temporally but also it provided the spatial and visual parameters for each shot. Temporally, the musical structure works in three main sections—the opening text (which I storyboarded word for word and pre-shoot to enable real lip syncing); the rhythmic variation (suggesting a move in toward the body, to the kinaesthetic dialogue); and the drone with words variation (suggesting a shift that has moved beyond the proximal to the experiential). These sections signalled the visual shifts from the face to face, to the intimate (the introduction of the physical dance vocabulary), to the interior (the lipstick camera close up in which the body as identity is surpassed by the body as experiential landscape). The final return to a coda of the opening text resolves the structure musically and visually and re-establishes equilibrium, coherence and identity.

8. The Supreme Ordeal

Here, watch me struggle with how I'm trying to deal with these issues and maybe you'll learn something from it and grow stronger. (Albright 1997)

Back and Forth is an autobiographical account of how my experiences have marked and been marked by my physical body. I am using dance film to get personal—show my scars, reveal my childhood, and speak directly. I am pointing to my specificity as an individual to avoid generic classification as female or dancer. My dilemma is how to draw attention to my body and dissuade a reading of the body as object:

> Driven by a compulsion to fuse the outer body, which for women in patriarchy is objectified into a "picture" through male desire, with the inner self (the acting cognito-the intellect, the psyche), they enable themselves by enacting the feminist axiom "the personal is political". (Jones 1992: 30)

In order to fuse my outer body with my inner self, I have drawn on autobiographical incidents in which the inner self and the outer body collide, where a point on or movement of my body references and reveals a specific emotional experience or intellectual realisation. The movement content for the central phrase[11] in *Back & Forth* was extrapolated from stories connected to specific scars or points on my body associated with accidents or trauma.

Back and Forth is also a direct reference to movement across frame, or movement of the camera (referring to the movement of the viewer's eye, and the shifting of their attention, to what is more important at *a* particular moment). I wanted to focus the viewer on a deeper understanding of myself, the subject, one that at once recognized my past experience and my journey to where I am in the present, and to understand the connections between the physical and the emotional. By bringing the camera in closer and closer to the body and almost de-personalising myself into a textured landscape of skin over which something other travels, I sought to evoke the kinaesthetic as well as the visual. Here Albright's observations are instructive:

> Although it is grounded in live human bodies … dance carries the contributing possibility of being both very abstract and very literal. Some movements will give an audience only vague physical sensations, while other movement gestures have unmistakable meaning. Thus, dance can at once represent images that cite known cultural icons, as well as present physical states whose meanings are not so much visual as they are kinaesthetic. (Albright 1997: 142)

9. Reward

Freedom is created <u>within</u> the forms I practice to penetrate my boundaries as an experimental dance artist. Freedom <u>rises</u> from the strategies I must invent

form and content, between spectator and performer/author, between the languaged exterior and the felt interior.

7. The Approach

> I want to communicate with people and find common symbols, which you can do by telling stories. (Wright 1999: 32)

The creative development of *Back & Forth* was done in collaboration with composer Mark Lang in 7 sessions (20 hours) over a period of 3 months. My initial concept was to create a microcosmic version of *The 12 Stages* journey, of the interior or emotional journey through a single body. I was paring back (from 12 minutes to five or six minutes) and pulling in to the body (from exterior location and six dancers, to the body as location and two dancers). I wanted to see if less *could* be more.

The autobiographical content and the choice to perform my own artistic subjectivity in this work was a mechanism through which I could balance the relationship between form and content. By inscribing both the form/structure of the work and inscribing the performed narrative/content, I hoped to draw attention to both. I sourced my own landscapes in terms of both physical presence on screen and personal, historical content. I mapped out a "trauma" journey, locating parts of my body from head to foot, which were historically associated with specific accidents or physical trauma, and a performance anecdote[10] that linked my relationship with my body as a performer. I took these ideas to Mark, along with a series of images and ideas that had a personal potency for me. The image of a drop of water travelling down the body provided both an aural concept as well as a visual anchor by which the camera (and viewer) could navigate the otherwise disorienting landscape of the body in close-up.

The approach to *Back & Forth* was to emphasise the editing. All the choreography was determined by the creative collaboration of the soundscape. Not only did it predetermine the picture editing structure temporally but also it provided the spatial and visual parameters for each shot. Temporally, the musical structure works in three main sections—the opening text (which I storyboarded word for word and pre-shoot to enable real lip syncing); the rhythmic variation (suggesting a move in toward the body, to the kinaesthetic dialogue); and the drone with words variation (suggesting a shift that has moved beyond the proximal to the experiential). These sections signalled the visual shifts from the face to face, to the intimate (the introduction of the physical dance vocabulary), to the interior (the lipstick camera close up in which the body as identity is surpassed by the body as experiential landscape). The final return to a coda of the opening text resolves the structure musically and visually and re-establishes equilibrium, coherence and identity.

8. The Supreme Ordeal

Here, watch me struggle with how I'm trying to deal with these issues and maybe you'll learn something from it and grow stronger. (Albright 1997)

Back and Forth is an autobiographical account of how my experiences have marked and been marked by my physical body. I am using dance film to get personal—show my scars, reveal my childhood, and speak directly. I am pointing to my specificity as an individual to avoid generic classification as female or dancer. My dilemma is how to draw attention to my body and dissuade a reading of the body as object:

> Driven by a compulsion to fuse the outer body, which for women in patriarchy is objectified into a "picture" through male desire, with the inner self (the act-ing cognito-the intellect, the psyche), they enable themselves by enacting the feminist axiom "the personal is political". (Jones 1992: 30)

In order to fuse my outer body with my inner self, I have drawn on autobiographi-cal incidents in which the inner self and the outer body collide, where a point on or movement of my body references and reveals a specific emotional experience or intellectual realisation. The movement content for the central phrase[11] in *Back & Forth* was extrapolated from stories connected to specific scars or points on my body associated with accidents or trauma.

Back and Forth is also a direct reference to movement across frame, or movement of the camera (referring to the movement of the viewer's eye, and the shifting of their attention, to what is more important at *a* particular moment). I wanted to fo-cus the viewer on a deeper understanding of myself, the subject, one that at once recognized my past experience and my journey to where I am in the present, and to understand the connections between the physical and the emotional. By bringing the camera in closer and closer to the body and almost de-personalising myself into a textured landscape of skin over which something other travels, I sought to evoke the kinaesthetic as well as the visual. Here Albright's observations are instructive:

> Although it is grounded in live human bodies … dance carries the contributing possibility of being both very abstract and very literal. Some movements will give an audience only vague physical sensations, while other movement ges-tures have unmistakable meaning. Thus, dance can at once represent images that cite known cultural icons, as well as present physical states whose mean-ings are not so much visual as they are kinaesthetic. (Albright 1997: 142)

9. Reward

Freedom is created <u>within</u> the forms I practice to penetrate my boundaries as an experimental dance artist. Freedom <u>rises</u> from the strategies I must invent

to surmount social, physical, professional, financial, and political constraints. (Hay 1994: 27)

My strategies for shooting *Back & Forth* centred on an economic refinement of my pre-production preparations and my resources, including equipment, venue and personnel. Whereas *The 12 Stages* represents the accumulative stage of my creative research, *Back & Forth* involved elimination, an editing and refining of my production processes. Moreover, this paring back was a distillation of my knowledge and experience of both cinematic and choreographic processes into a hybridised approach, where a new interaction and language could be explored between subject and camera.

I approached the shoot as if facilitating an improvised performance, defining the parameters and stabilising the context while encouraging open decision-making and creative interaction—setting up prepared spontaneity. With the edit structure in place, predetermined by the completed soundscape and detailed storyboarding of the first minute, my shot list was specific and manageable. I had also selected an indoor venue that offered a controlled environment.[12] With two camera operators, Paul Huntingford (previous collaborator)[13] and Francis Treacey (University colleague)[14] and multiple cameras we were able to catch more angles of the one movement event, providing excellent matching for editing, while minimising the number of physical "takes" necessary. I chose to work with them because, apart from liberating me from the role of camera operation, both Paul and Francis are dance conversant and familiar with my aesthetic. They also have a good eye for visual design within frame, are experienced cinematographers, and are willing to participate physically:

I'm happy to be jumping on stage or being in the wings, or getting in the roof and shooting down like Busby. I'll do whatever it takes in that respect. (Huntingford cited in Reid 2001: 6)

Fiona, as the only other performer (and only other member of the entire shoot ensemble), also has the match of technical skill and improvisational and interpersonal responsiveness that I see in my camera operators. My preparation with her included a minimal number of rehearsals that divided the emphasis equally between preparing movement material and practising with particular improvisational structures in relation to the camera. I informed the physical movement with visual information from the storyboards, aural information from the completed soundtrack, and reflective feedback through video playback of rehearsals. I also discussed the autobiographical content and my overall artistic vision with her, inviting and empowering her creative contribution.

My instructions for Paul and Francis, their movement phrases, were to both select and follow a specific pathway across the dancer's body, or to let the body enter and exit the moving frame. In essence, their focus was on the juxtaposition between their movement pathway and the dancer's with an attention to both real space and frame space. All four of us had to negotiate our bodies in concert within the stage space

(not move near leads, or kick the camera, and keep the other camera and performer out of shot). We also had to be responsive to shifts in active and passive roles in the duet of frame and body (the dancer reduces their movement to allow the camera to travel across the body, or the camera reduces its movement to allow the dancer to travel across frame):

> The moving frame … can be used not only as a means of viewing action, but under certain conditions, can become the action viewed. (Clark et al 1984: 96)

Using the moving camera in close up, I aimed to deconstruct vision in favour of kinaesthesia. The close-tracking lipstick camera shots of the water droplet traversing the landscape of my skin, follows the journey to maturity, a journey that has involved battles of control. The camera journeys over scars and wrinkles that infer age, trauma, exposure, lived embodied experience, and as Bromberg observes it becomes a *'tool with which the human and corporeal can be magnified and revealed'* (Bromberg 2000: 27). The moving camera at this close range exaggerates the kinetic effect and disorients the viewer. The intimate proximity of the partners (camera and dancer) and the concentration on the skin, our largest sensory organ, again brings me to a comparison with contact improvisation, where, 'the basis is a constant bodily contact through a shared, ever-shifting contact point or surface with a partner' (Kaltenbrunner 1998: 10).

10. The Road Back

The clarity of structure and content I had set up with the soundscape and the shoot made the editing of *Back and Forth* more a creative act than a technical one. Without the preoccupation with form I was freed to explore my editing choices on the basis of meaning. I let my technical skills support and facilitate my creativity in much the same way as my dance technique opens (rather than dictates) my creative range in physical improvisation. I had the support of the musical framework and the quality and specificity of the shots in place, allowing me to do the "colouring in" of the content, of how it reads. In this action my body becomes the fabric, which according to Merleau-Ponty, 'is the fabric into which all objects are woven, and it is, at least in relation to the perceived world, the general instrument of my "comprehension"' (Merleau-Ponty 1962: 235).

My film is intended to display and provoke sensuous experience (as opposed to sensual, pleasure) by entering the intimate space of the body and traversing the skin, the location of touch and sensation. As microscopic viewer, the openings and secretions of the body become significant parts of the macro landscape, the site of heat, moisture, and texture. I am blurring the boundary between the interior and exterior of the body. However, by constantly "pulling away," by cutting in glimpses of whole body or recognisable feature (Fiona's whole body, or eyes, costume features), I am able to reconstruct identity out of the deconstructed body landscape. The drop of water on the magnified skin surface places the viewer at this theoretically blurred

boundary. Largely comprised of water, the body's interior is presented to the viewer as the drop travels over the skin surface. The magnification of my scars, of the hairs, pores, textures of my skin's surface confronts the viewer to recognize the detail of my lived experience which is the sum of inside and outside, of past and present. Here Elizabeth Grosz's observation is useful:

> The body image is always slightly temporally out of step with the current state of the subject's body ... there seems to be a time lag in the perception and registration of real changes in the body image. (Grosz 1994: 84)

By inscribing myself with a temporal identity, with a history, I am also disallowing my objectification by the viewer. With history, I achieve substance rather than surface. By illustrating my aging, I am giving my individual persona a temporal weight, and, at the same time, alluding to the destructiveness of these imposed representations. By dissolving between my eye and Fiona's eye, my face and her face, I link us as two temporal versions of the one self. With the close tracking of my skin's marked surface with a tear and the descent of the movement (as skin gives in to gravity), I am bringing my past body into my present text which is, as Grosz notes, 'almost as if the skin itself served as a notebook, a reminder of what was not allowed to be forgotten' (Grosz 1994: 132).

11. Resurrection—Another Ordeal

In October 2000, after having completed the edit of *Back & Forth,* I set off for Perth in Western Australia to choreograph a stage work for the West Australian Academy of Performing Arts (W.A.A.P.A.). I was returning to live choreography from the dance film context and had discovered new things about my spatial and temporal creative processes. From accumulation and elimination, I had now reached illumination. It seemed, at this time, that this project could offer a reflective analysis of how my choreographic processes had shifted, and could come full circle in considering the general impact of dance film on the form, content and reception of live dance.

I decided to let my questions about form steer the content of the work. To deal with this reconfiguring of space and to employ the creative potential I had discovered in editing, I chose to focus on the idea of time itself, specifically a short period of time, *27 Seconds.* Inspired also by Twyker's film *Run, Lola, Run,* the neo-narrative for *27 Seconds* is about revealing the simultaneous narratives possible within a single event. I wanted to focus on the detail of an event and the ways in which it could appear differently and have different outcomes depending on how you were positioned within it. Extending on the idea of accidents or events that change the course of our lives, I was interested in the emotive landscape of events and the impact of life's collisions—the meeting of time and space—on our actions and reactions.

As the choreographic process of *27 Seconds* unfolded, its resemblance of a live editing process became more explicit for me. My choreographic tasks became exercises in transposing the techniques of post-production technology onto physical bodies. If I use the metaphor directly, regarding the final piece as the edit program, the re-

wind[15] phrase became the master shot into and around which I cut and pasted the other choreographic material. With the potential to be performed forward and backward, I divided the phrase at half a dozen points between which the material could loop or jog,[16] providing potential complex canons between dancers. I could further complicate the sequencing and the consequent relationships between the dancers by inserting other fragments of material[17] at the same jog points. With nineteen dancers in the piece, I had a larger palette or "bin of clips"[18] to work with. To create these clips, I needed to apply the spatial frame of the screen to the stage, creating live mise-en-scene. By using depth of field, that is, positioning dancers in vertical relationship (foreground and background), I was redefining the spatial frame of the stage. I selected to divide the stage into smaller frames, layering a single body or body-part as foreground frame, and multiple bodies and/or single whole body composition in the background. In this way, I could play multiple shots throughout the stage space, providing a single shot for each audience member depending on their placement (as camera) in the auditorium.[19] Then by manipulating the temporal sequencing of the movement phrases between the dancers within a given shot, I could apply the post-production effect of a dissolve or cross-fade. By having a significant movement motif (the high side leg kick or handstand) or rhythmic pattern (the sustained pedalling action of the hands while balancing curved over one leg) reappear from body to body, I could shift the viewer's focus between foreground and background in the same fashion as a camera lens pulls focus. The layering of the looping phrases within frame also creates a live dissolve, that is, the viewer perceives two sets of action (two shots) at once as movement across the space connects temporally (dancers reaching the same point in the sequence).

Fragments of the dancers' texts[20] informed both the movement material and the soundscape, but also personalised the physical and aural landscape of the work for them, inscribed their performances with a body of history:

> It gives that movement a history. Even if you don't use that material it has given what you end up with a history … it gives the movement a bit of depth for them as performers, and I think that resonates in the performance for the audience. (Reid cited in Norris 2000)

12. Return with The Elixir

> The challenge for the choreographer/filmmaker is to find the new form which is inherent in bringing together two forms…. If the choreographer/filmmaker taps into this film language and understands the properties of the technology that penetrate so deeply into the web of the work, then the form of dance film, regardless of style, can suspend disbelief. (Simondson 1995: 149)

During the course of this research, I have discovered numerous new intersections between artistic, technological and socio-political pathways that point to exciting new contexts for and outcomes from artistic practice. Specifically, I have discovered that

the role of editor matches my choreographic aesthetic and facilitates my next stage of development as a choreographer, and artistic researcher. My identification and refining of my skills in "cutting choreography" has, in turn, refined and redefined my skills, creative processes, and communicative capacity in the context of creating dance for the live stage. Furthermore, the tangibility of the dance film/video product, the immediacy of global communications, and the development of new platforms for creative exchange and critical discourse, provides me, the dance film artist, with both a palpable history and a multifarious future. Bromberg suggests that:

> As the movements of dancer and dance are inscribed in film or video, that inscription becomes the artefact that endures over time. And by this process, as choreographers, dancers and filmmakers, future generations will have access to the marks we have made. (Bromberg 2000: 27)

Acknowledgements

I would like to acknowledge my collaborators: Julian Barnett, Natalie Cursio, Viviana Sacchero, Hayden Priest, Cara Mitchell, Jacqueline Sherren, Paul Huntingford, Francis Treacey, Mark Lang, Fiona McGrath, Katie Moore, Lisa-Marie Walters, Molly Tipping, Bec Reid, Megan Mazrick, Felicity Morgan, Susan Smith, Jennifer Birch-Marston, Eleanor Jenkins, Rebecca May, Lucy Taylor, Sasha Bashir, Laura Mulherin, Fanci Hitanaya, Vijay Nair, Nina Levy, Casey Organ, Kylie Hassan, Fushia Carlino, Claire Granville and thanks to W.A.A.P.A., Danielle Micich, Deakin University, Colin Savage, Kim Vincs and Plaza Theatre in Kyabram.

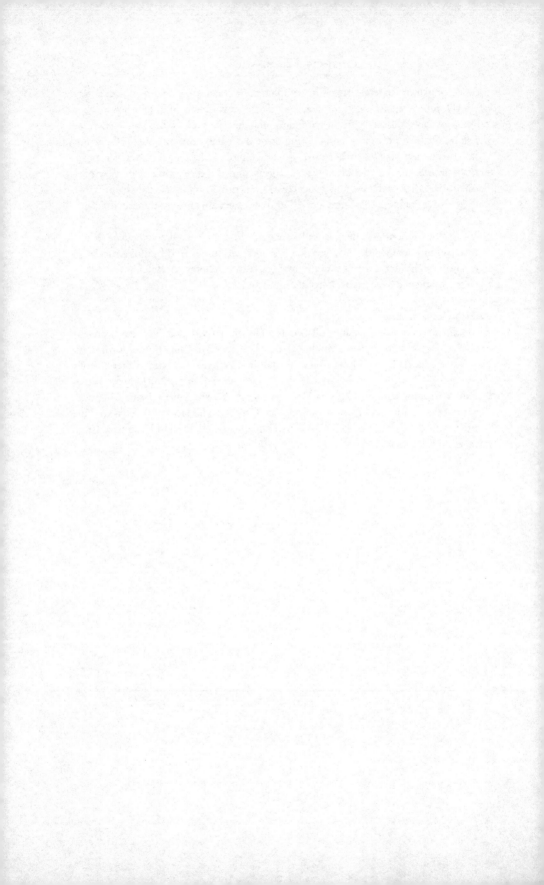

5

"SILENT" SPEECH
Annette Iggulden

Today the suggestion that a woman must be silent could be seen as a source of great amusement, disbelief, anger or sorrow. However, for women who have internalised the belief that this is the only acceptable position for them in society, the basic human right of free speech appears inaccessible. Born in England and growing up in Australia in the 1950s, my experience of the Christian home and of society in general was that "Little girls should be seen and not heard". To use the spoken word came at a huge price: a fear of crushing censure and a distrust of the meaning of words. Silence became a safe place to inhabit. However, by drawing on the generative aspects of silence to work with words and images within the studio, I found an alternative avenue for my voice and the means to articulate my experience of silence. In this Chapter, I shall demonstrate how the combination of scholarly research with studio practice required for my thesis, *Women's Silence: In the Space of Words and Images* (2002) provided insights into this phenomena and its ongoing impact on women and their forms of speech. Furthermore, by documenting the outcomes from my studio investigations, I shall show how the nature of these activities determined specific outcomes that were unique to studio practice.

Traditionally, artists refer to their predecessors to see how their practices relate to the genre in which they work. I am interested in how women can express the silence in their lives by transforming words into images. This interest made me turn to the art of medieval nuns and their work with words and images in illuminated manuscripts; firstly, because of the scripto-visual developments in my own work, and secondly, because these women "spoke" from within an enclosure of silence. I made a comparative study of original illuminated manuscripts focussing mainly on visual language and locating aspects of the work closest to my own art-practice: the visual treatment of the space and inter-textual components of the page or folio. My project did not include an examination of miniatures or historiated initials. Rather, its aim was to identify and compare the use of other aesthetic devices available to the medieval scribes/artists through which they might have interacted with the text. I believe my understanding of visual language brings a different perspective to that offered by scholars whose primary tool is the written language.

Historically, the speech and silence of women appears intricately intertwined with

and shaped by attitudes borne from various visual and verbal discourses about their bodies. This became startlingly evident to me about one year into the making of the work for my exhibition entitled *A Fair and Virtuous Woman* (1991). I believed that silence and passivity held great strengths as contemplative states and forms of non-violent protest. However, these paintings were a response to my anger and distress at the painful realisation that the naturalisation of silence and passivity as feminine virtues had left women profoundly vulnerable to the exercise of male power and control. I looked at images such as *Susannah and the Elders* and *The Rape of Lucretia,* represented over the centuries in painting, literature, poetry and drama. With very few exceptions, these visual and verbal narratives fused the view of women as fair and virtuous to passive sexual objects and silent victims. Susannah and Lucretia were portrayed as highly literate and articulate women, yet their protesting voices were effectively silenced because they were judged socially as body without voice: the cultural image of "woman".

Women artists have explored ways of expressing their own feminine desire, by deflecting the objectifying male gaze and attempting to remove the limits that fix the identity of woman and her expression. Scripto-visual art practice is one such strategy (Meskimmon 1996: 100, Betterton 1996: 103). The term "scripto-visual" in contemporary art was introduced through feminist art discourse in the late 1960s. It refers broadly to women's use of words and images within the visual field as a means of feminist enquiry and critique into the function of language and sign systems that affect the image we have of ourselves and of others (Parker and Pollock 1987: 5, 81, 310).

For example, the artists Jenny Holzer and Barbara Kruger have used words and images as a conceptual means to subvert the language of patriarchy and to reveal the impact of mass-media representations on the formation of gender identity within capitalist societies. More recently they have extended this work to investigate the mutually interactive relationship of words and images with the body (Weir 1998). Words and images are also used in the paintings and mixed-media work of Nancy Spero to draw attention to the historical silencing that violence against women has sustained (Wally 1995). Another artist, Mary Kelly, juxtaposes words and images in her investigations into the relationship of language, gender and psychoanalytic theory. She uses this approach to examine her own life as a mother and a woman within patriarchal society (Kelly 1996). I share her interest in the act of writing as a means of directing the viewer's eye away from the body of woman. This is not a rejection of the female body, but rather creates 'significance out of its absence' (Kelly 1996: 125).

From this background, I began an intense enquiry and on-going dialogue between both written and visual resources, between studio-practice and scholarly research. Within the studio I used paint and drawing materials to reveal the nature of "process" and explore how material practice might advance and challenge theory. My principal consideration was to discover what occurred in the transition of words into images in the act of copying texts. My studio investigations went hand in hand with research into words and their meaning. Words come out of silence. I explored what happens when one breaks that silence with the materiality of words. What happens

when colour, gesture, form, and an awareness of spaces in and around words, are brought to bear on a system of language meant to reflect a clarity of ideas, order and sense? I saw the interplay of these two systems of language providing me with an opportunity to articulate silent spaces that lie between and within both the written word and the visual image. I applied three orders of comparison to this study: theory to practice; verbal to visual means in my studio work; and the relationship of these two to the lives of medieval nuns and their work with words and images in the illuminated manuscript. The inspiration of their work and my practical engagement with scripto-visual processes in the studio provided a context within which to articulate my feminist concerns about the historical silencing of women.

Within the Studio: Words as Images

My use of words in paintings was a consequence of the gradual unravelling of events in my life and the development of my studio investigations: an outcome of my emotional and conceptual responses to both. My work is never theory driven, although theory has played its part in my understanding of the issues I address through my art. In fact, no matter how much I might think I have conceptualised the work, the idea is always secondary and often sacrificed to my intuitive response to working with the materials: the "matter" of painting itself. My images of words evolve from alphabetic writing, as did the work of medieval nuns in illuminated manuscripts. However, my writing should not be considered as separate to my choice of materials, colours, and size of the works for, as a painter, I respond to the materiality of paint and all that visual language provides, as well as to the words that I write within its visual space.

Progressively, I found myself "speaking" through writing directly onto the surface or skin of the canvas. Initially, this script was written with punctuation and spaces between the words, but positioned vertically as a veil to look through at the images that lay behind. In exhibiting this work, titled *What was that you said?* (1997) I had hoped to raise questions about how both words and images could reveal or conceal meaning. I was aware that whether we are in the position of the speaker or the listener, the viewer or the viewed, the artist or the audience, we are equally susceptible to manipulate or be manipulated by verbal and visual languages. However, I noticed with some alarm that the viewers positioned themselves askew so that they could read the vertical screen of words as a text. Such is the strong association of writing to linear comprehension. This was at odds with my intention. Prioritised in this way, the appearance of words pre-determined the expectation of a verbal or didactic statement. Although I did not fully grasp what I was after at that time, it became increasingly urgent that words had somehow to express my silent or unspoken voice and my "invisible" female body.

I turned to the work of medieval nuns in the manuscripts to see how they had handled this pictorial dilemma. I also hoped to gain some insight into whether their solutions had any relationship to their silence and speech. I found that they had used a technique of framing to delineate both the letters *and* their spaces. It was from this that I developed my first form of "spatial script". The cryptic appearance of

this writing gave me a freedom that I had never experienced in my paintings before. The letters illegibility or "silence" allowed me to speak freely with words without fear of censure and to use both verbal and visual languages as a singular channel for my expression. My exhibition: *A Weft of Words* (1998) was my response to both the oppressive and expressive power of language in my life. I painted, drew and sewed these spaces-between-words onto different cloth or skins as emblematic inscriptions on the female body.

I developed my second form of script in 1999, during my three-month period of empirical research into illuminated manuscripts in England and Europe. It is impossible for me to separate the advent of this writing from three overlapping circumstances in my life. These were my examination of the manuscripts and associated literature, studio investigations into this material, and the impact of a personal experience I had shortly before leaving Australia, an experience that acted like a leaden weight on my being during this time. Within a twenty-four hour period, I had lost a child to suicide and my daughter had undergone an emergency Caesarean delivery of a new grandchild. Each day after examining the manuscripts, I would return to my room to document all the relevant information I had collected and work on small expressive and investigative pieces on paper with coloured-inks. The urgency to express my grief and loss, and the joy of new life and love, brought about a change in the image of my writing. My previous form of "spatial script" did not allow for the speed I needed to bring speech, feeling and thought together, to write without pause using words to move beyond words, to a silent space and image of felt knowledge. A rapid and unbroken outpouring of intimate thoughts and feelings became possible through minute illegible continuous-cursive writing. At the same time, the communicative potency of the "unintelligible" or non-verbal image of hand-written script was heightened through my daily viewing of manuscripts that were written in languages foreign to me. Not being able to read the words as text had prioritised my seeing the writing as a visual image: a record of cultural and individual traces that re-embodied the invisible body and "silent" voice of the scribe/artist.

On my return from studying original illuminated manuscripts in overseas collections, I started for the first time, to copy texts. Using both methods of writing as investigative and expressive means, I explored the processes involved in the *act* of writing within the visual field of painting and drawing. I began by experimenting with different mediums—cloth, glass, wax, oil paint and mixed media—to see which would best suit this undertaking on practical, emotional and conceptual levels. I found that the tightly stretched fabric of the canvas (like a taut skin) painted with acrylic provided a surface and form on which I was happy to inscribe. When I was travelling, I had worked with inks, gouache and collage in notebooks. I continued to use inks and a variety of papers: tracing paper for its fragility, transparency and smoothness and Finnish newsprint for its colour and softness. However, in the final series on the alphabet, none of these materials could adequately express my concerns. Because of its associations with my acquisition of language as a child, I instinctively returned to materials that were representative to me of the Maternal (fabric) and the Paternal (wood). This search for and experimentation with materials

was finally determined by my inner dictates. The relationship between sight, touch and the mobility of materials to language, the maternal body and the embodiment of the self is an interest of many women artists who seek to find a different aesthetics using materials that might more closely express their concerns as women (Florence and Foster 2000).

To identify the continuing significance of this practice to women I investigated the acts of:

- writing as a form of drawing and speaking;
- copying the words of others;
- changing written texts into visual images;
- "imaging" the letters of the alphabet.

The Act of Writing: A Way of Speaking and Drawing

When I draw, the line carries a gesture that embodies and activates the visual space that it inhabits causing the eye to follow its movements throughout that space. When my gesture is taken into the act of writing, it crosses over the boundary of visual language as line, to share its space with a verbal code of language-as-word. This merging produces a different meaning or narrative to that contained in their separated states. When the written word co-inhabits the space of painting, it enters a dialogue with all other visual components that share its space. This interaction with pictorial language affects both its image and its interpretation. Words can evoke similar imagery to visual representations. However, the visual image of words differs vastly from other forms of representation in painting because of its oral history. It is at once spatial and temporal, discursive and figural. It is drawing and linguistic sign: an image particularly associated with the voice. In 1999, I had the privilege of being the guest of nuns of a silent religious order in a thirteenth century abbey in England. This community of women, committed to lives of silence within religious enclosure, left small folded notes in specifically appointed places so that they could communicate informally with me and each other. The nuns called this silent and disembodied form of speech their "Talking Notes".

Despite the differences in words and images as codes of communication, the image of writing contains many of the rhetorical and mimetic functions of drawing and painting. The shared physical and visual qualities of flow and movement are reflected in the historical origins of these words and those of writing and drawing (Mitchell 1980: 548). Laura Kendrick notes that, 'In Greek, the word *graphein* signified writing, drawing, and painting' (Kendrick 1999: 235, ftn 22). As an artist, I bring "visual thinking" and lateral and sensual pathways of expression to a code or system of communication that prioritises rational and logical thought. As I draw the image of words, I traverse the space between and within words and images: verbal and non-verbal articulation.

Situated within the context of painting, the image of writing is subject to the interpretative practice of visual art. It could be argued that its interpretation is solely determined by the genre that predisposes its space and its reading, that is, verbal communication in a book, or visual image in a painting. However, I would argue that

whilst these settings may pre-empt the expectations of the reader/viewer, it depends primarily on the intention of the artist, who uses strategies of disjunction and displacement precisely to challenge these preconceptions and to unsettle its reading. Therefore, the act of writing *as* drawing carries the potential to critique both verbal and visual systems of representation.

As a woman artist, this act has further significance to me. It engages me with the didactic nature of written language, the oppressive aspects of symbolic law that excludes women's voices, at the same time as it provides me with an alternative means of speaking and of being seen and heard. My body is totally involved in processes of seeing, saying, hearing and touching. I see my "silent" voice re-embodied as a texture of speaking within a visual field. As a personal and expressive means of imaging the feminine body and voice, I see this act of writing as an act of "becoming" and an agent for psychic and social change.

The Act of Copying a Text: Re-reading and Re-Writing

In the footsteps of the medieval *scriptrix*, I set about to copy texts: the words of Law given to, not chosen by the scribe who spoke the words of others with her pen. The tools of her trade became the means for her to leave the evidence of her presence and the image of words, the resonance of her voice. Because the daily ritual of singing or reciting the psalms was an important part of medieval nun's lives, I decided to copy the one hundred and fifty psalms that make up 'The Book of Psalms' in the Bible. This series of paintings was named *Psalmody: 'Why—do they shut me out of heaven? Did I sing—too loud?'* (after Emily Dickinson 1861).

I painted the cloth of the canvas black, reminiscent of the black habit that hid the nun's physical body and provided a space free from the censure of the male gaze. This also enabled me to reverse the traditional page of writing from black on white to white on black and to use silver ink to illuminate the meaning of the act of re-inscription. I employed my technique of continuous cursive writing, not so dissimilar to early medieval practice of continuous script and cognisant of their ritual recitation of texts. This method permitted an uninterrupted momentum of body movement, rhythmic flow of line, less conscious control of the words and evolving overall image, allowing for an intuitive response and slippage of thought, feeling and action. It also rendered the line of the letters as a silvery trace, an image of sound weaving the fabric of the text. However, the words themselves are scarcely legible. The "unintelligibility" of the words left a "silent", non-verbal, visual image in its wake. Its visual texture became a barrier that the eye could not penetrate, keeping the viewer's attention on the two-dimensional surface and the image of words: the image of my voice.

I found that to follow a given script demanded not only a co-ordination of the eye, hand and mind, but also an inevitable emotional reaction to the meaning of the words as I read and wrote them. Some of the time my eyes seemed to float over the surface of the words, scanning and writing them without much engagement. At other times, I was brought to an abrupt and involuntary stop and felt a need to re-read as something resonated with meaning or struck an emotional chord. This always caused

Annette Iggulden, from the series *Psalmody: 'Why—do they shut Me out of Heaven? Did I sing—too loud?'* (after Emily Dickinson, 1861) metallic ink & acrylic on canvas, 2000 (detail).

me to pause in the writing: to smile, be enthralled, moved, astounded, or/and to be horrified—did this passage, or maybe just a combination of words, actually mean what I thought it did? I soon realised how the processes of seeing the words, reading, saying and writing them also required that I fragment the text. I had to repeat small segments or phrases so as to hold them in my mind and record them accurately. However, as I repeated these clusters of words (with my mouth, tongue, vocal cords and breath), I was also conscious of hearing the *sound* of *my* voice, hearing it in my mind or in saying the words out loud. This mixture of emotions and the experience of *hearing* my enunciation of the words, *seeing* my hand, my line, recreating the text, *feeling* the resistance of the surface respond to the pressure of my pen, involved my entire being. As the person who had the responsibility of re-inscribing the text, this involvement was mine alone. Although conscious of these sensations during the execution of the work, their effects were not always apparent until its conclusion.

Unintentional errors were an on-going problem. As I noticed them, I had to stop and consider what I had done wrong. Sometimes it was that I had unconsciously missed a word or two, or unwittingly paraphrased what the author had said. The act of copying made me very aware of the errors that may have surreptitiously crept into the text, either because I had missed them in the intensity or desire to get the work done, or I had chosen, on some level, not to recognise them. Errors, erasures and interruptions proved to be both inevitable and meaningful, as they changed, no matter how slightly, the visual dynamic, rhythm, intonation and thus the meaning of the original text.

Mieke Bal suggests that repetitive re-writings offer the opportunity 'to initiate counter action, or to write back' (Bal 1994: 298). As I made the paintings entitled *Shhh* (2000), I realised that this was precisely what I was in the process of doing. As a post-script to my work on the Psalms, I was attempting to re-address my past. After my mother's death I was sent photocopies of the notes she had used in her pastoral work as a missionary in Pakistan in the 1960's. These included direct quotations from the Bible and her exegesis of the story, 'The woman at the well' (St John 4: 1-29). As I copied the already thrice-copied words (the photocopy of her hand-written copy, from the copy of "God's words" in the Bible), the "positive" shapes formed by these re-writings left an image suggestive of the female body in the "negative" spaces of the paintings. I had unconsciously reasserted the memory of my mother into the spaces of the words of Law that had been used to silence her.

From Written Text to Visual Image: Traversing the Spaces Between & Within
For this investigation, I moved from the words of Law to transcribe a contemporary text on the discourse of love: Roland Barthes' *A Lover's Discourse: Fragments* (1978). His poetic, self-reflexive dialogue on the agony and ecstasy experienced in the pursuit of love, resonated with the fresh images I had in my mind of the similarities between the erotic language used by medieval women to express their spiritual desire and that used between lovers. The denial of the senses by the "Brides of Christ" who spoke from within religious enclosure, on one level, were replete or exceeded through their performances of ecstatic utterance. However, their passionate female

desire for their "Groom" was manifest through alternating states of receptivity and action. Barthes relates these changing states to our repetitious utterances, or writings that affirm both the existences of love and our desire to breach the gap between silence and speech, the self and the other. As Barthes manipulated his pain created by the absence of the loved one to 'make an entrance onto the stage of language' (Barthes 1978: 16), I actively manipulate the pain of my silence to sustain my speech through visual language.

In the months before I saw the Belgium exhibition *"Wachten Op De Prins...": Negen Eeuwen Adellijk Damesstift Munsterbilzen*, an exhibition based on the women from the cloister where the *Manuscript of Isidore of Seville* had been produced (Mertens 2000), I had worked on a series of paintings that I later discarded. I had been trying to identify and somehow express a common ground that I felt that I shared with these women of the past who had produced this particular scripto-visual work. I attempted to construct a "frame" reminiscent of a window or mirror through which to reflect on the notion of freedom and enclosure. I had overlaid these paintings with wax and inscribed on them as if on the wax tablets of old. However, I felt compelled to cover the paintings with one overall colour, which overwhelmed the images and made them redundant. Having struggled with these works for some months, I was reluctant to put them aside until I understood what they had to teach me. For this I had to be silent and to "listen" to the work itself. I realised that it was the colour alone that was significant and which resonated with meaning.

On my return, I reclaimed that colour for I now understood its relevance to the common ground I had been seeking. To the purity of the colour violet (associated with the spirit), I added the density of warm reds, reflecting the earth-bound heaviness of the body. Rare medieval manuscripts were also, at times, stained purple and written on with gold, silver and various coloured pigments, to be presented as gifts of the highest regard. This resonated with my desire to pay homage to these women of the past and to celebrate the *jouissance* of poetic utterance. I entitled this new series of paintings after the words of Hildegard of Bingen (1098-1179), *Enunciation: 'A Feather on the Breath ...'* (Flanagan 1989 Notes 12: 114).

I wrote/drew Barthes' words using my two forms of writing, moving over the painted surface and allowing the line and its emerging shape to reveal itself. When starting a work, I neither know what images may arise nor the final image that the painting itself will take. As the bronze and silver line moved over the surface of the changing hue of the purple ground, so did my response to the shift of colour and light. I rubbed back and reshaped the original text until the form and colour of the fragments sat comfortably within the format of its pictorial space. This intuitive pictorial transformation left residual traces of erasures and a form of calligram in its wake, which, as Michel Foucault reminds us, 'by its double function guarantees capture, as neither discourse alone nor a pure drawing could do' (Foucault 1983: 22). These images retain their tenuous link with both verbal and visual language, for, although illegible as written language, they stem from alphabetic writing and its associations with the spoken word. In the smaller paintings, my "spatial script" became a dialogic overlay of Barthes' words with my own. Performed in the mood of a

medieval pictorial gloss, this semi-transparent veil of script created an image through which to engage and reflect in a double discourse on love.

This part of my research clarified how the particular nature of the text I copied affected my journey back and forth from the printed black text on white paper from a book to the word as visual image in my painting. The series of paintings, *Psalmody: 'Why—do they shut Me out of Heaven? Did I sing—too loud?'* (after Emily Dickinson 1861) was in response to my feelings about the Word as Law. I felt a strong need to prevent the viewer's eye from penetrating past the veil of words to the black cloth that "clothed" the "skin" of the canvas, keeping their attention instead on the rhythm and intonation of the voice alone. However, the openness of Barthes' invitation to use his thoughts 'to be made free with, to be added to, subtracted from, and passed on to others' (Barthes 1978: 5) encouraged me to see this as a collaborative enterprise, not so dissimilar to medieval manuscript production, but with greater contemporary freedom. My response to this act of copying was affected as much by the fact it was an open text, reflecting the non-fixity of subject positions and of writing as a poetic affirmation of love, as it was to my subjective response to colour and the evolving image. The process of changing written text into a visual image were innately tuned to my emotional and intellectual responses *as a woman* to the meaning of the words, as well as the evolving field of colour line and form, and the tactility and mobility of the "matter" of painting.

I would suggest that my experience is not unique, but rather the result of my immersion in the creative process that engages with all levels of the artist's being. The intensity of focus required for this performance moved me into a space and experience of silence where material practice became the means of unifying mind, body and spirit, in action. In blurring the boundaries between the conscious and unconscious, this creative process allows the silenced utterance to be spoken.

My intuitive dialogue with visual and verbal languages has changed or added to the meaning of the words. This raises the question; could not medieval nuns have also intuitively subverted the dominant male language in response to the words they copied, through their use of colour, lines, form and space?

Each of my paintings record the transition from verbal to visual language, and the changes that took place in the history of their making. Far from being an illustration of a text, they are as much a mapping of visual space and of the time required for their production as a tracing of the body and voice of the artist that made the journey from word to image. This engagement left an excess in its wake which was of a less conscious nature, an image produced from, but not the same as that created by verbal or visual language alone, but by traversing the space between and within words and images.

"Imaging" the Letters of the Alphabet: An Alternative Form of Speech

When I began thinking about the alphabet for this part of my research, memories of early school years reasserted themselves: seeing and trying to remember the shapes of the *image* of letters—the "A.B.C". I remember endeavouring to fit the right sound to the right shape, through repetition, and striving to get the lines of the letters

Annette Iggulden from the series *Enunciation: 'A Feather on the Breath ...'* (after Hildegard of Bingen, 1098 - 1179) metallic ink & acrylic on canvas, 2001.

(black on white) to follow what I saw on the blackboard, (white on black). The task before me was to make the letters recognisable, but smaller than I instinctively would draw them, and to keep the letters sitting on the lines drawn horizontally across the paper, rather than dance unrestrainedly as what they were wont to do, seemingly of

their own accord. How well I can remember on finishing my work before the set time, letting my line continue its journey into the appearance of a large duck standing astride the page and of then being promptly sent to the "dunces" seat. But how proud I felt when, because I had "got it right" I was sent to "the top of the class". As if by magic, when copied correctly, the black marks on white paper came into existence as letters, legible as sound and image.

Medieval artists constructed the letters of the alphabet from multiple abstract and figurative forms, such as fish, birds, human figures and hybrid fantasy figures. These gave structure to the letters. Their intention was to honour the Word, to illuminate the meaning of God; who God was and what this meant to them. Today, I cannot speak with such certainty. I could not "name" the presence as God, nor did I have any desire to do so. In fact, it was important for me "to-not-name". From 1911 to 1968 the artist Erté re-figured the letters of the alphabet into whimsical and seductive images of women (Barthes 1985: 104, 113). My shift away from representing the literal female body and my difficulty with making the word "flesh" in contemporary terms, returned my focus to the common ground shared historically by artists; the creative process.

I wrapped lengths of timber in raw (un-primed) linen as the ground on which to paint or write the letters that symbolised the heaviness or weightiness of the law, softened by the weave, warp and weft of the fabric. I positioned the pieces horizontally so that the eye might travel along them as in a journey through time and space or a visual equivalent to the act of reading. I began by using colour in the letters and their spaces so that the image hovered on the border between verbal and visual imagery. This approach resulted in a familiar but now inadequate image to express my desire. I experienced such restlessness and anxiety that I took the pieces and drenched them with water. With my brush loaded with ink, I obliterated the recognisable image of letters. In my attempt to re-write the alphabet, the letters were left as fragments of the alphabet or as painted ciphers. My overwhelming mixture of emotions, distress, fear, rage mingled with sorrow and loss made me realise once again that this struggle was from my experience of having been silenced because of my sex.

There is a violence that resides within the language of the Law: the language of the Father. I had to overcome or negotiate the oppressive memories and feelings that silenced me, before I could speak with my own voice, as a woman. I had to move to a space of silence and a state of forgetfulness to reclaim my speech and actively integrate thoughts and feelings through my reaction to the materials and disparate pictorial elements. I could not achieve this integration by symbolic, rational means but through creative practice. The colours I used were driven by an emotive and aesthetic response of my body: eye, hand, head and heart. As thought appeared, the touch of colour changed the thought. As I continued to lay one colour next to another my attention became totally focussed on "visual thinking", where rationality plays no part in the problem solving process. My repetition of the alphabet then became a continuous line of "silent" sound. As Amando Maggi so astutely observed in relation to the monologues of Saint Maria Maddalena de'Pazzi and the work of contemporary artist, Linda Montano: 'Both of them speak to originate silence…. A

Litany is a speech with no silences that only articulates silence' (Maggi 1997: 117).

In themselves, colour and gesture provide an "embodied" image of the letter, but colour has its own inherent energy and affective power to evoke a multitude of feelings associated with the senses, one of which is sound. Colour was used for letters in the manuscript to announce the beginnings of passages to be recited out loud, which, in a sense, introduced sound to the visual image of words. As I repeatedly recited or chanted the sequence of letters in the alphabet, they became like Mantras. I inscribed the rest of these works with my "spatial script" and placed them vertically to be seen as rods reminiscent of authority, yet transformed to convey a free-fall of sound. I named this series: *"Silence" … In the Space of Words and Images.*

The intensity of this performance returned me to the silent space of felt knowledge that lay beyond words and the meaning of the word "alphabet". The materials, colours and my act of writing created an embodied pictorial field, as much of the senses as of the mind and spirit. The alphabet, as a visual and verbal system, was developed over the centuries so that we might communicate thoughts and feelings. The medieval scribal-artist revealed the visual co-dependency of the "positive" letters of the alphabet to their "negative" spaces. Without this co-dependency, neither the letters nor the spaces that bound them could exist. The structure of language would collapse into glossolalia and meaningless without the support of silence: the evidence of its co-dependency with utterance. Women have been symbolically placed in the space of silence. However, they are *not* silence. By emphasising the "silent" spaces in the visual structure of the letters of the alphabet and the female embodiment of the word, an alternative way of seeing, reading and hearing women's voices might be heard.

When acknowledged as the unspoken excess of symbolic language, women's "silence", speech and song may be different to that recognised by the Law and linear systems of thinking. However, it can be understood when seen through "the glance" of non-possession and in the act of reciprocal looking (Bal 1991, Bryson 1983).

Pollock writes that:

> It marks the spot where women's cultures appear unreadable according to the dominant narratives of art, modernity and modernism, while to a different eye that seeks beyond the visible for the index of other meanings, lives, traces of other configurations of the subject and the body, the surface is rich in possibilities for those desiring to decipher inscriptions of the feminine as dissidence, difference, and heterogeneity. (Pollock 1994: 75)

In Conclusion

My studio investigations have shown how the creative practice of writing, copying the words of others, changing words into images and "imaging" anew the letters of the alphabet, can provide the artist with the means to express both personal and political concerns. The development and form of the paintings was affected as much by my position *as a woman* in western patriarchal society, as my response as an artist to visual and verbal language. I believe my studio-research raises the possibility of a

deeper understanding of this practice by medieval and other contemporary women artists. By "illuminating" some of the unseen, unspoken spaces within language, women's silence held between and within words and images, might be articulated.

The exhibited work would not have existed without the questions raised from my brief encounter with, and examination of traces from the lives and work of a handful of medieval scribal artists. In particular, my engagement with the work of the eight women who wrote the Manuscript of Isidore of Seville: Sibilia, Vierwic, Gerdrut, Walderat, Hadewic, Imgart, Uota and Cunegunt. I am extremely grateful to these women and the opportunity to research their work.

My paintings and the discussion of other contemporary artists' work have revealed that taking up the pen or brush will always break the silence of "enclosure". Other women artists have used words and images to draw attention to the silencing of women. I was unable to "speak" my silence when visual or verbal language remained in their separated states. I could only articulate or sound it, verbally and visually, when I merged both words and images. In seeing, saying, hearing and writing words, I was able to transform them into a non-verbal image of colours, lines, form and space that expressed *my* thoughts and feelings, *my* silence. My utterance from a position within silence became visible through the mediation of "matter" and the illegibility of the word's image.

In my discussion of the lives of medieval nuns, I posited the idea that historically, women have accessed or created "silent" or alternatively audible languages that are disembodied from the image of woman on which the prohibition of their speech was based. I put forward the possibility that those medieval nuns re-embodied words with their voices and articulated their silence through their creative performances of male language. I supported this idea by describing how words were shaped and sounded by my mouth and resounded with my own meaning, in my practice of reciting the words of others within the studio. Furthermore, I have established links between verbal and visual performances of language by demonstrating how the artist moves between both in the acts of writing, drawing, painting and copying texts. I have suggested that as artists working with words and images in the illuminated manuscript, medieval nuns had an avenue for this alternative mode of speech.

From my identification of, and experimentation with, the aesthetic means available to medieval scribal/artist in illuminated manuscripts, I have shown how it was possible for the individual artist to engage with the text. I found this outcome of the research exciting, but not surprising. Artists understand the qualities of visual language. If through my studio practice, I had been able to recognize its power to affect the reading of words, why not the medieval artist? This seems even more likely when we consider how visual and verbal processes were integral components of the medieval practice of reading illuminated manuscripts. On the one hand, I was frustrated by my inability to understand the language of the text in the manuscripts. On the other hand, I appreciated that this limitation heightened my awareness of the subtle innuendoes of visual language in the manuscripts. From my studio investigations of copying the words of others, I have demonstrated how my responses as a woman to particular texts affected the development and final form of the paintings.

By extension, I have suggested that medieval nuns could have done the same in the manuscripts. In providing different examples of how they used visual language, new ways of seeing and "hearing" the voices of these silent women of the past might be possible. I am hopeful that my findings provide a stimulus for further research by others into this little explored area.

I have drawn on both words and images as modes of communication to write and to paint my experience of silence, and to compare it to the historical silencing of women and its expression through visual language. The combination of studio research with theory has advanced and challenged both forms of inquiry: the paintings have developed from my dialogue between the two. Both words and images have proven to contain strengths and limitations. The aims and outcomes of my practice can be explained through the words of the exegesis. However, the non-verbal language in the paintings confronts the viewer with a visual experience that expresses the emotional and conceptual impact of its lived-experience.

By engaging in both verbal and visual processes, I have attempted to reveal the "silent" spaces that lay within and between both languages. The act of changing words into images within the studio has required that I traversed their visual and temporal spaces. These spaces have been articulated through the use of visual language, which recorded my response *as a woman* to the text. I remain fascinated at the capacity of visual processes and material practice to reveal the unexpected and provide fresh insights into what otherwise might remain only sensed. My practice has raised questions and attempted to provide at least partial answers that have preceded and extended my theoretical speculation on the historical silencing of women and its articulation through scripto-visual practice. The outcomes of my studio research do not attempt to posit absolute truths, but to re-question and to raise hitherto unasked questions. As a consequence, I hope to challenge so-called "truths" and suggest new ways of looking for and hearing the voices of women who speak from within silence.

6

CHAMBER: EXPERIENCING MASCULINE IDENTITY THROUGH DANCE IMPROVISATION

Shaun McLeod

Self-absorbed and with eyes closed, he reaches upward, outward, with no urgency, calmly gestur-
ing and shifting weight. His focus is internal, an indication or metaphor for the self-reflection that
motivates his measured movement; his fingers, hands and arms articulating the "searching" he is
engaged in. This is not an image of masculinity uncomfortable with itself. This is a man able to
"look inside", to enter the chamber of the male psyche. The sound is of subterranean water with
the associative qualities of contained fluidity and depth. Yet this is not an immediate or forthright
image of masculinity. His self-absorption is delicate, never direct or bold. The man seems elusive or
slippery, unwilling to conform but unable to present himself fully.

Chamber—a dark, dense and almost claustrophobic work of dance theatre—con-
stituted the performance component of the Masters by research thesis aimed at
defining and extending my choreographic practice. The work was choreographed
for three mature and experienced male dancers, Simon Ellis, Martin Kwasner and
Jacob Lehrer, with the performances held over four nights during April 2002 at
Dancehouse (in the inner-Melbourne suburb of Carlton). Audiences were small but
seemed receptive. Aural and visual texture (as well as psychological intensity) was
provided by David Corbet's sound scape and Cormac Lally and Christina Sheperd's
video imagery. The combined effect was multi-layered and multi-dimensional but
with all elements reinforcing a singular aesthetic and intention. The structure of the
piece had been carefully crafted and pre-determined and the intentions of each sec-
tion specifically defined. Yet, the movement content itself was almost entirely impro-
vised. As such, the work functioned as a "structured improvisation" which explored
the synergies between formal choreography and improvisational practice.

The project began as a response to the complexities and pitfalls in trying to de-
fine, succinctly, masculine identity framed through examination of the links between
masculine subjectivity, embodiment and dance improvisation. This beginning was a
recognition made possible by feminist explorations of gender identity: that he idea
of masculinity has historically been assumed as the norm and is therefore unworthy
of attention has ironically largely rendered it invisible. The choreography itself was
derived from the experiences of the four men involved in the process—the three
dancers and myself as choreographer. *Chamber* was an attempt to present a small

moment of troubled masculinity as a metaphor for problematising what is otherwise taken for granted.

As a practice/exegesis model, the research project in its entirety, was a kind of marriage The union between my embodied understanding of dancing, and an intellectual demand to contextualise dancing in a way that reached beyond the confines of the dance studio, was often uncomfortable. But it was a coupling that extended and challenged me to act or think beyond the constraints each imposed on the other. The combined result charts the interrelated philosophical and artistic processes through which the performance was produced. The outcome is a dual record, danced and written, of an investigation into how dance might express and reveal masculine subjectivity.

My original line of questioning in this project was an enquiry as to why so few men pursue dance, or more specifically contemporary dance, as a form of physical expression? Why don't scores of other men dance, when I find it so rewarding and enriching? What is it about dance that men find difficult to align with their sense of themselves and the construction of their masculinity? In contemplating these issues it became apparent that men's distrust did not lie exclusively with dancing but with the way men regard many embodied practices. Almost any unusual physical display by a man is subject to scrutiny and viewed as suspicious. The problem, as I saw it, was more fundamental, and lay not with dancing itself, but with the way men see themselves and masculinity in general.

Part of my wanting to work with male dancers was simply to seek out the company of like-minded men: men who were asking the same questions about what constitutes positive communication amongst ourselves. Through this process, it became apparent that the working questions should not be about why men do *not* dance, but to find the positive perspective on the same issue. In other words what happens when men *do* dance? How do we experience dance and identify ourselves through it? And how can these perspectives be realised in choreography?

Men certainly experience questions such as these in many different ways. But self-definition for men through experiential dimensions that require sensing and feeling, and in other ways which are regarded as marginal to masculinity, remains restricted and problematic. Laurence Goldstein summarises a trend:

> If recent writings are any indication, the task of men's studies is to recover from history and from empirically-observed behaviours in the present day, that sense of choice and variety in self definition that so many women have embraced as a means of personal and social liberation. (Goldstein 1994: vii)

Chamber is the spirit of this observation. It is a plea for alternative expressions of masculine embodiment by defining the subjective danced experiences of the men involved, and alluding to the multiplicity of subjective experiences that all men experience.

Defining Masculinity

Attempts to define the term "masculinity" as a fixed and unproblematic reference cannot be sustained under the intense scrutiny applied to it in relatively recent scholarship. Indeed, as Robert Connell points out, a key finding of recent sociological research into masculinity is that there is no globally imprinted pattern or globally understood definition of masculinity (Connell 2000: 10).[1] Connell cites various masculinities, conditional on factors such as culture, history, nationality, race, class and traditions of gender construction. For example different cultures have at different historical moments, allowed for very different levels of acceptability and participation in homosexual behaviour (Connell 2000: 10).

As feminists have been arguing, gender organisation is not a fixed entity. It is mutable and dynamic, not essentially dominated by human biology. A man does not *need* to behave violently simply because he has the power to do so. For certain men to be encouraged to behave aggressively, as they often are in many activities and social interactions (for example sport) they need the support not simply of a biological response, but of an entire cultural system which bolsters such behaviour. Men are not born as aggressive entities, but some learn how to behave in this way by engaging in an extremely complex interaction with social forces, institutions, peer-groups and so on. Consequently masculinities are primarily defined in cultural arenas, not biological ones (Connell 2000: 10-13).

However, in most cultures a dominant form of masculinity holds pre-eminence over others. The cultural authority invested in this form creates a situation of dominance and subordination within the masculine gender order:

> In most of the situations that have been closely studied there is some hegemonic form of masculinity—the most honoured or desired ... The hegemonic form need not be the most common form of masculinity, let alone the most comfortable. Indeed, many men live in a state of some tension with, or distance from, the hegemonic masculinity of their culture or community. (Connell 2000: 10-11)

In a patriarchal system, gender is presented as dichotomous, with masculinity defined not so much by what it is, but by what it rejects or expels. Defining practices that are excluded from hegemonic masculinity, that is, all other manifestations of masculinity are consequently tainted by a symbolic association with femininity (Connell 2000, Seidler 1989). In Western culture, hegemonic masculinity is relentlessly represented by media image of men as the muscular hero; heterosexual, all-powerful, controlling, driven, and lacking any hint of self-doubt. But men do not live in a world free of contradictions and self-doubt. The marginalisation of all other forms of masculinity by the hegemonic form creates a continuing point of challenge for many men as they attempt to live up to, or alternatively avoid the cultural impact of the dominant form. Connell cites the example of a study on male body-builders who would, in the pursuit of a muscular body and hyper-masculine identification (heterosexually defined) often finance their physical regime by eliciting payment for

sex from homosexual men (Connell 2000: 13). This tension confirms the inherent contradictions and the problematic qualities surrounding the notion of a fixed and comfortable, all-encompassing masculinity and sexuality (Rutherford 1988: 22).

However, in situating masculinity as a culturally constructed order, Connell also makes explicit the necessity to acknowledge the materiality of the body. The masculine body cannot be defined as a passive object, which all men receive or experience in the same way. Bodies are as diverse as are the ways in which men are able to use them and these factors must have bearing on the ways in which men define their cultural practices. But it is the emphasis on "practices" which seems crucial here rather than on any presupposed "natural order" for what men's bodies can or can't do. All practices, which are used to define gender constructions, *refer* to the body and its workings rather than being *determined* by it. Thus, the 'materiality of male bodies matters, not as a template for social masculinities, but as a referent for the configuration of social practices defined as masculinity. Male bodies are what these practices refer to, imply or address' (Connell 2000: 59).

Masculinity and the Experiences of the Body

> I would emphasize that, given the importance of body-reflexive practice in the construction of gender, remaking of masculinities is necessarily a re-embodiment. (Connell 2000: 66)

Bodies have agency and that agency is implicit in the ways in which men configure and re-configure masculinity. But the patriarchal denial of the body in western societies has meant men have generally distanced themselves from ontological considerations of the body but also from bodily practices and expressions, except in a strictly defined and controlled way (Rutherford 1988: 26). As such it is acceptable for men to play sport (as long as they don't throw like girls) but it remains problematic for men to dance, this being a "feminised" and therefore less worthy pursuit. Within hegemonic masculinity, acceptable uses and understandings of men's bodies remains mechanistic; that is to say the body is used as an instrument of extension, valued for what it can do or achieve and how it can be trained to maximise its capabilities. The body is rarely felt or enjoyed and its sensations rarely attended to outside the parameters of sport, during sex or in situations of extreme need. It is not generally seen as having a responsive or distinctive aspect. Emotion, residing as it does in the body, is also suppressed. The object-body is in need of subjugation and according to Elizabeth Grosz, this subjugation is accompanied by a 'refusal to acknowledge the distinctive complexities of organic bodies, the fact that bodies construct and in turn are constructed by an interior, a psychical and a signifying view-point, a consciousness or perspective' (Grosz 1994: 8).

Hegemonic masculinity remains too restricted to easily allow within it, dance practices that reflect upon and utilise the experiences of the body. Indeed, masculine experience itself—the very idea of a distinctive realm of experience for men—remains an area only vaguely defined, hidden behind a homogenising acceptance of "mas-

culinity"; a kind of unapprised code of silence regarding the differences in the ways men live their lives. This notion states that all masculine experience is equivalent or uniform, and that *experience itself*, with the notable exception of sexual experience, is masculine experience. The term masculine becomes interchangeable with the term universal (Seidler 1989: 47). Male subjectivity and the multiplicity of masculine experiences have consequently been rendered invisible by their subsumption under the comforting stasis of an ideal masculinity (Goldstein 1994, Middleton 1992).

As a consequence of this totalising practice, men have never adequately attempted to detail the differences and intricacies of their experiences: experiences which might indicate areas of difference, plurality, divergence and surprise. Masculine experience has been regarded as a given or not regarded at all, but it is only recently that it has been regarded as problematic. Grosz points to this omission:

> Men have functioned as if they represented masculinity only incidentally or only in moments of passion and sexual encounter, while the rest of the time they are representatives of the human, the generic "person". Thus what remains unanalyzed, what men can have no distance on, is the mystery, the enigma, the unspoken male body. (Grosz 1994: 98)

Clearly if men are to be free to pursue embodied practices outside the realm of the acceptable then they must also attempt to free the body from its negative associations. Part of this task entails detailing what individual experiences men have of their bodies, how they "live" their bodies. Where are the phenomenological reflections on masculine embodiment, the nuances and subtleties, beyond the usual iconic or heroic representations of men's bodies? In order for men to discover their bodies within an atmosphere of positive acceptance, men need to relate to their bodies and identify its practices and its becomings as well as the sexual specificities these entail. Grosz argues that if, 'the mind is necessarily linked to, perhaps even a part of the body and if bodies themselves are always sexually (and racially) distinct, incapable of being incorporated into a singular universal model, then the very forms that subjectivity takes are not generalizable' (Grosz 1994: 19). Thus men need to extract specific experience from the haze of the universal by particularising the forms of their subjectivity, and even more of a challenge, by manifesting this in an embodied fashion. One embodied particularity of this project is dancing.

Masculinity and Chamber
Chamber articulates, performs, engages with and alludes to masculine experience as problematic. In particular it gives body to the experiences of men, aligns men with the body and identifies their bodily practices and artefacts. The work endeavours to acknowledge Grosz's point that:

> a different type of body is produced in and through the different sexual and cultural practices that men undertake. Part of the process of phallicising the male body, of subordinating the rest of the body to the valorising function-

ing of the penis … involves the constitution of the sealed-up, impermeable body.… A body that is permeable, that transmits in a circuit, that opens itself up rather than seals itself off, that is prepared to respond as well as initiate, that does not revile its masculinity … or virilize it … would involve a quite radical rethinking of male sexual morphology. (Grosz 1994: 200-201)

Dance practices which centre on the experience of the body, are explicitly aimed at "opening up the body"; making it responsive. As a gesture towards rethinking or reformulating the male body, *Chamber* is therefore a questioning of the masculine status quo and the phallocentric systems that govern and control the way men express their physicality and subjectivity. It is not an attempt to illustrate a theory applicable to all men or speak for all men. *Chamber* comes with a phenomenological slant driven by the subjective particularities of the men dancing in it and by myself as maker of it.

The other assumption pursued in *Chamber* is that subjectivity can be, and for men needs to be, embodied. The phenomenological focus within the making of *Chamber* was on ways in which subjectivity could be constituted corporeally— in dance or movement. Credence has to be given to the life of the body, to functioning within subjectivity and to the interaction between consciousness and physicality.

If we accept that men have not adequately articulated the experiences that give shape to the nuances of masculinity, particularly with regard to the male body, then dancing offers just that possibility. If we also accept that masculinity needs to be reformulated and therefore (re)embodied in order for the hegemonic model to be challenged, then the "feminised" pursuit of dancing offers a powerful opportunity for this to happen. Dancing is necessarily embodied and requires that the dancer "feel" the movement, not think it. It requires him to experience his body, not as armament, but as intelligent, responsive and dynamic. An instrumental approach to the dancing in a project such as this would be an anathema. All masculine dance can be a challenge to a patriarchal economy but more powerfully so, if it can be done by men who are fully aware of the political implications of what they are doing. Indeed, it calls for a conscious political decision to do so; the political dimension cannot be circumnavigated. If men who dance and choreograph insist on portraying men in dance only as "strong" and "muscular", analogous to the macho hero in movie making, then they are failing to acknowledge the issue. If men in dance insist on making male dancing "acceptable" by continually virilising their activity, then the act is one of compliance to the patriarchal demands. Men will have failed to create a dynamic, felt, specific and embodied practice to reconfigure masculinity into multitude ways of moving, reflecting the multiple differences in men's lives.

As the video image fades the three men stride into the space. they walk and turn, aware of each other's presence but tentative because of this. They begin to edge toward one another, then breaking away to return to a walk. The skittishness fades as they reach towards each other, finally offering a cheek to connect with another's. They relax as the three of them connect cheek to cheek, a single moving entity. their breathing softens as the release into the sensuality and kinaesthetic intention

of the "score". They drop to the floor always seeking to stay connected cheek to cheek, but physical necessity sometimes determining that they separate. Quickly they return to the point of connection. the quality is gentle, tender even, despite the physical manoeuvring that the score requires. The harmonium provides a warm backdrop to this supportive and cooperative image. Despite the faltering start, they embody intimacy or trust in their connection.

Improvisation as Methodology

The icon or ideal of masculinity creates a situation of inadequacy or lack for many men as they attempt to live up to the demands of the image but fail to do so. It was this contradiction that I was also intent on capturing in the structure of *Chamber*. The aim was to try to contain something slippery and difficult to define within a fixed and, by association, masculine structure as a metaphorical exploration of this contradiction. Consequently, *Chamber* was framed as a "structured improvisation" in which the order of events was set and known, but the movement material within each event (while operating within certain parameters) was changeable and indeterminate. The improvisation is reflective of the men's search for a subjective dimension and an alternative sense of identity. The difficulties in moving spontaneously without prior definition or certainty are representative of the struggle for masculine identity. Within each man lies another realm of possibility, despite the fixed, stable image they might present to the world. It is a gesture toward an alternative space inside a familiar one, in which another less known kind of dancing might emerge. This is the image of the chamber.

In response to these considerations, I chose to work with three male dancers whom I felt would be prepared to invest emotionally, physically, intellectually and creatively in the process.[2] Their contributions made it possible for this work to hinge on a subjective engagement with the creative parameters and for this concentration to be maintained in performance.

Improvisation also allows for the dynamics, movement preferences, spatial understanding and other manifestations of 'the embodied subjectivity of each dancer to be expressed in a relatively unfettered way (De Spain 1995). In an unstructured, open-ended improvisation the need for a choreographer would seem to be obsolete.[3] Yet even in a structured improvisation, the movement style and preferences of the choreographer are de-emphasised and control over what the dancers do is partially relinquished. The movement material itself also changes between performances. Within this context, the dancers are required to create the movement of the performance afresh on each occasion, even though an understanding of the movement quality or intention has been decided upon. This strategy seemed essential to a project that was endeavouring to unravel the intricacies of individual masculine experiences.

The intense, almost ritual quality is made more complex by the appearance of Martin in the upstage corner. Martin progresses on a diagonal towards Simon stopping three times. At each pause he performs small solos, which are twitchy, staccato, erratic little cameos—minute collapses of identity. He seems drawn to Simon as if Simon has an understanding of something, which he

lacks—perhaps a psychological clarity regarding the ailment he suffers. But Simon, unaware of his presence, offers nothing. Martin backs away to re-engage with his own uncertainties, reconfiguring his body in sharp breaks at the hips and bursts of tensile movement. He cannot find a comfortable and sustained rhythm.

Improvisation has been central to both the choreographic and theoretical aspects of the work and the ways these two aspects coexist and inform each other. As a method, improvisation offers the possibility of an on-going dialogue between the phenomenal and objective dimensions, a dialogue in some ways observable and sometimes reportable. As Phillipa Rothfield notes:

> A phenomenology of bodies looks to the ways bodies feel in movement. Not only what muscles and bones are being utilised to move or to dance, but what that feels like. It represents a kind of kinaesthetic sensitivity. (Rothfield 1994/5: 80)

A phenomenal orientation to dancing implies each dancer's experience is different, that their internal understanding will manifest in a unique way. With such an orientation, improvisation has the potential to tap into these experiences and how each dancer embodies his sense of identity. As this work is directed toward the specificities of masculine subjectivity, what Rothfield calls "kinaesthetic sensitivity", was crucial to realising the goal in an embodied form. Improvisational dancing, then, provides a methodology for sifting through phenomenal perspectives on dancing and a way of moulding multiple contributions into an objectively constituted performance.

As a result of this strategy, the movement material became extremely particular to those who danced it. Although I maintained a large degree of navigational control regarding the direction and form the piece would take, in many ways this piece was specifically *about* the experiences of the three dancers. *Chamber* was particular to their anatomical structure, to their kinaesthetic relationship to time and space, to their body image, and their unique interweaving of the psychical and the physical. Their motivation to move was determined by an internal or subjective source. This motivation was on occasion affected by my input or direction, but was also determined by their own responses to tasks over which I had limited control:

> The practice of inward focusing, central to ideokinesis, places a person directly in touch with their own unique world of images, and with the unique operation of their own creative process. Spontaneous images, often filled with personal significance, are the very stuff of creativity, and exist as rich sources for dance. The ideokinetic method outlines a clear practice of incorporation, articulation and physicalization of images from image > action. In practice however the work more often than not moves in two directions, image >< action, image and movement constantly informing and modifying one another. (Dempster 1985: 20)

Dempster's passage provides a useful comparison. While the process employed in *Chamber* was not consciously based on ideokinesis[4], the concerns and methods of ideokinesis run parallel to those of improvisation and indeed often overlap. Improvisation has the potential to draw upon the emotional, psychological and cultural positions of the dancer in extremely complicated ways; ways which are often more difficult to verbally articulate than physically express. There is often a kind of "universe of possibilities" within improvisation but despite this, very personal, intimate moments emerge that speak strongly about the ways that individual engages with the world. The dancer's physical disclosures are imbued with the personal, acting as a conduit between the internal machinations of consciousness and the audience's scrutiny of the object body. These disclosures inevitably reflect his understanding about how his private self meets the world.

The dancer's culturally attuned persona will also inevitably be exhibited in his improvising as surely as a man walks, sits, throws and runs differently from a woman. Men's bodies clearly carry gender codification as strongly as women's bodies do. Sally Gardner, in talking about the post-modern dance practices of certain 1960's and 1970's choreographers, says that by 'placing necessarily coded bodies in non-representational or "other" contexts they contributed to a displacement or unsettling of conventional readings of the body' (Gardner 1996: 56). I would argue that improvisation offers this occasion for disruption, for surprise, for revealing what was not known, for disturbing the habitual. This is when the veneer of masculinity may slip for a moment. This is when the dancer's fixed gaze is interrupted to reveal pleasure or fear; when his body becomes animated by the fleeting, long-forgotten memory; when he forgets himself and moves with a delicacy and fluidity he may never have achieved when dancing in predetermined choreography. This immersion in the moment of improvisation has the capacity to suspend the requirements of the masculine order. Gardner continues by saying:

> Earlier, I suggested that the idea of 'neutrality' in certain dance practices might also be formulated in terms of their aiming to make the body available for re-inscription in 'other' ways. These practices require a certain ambience or environment—a space and time in which purposes and activities are strategically suspended, perhaps to enable the dance to move 'in a space emptied of things and thus of the order of things' as Alphonso Lingis suggests—space for a wilful hesitation during which a gap might be opened for the creation of a different kind of bodily order. (Gardner 1996: 55)

This was the spirit in which *Chamber* was investigated. The outcomes in performance still exhibit strong links to the old order and the inherent contradictions it contains. But the project was an attempt by us as men to engage with this ideal and to initiate a small and particular re-embodiment of masculinity.

In the Rehearsal Studio

For me as a choreographer, improvisation is a powerful creative tool. My work, in

its initial stages, was forged from repeated improvisational sessions with the dancers and myself. From these sessions emerged, themes, ideas, images, relationships and spatial considerations. It is from this rich resource that the content, the structure and, to a certain degree, the intention of the choreography was drawn. The movement parameters (defining the type or quality of movement, how long it lasted, who was involved, and so on) were usually made as a result of testing ideas through improvisation rather than applying a predetermined movement or movement qualities onto the dancers. I would then attempt to clarify or objectify what it is the dancers would show in a performance. In this sense, there was a link between the subjective origins in improvisation, and the objective imperatives of producing a piece of choreography for public viewing.

These rehearsals became a way to try out or test ideas gleaned from the theoretical reading I had been doing. It became a form of physicalised debate and self-reflection, for the dancers and me, as we engaged with issues pertaining to masculine embodiment and subjectivity. By using discussion and improvisation as the starting points I aimed to create an open and fluid working environment in which I could experiment, surprises could occur, and to which the dancers could contribute. The creative structure enabled me to operate intuitively throughout, be open to the unexpected outcomes of improvisation and to defer any final decisions about the appropriateness and structure of material until close to the performance time. By working intuitively rather than with predetermined directives and ideas, by focusing on the embodied experiences of the men involved and by using the indeterminate quality of improvisation I aimed to make a dance work that avoided yet commented upon the universalising and dominating capacities of hegemonic masculinity.

Uses of Improvisation in Process and Performance

There were three distinct methods in which improvisation was employed. The first of these was as a way to play with an idea or an image that I had previously devised and consequently the intention was largely predetermined. Despite my intention of being open to the discovery of material through the improvisational process, these ideas seemed necessary in order to anchor the piece in the context I had set out for myself. These ideas would then be interpreted as scores for the dancers to improvise with and the results either further developed or discarded. The outcomes would then be loosely set. For example, the image of Simon and Martin walking toward the audience with pants down and shirts up was constructed in this way. This image began with the idea for the text (an authoritative voice reading the executive employment advertisements) and was originally constructed as something more physically complex. However, as the dancers played with the instructions (involving a degree of set movement and them sitting on chairs) I began to whittle down the movement content until we were left with the simple act of walking in a straight line toward the audience.

Another use for improvisation was as a method for exploration. When I had only a very ill-defined sense of what the possibilities might be, I would ask the dancers to improvise around a loose score without the expectation that I would use this score in its current state. For example when I asked the dancers to dance cheek-to-cheek

that was the limit of the instruction. In my mind there was a question about what effect might emerge from three men dancing in such an intimate relationship. What they did with this instruction was completely open, at least initially, and refined in its intention as we rehearsed it. This method was essentially a way of scanning for material but without knowing what I wanted or what I hoped to find. Often this was a way of investigating a specific context in which to view the movement ideas.

Sometimes the instruction was completely abandoned in the course of an improvisation when the dancers became completely absorbed in new material and discoveries. The decision about the appropriateness of this material (did it fit into the work?) was suspended as I attempted to follow an intuitive response to the material and defer any judgements about how the work would crystallise. If the outcome of an improvisation were fresh and engaging we would work with it until a later time when a more formal editing and structuring process occurred.

Finally improvisation was used as a performance mode in its own right. That is to say the movement material was discovered for the first time in performance with no relationship to anything done in rehearsal. Usually there were elements of structure containing these improvisations but no predetermined score. The main examples of this in *Chamber* were when touch was used as the motivating factor for what the dancers did. The quality of the touch and the dancer's response to it, determined the nature of the movement material. This was an element over which I had very little or even no control. The structure that inhibited the dancers was the consideration about where in the space they danced (so as to effectively light their actions in the space or to provide room for another event to occur) and to a certain extent how long they danced for.[5] Otherwise they were free to find fresh material in each performance. This ploy was at the heart of my desire to keep the piece alive, risky and indeterminate and for it to be embedded in the personal signatures of the men dancing in it.

Effects of Improvisation on my Role as Choreographer

As a choreographic tool, I found that improvisation can reverberate with the sentience of the male dancers themselves. It also allowed for the unexpected in what I, as a male choreographer, see as possible. It interrupted the habitual in my choreographic sensibility letting me work in an intuitive way rather than following a blueprint of choreographic intent. This enabled me to engage in a process of trial and error, of feeling my way, of touching the contours of the thing before it is seen.

My role as choreographer shifted between two models. The first model was that of the traditional choreographer who was directly responsible for the material and transcribed this unchanged onto the dancers (although the occasions that this occurred were extremely rare). The second model was the dominant one in which I played a more directorial role, less physically involved but shaping and structuring the contributions of the dancers themselves. Their work altered in response to my thoughts or suggestions, but the actualisation of these thoughts was carried out by the dancers themselves. This model was used for the bulk of the material generated and kept for the final form of the work.

None of this diminishes my impact on the work. My sensibility was evident throughout in the choice of movement instructions (scores), in the chronological placement of sections, in the juxtaposition and combination of discrete movement sections and images, or in the collaborations I had with the composer and video makers. I was alone in having access to and an understanding of all of the elements that went into the making of *Chamber*. My choice of a very specific strategy of cultivating the indeterminate in the choreographic process and shaping the structures this entailed gave the piece its tenor and defining qualities. However, the contributions of the dancers (and the other artists involved) gave the work a greater depth and level of intimacy: a deeper well of experiences from which to draw.

The Development of Some Key Rehearsal Scores

The Touch Improvisations

Many of the early rehearsals and improvisations centred on the use of touch, as an entry point to an improvisation. With eyes closed, one dancer received the tactile information given by a partner. This was not the alignment-specific touching which many dancers are so familiar with, but qualities of touch that were erratic, delicate, flippant, annoying or unexpected. When the touching finished, the dancer used the physical memory of the experience as source material for their improvisation. The results in movement were often imbued with a sense of rich association to memories and personal experience that no verbal instruction could hope to achieve. These dances were very personal in the ways they played out and riveting to watch because of the dancer's attention to the quality of the experience.

The touch improvisations proved to be an exceptionally rich resource, one which created different responses each time we did it. The tactile information was easy to vary and extremely changeable in the kinds of responses it generated. Assimilation of the information received from these tactile sessions often proved to be extremely complex. It was difficult to capture a particular thought or association: sometimes memories would be brought to life, sometimes feelings, sometimes sensations which felt familiar or alternatively quite strange. We deliberately avoided the kind of tactile work which dancers often experience in release–based dance classes. We did not, for example, use specific patterns of touch that are designed to increase awareness of particular postural or alignment goals, such as might be used in a Skinner Release Technique class. The aim was not to make the dancers move more efficiently, but to stimulate a personal response. As such, the touch was often erratic and random or with variable qualities of pressure. Several sections of *Chamber* drew on the work developed in these sessions:

Simon closes his eyes and jacob begins to carve simon's skin with the edge of his hand. Jacob lifts and drops simon's arm, or lifts his whole body weight on his knee. He pokes, slices, brushes, digs and scratches simon's surface. It looks as if to be a bizarre continuation of the previous duel, and in a sense it is. But it is also a leap into another kind of logic. Then jacob leaves indicating the beginning of simon's solo. This is simon 'embodying' his subjectivity, his identity, and his memory as jacob's

touch triggers a plethora of complex images and sensations, and plunges him into a rich realm of association. There is immediacy about his response that never seems to diminish with the repetition in performance. It is hard to get used to this. The touching asks many questions and simon is impelled to give account; his responses are telling without any words to describe them. He encounters many divergent narratives in this act, jumbled and confused, but always embodied. There is an existential dimension to simon's ensuing solo that the audience can kinaesthetically sense but never quite see.

In their physical interpretations, all of the dancers were attempting to remain as true as possible to the reception, memory and associations of these complex stimuli.

As we watched, in rehearsals, the act of one person giving the tactile information and another receiving it, it seemed to me that this was in fact a duet. There was just as much interest for me in watching what kind of approach the toucher would take as there was in watching the improvisation that ensued. This then developed into a score where Martin and Simon used wooden sticks to touch Jacob to see if there was a noticeable difference. The metaphor I was interested in was about a more clinical form of touch, where the warmth and support of touch could be held at bay. A more objectified, medical or scientific kind of touching might speak more about the difficulties men have in touching each other free of any sexual overtones. But in the reworking of this idea we discarded the sticks as an unnecessary and clumsy addition. Martin and Simon were able to apply a kind of "measuring and testing" form of touch without them. This created a slightly mysterious extension of Jacob's personally absorbed solo at the very opening of the piece.

The Secrets Improvisations

Score: Think of a secret you have never told anyone and use your feelings, thoughts and associations of this memory to initiate movement.

This score was given to each dancer separately and at different rehearsals. They spent some time thinking about a situation from their own lives, which they had never revealed to anyone else as the basis for their improvisation. My intention was to work in an area of some discomfort for the dancers and to site this discomfort in their own experience. I never found out what the secrets were for any of the three dancers. The interest for me lay not with the content of their secrets but in how they responded to them in movement.

The outcome of this exploration for Martin was a knotty and troubled solo in which he buries his head in the crook of his elbow and struggles with his own insubordinate hand. For Simon there is an equally edgy motif of thrashing arm and deep squats combined with moments of him quietly speaking: *there was blood ... the first time. How do you tell someone?* With Jacob the situation was slightly different: he claimed not to have a secret that he never told anyone. Instead, he said, all his secrets were told to various people in different ways. What developed out of his response was an improvisation where he began telling a story about Simon—a completely fabricated

scenario—that Simon felt inclined to put a stop to by putting his hand over Jacob's mouth. By working with this beginning, the scene was rearranged slightly to have Simon begin to tell a story and for Jacob to stop him and then for Jacob to take over by telling a story about Simon. Jacob told a different story for most performances and managed to keep the surprise and expectation for Simon quite genuine.

The challenge, in the development of these three fragments of material, was to re-find the same state of feeling and quality of movement. This was material which I felt warranted being presented with its original intensity, rather than providing a space for more open-ended improvisation. They also provided strong references to the nature of the struggle for identity these men were engaged in.

Goya Improvisations

The so-called Goya improvisations were sessions that used as impetus the grotesque, black and white prints of nineteenth century Spanish artist Francisco Goya. More specifically we drew on the series of prints loosely entitled *Los Disparates*:

> These prints contain more or less absurd, Surrealistic images: bulls flying through the air, an elephant staring motionless at a group of men, people crouching like frozen birds on a branch, a horse catapulting a woman into the air, distorted faces screaming silently, and people fleeing from phantom. The Disparates could be described as a series of dreams. For just like nocturnal dreams they are strange and familiar. Whoever tries to decipher them is groping in the dark. This enigmatic quality is precisely what endows the series with modernity. These subjects are no longer drawn from the traditional language of artistic images, but from a private world. (Buchholz 1999: 80)

It was this enigmatic quality that I was drawn to, and the metaphor is quite straightforward: masculinity groping in the dark, uncertain of its own interpretation, surprised and frightened by what steps out from the shadows. The sense of the grotesque in the prints, which I equated with a fear of the unknown, linked closely with my intentions for *Chamber*. The ambiguity was also attractive; no clear answers, no easy options and a search for meaning.

These prints, generated responses which formed the latter part of *Chamber*. The duet between Martin and Simon was conceived as an embodiment of two of the characters from the print entitled *Disparate Carnaval (Carnaval Folly)* (Heckes 1998: 74).

By beginning in the pose and attitude of these two strange figures, Simon and Martin slowly fleshed out, over numerous attempts, a duet that captured their spirit. Jacob's slightly comical character that makes a surprising entrance after this duet was also a progeny of these prints. His print was called *Disparate de bobo (Simpleton)* which features a huge simpleton with a broad but eerie grimace (Buchholz 1999: 81). Jacob slipped into a kind of approximation of this character quite readily, but his introduction created a huge shift in focus for the performance as a whole. I was not able to resolve this shift to my satisfaction, despite feeling like the introduction of this darkly amusing dullard was entirely fitting:

Jacob's entrance has the potential for comic relief as he mugs like a simpleton and meanders around the space, humming quietly to himself. But the laugh is still a black one as he too has lost any resemblance to temperate masculinity. He has become a deranged and gormless caricature as he skips and frolics through the shadowy light. His is a contradictory presence—funny and bleak, a simpleton but complex in his impact, unskilled as dancer in a way that takes great skill. He can negotiate the uncertainty of the place they have all arrived in, in a way the other two cannot, because he is beyond caring. But this ability marks him as even less of a man. He is stranger in the final analysis because he has stepped further over that line of demarcation that gives psychological definition to a man. As he sits down on Martin's supine form and blinks cheerily into the light, the poetry of James K. Baxter casts an apocalyptic pall over the stillness.

Reflections on *Chamber*

The performances of *Chamber* were the brief, but intensely satisfying reward for the long hours spent on its conception. One of the most satisfying aspects of watching the piece unfold in front of an audience was seeing how it took on a life of its own. The work seemed to expand and contract and take on an organic shape in ways I had not seen in rehearsals. The dancers, spurred on by the presence of an audience, came to life and injected fresh imaginative spirit into their movement. They also came to understand *Chamber* in a much more intimate way; in a way that only the experience of the work in performance seems to bring. This sharpened their sense of timing, heightened their awareness of their movement and of each other, and let them occupy the space with greater performance presence. There was no longer the necessity to think their way through the performance, able instead to be in the movement and to intuit the implications one moment or one gesture would have for the next. As a result *Chamber* changed in subtle but discernible ways over the course of the performance season. These shifts were never seismic or glaring. But there was steady centrifugal pull toward focus: like watching a Polaroid photograph develop before your eyes until the image is sharply defined.

From the outset, I pursued the agenda of complicating masculinity and of sullying the iconic uniformity it often still holds. I believe I succeeded in doing this but at a certain cost. It appears to me upon reflection that the alternative space in which men might dance, the kind of utopian aspiration that was also an initial desire, became overshadowed by the sheer weight of the reaction to the influence of hegemonic masculinity. It was a conflict in a piece about contradictions. And possibly the most tenuous proposition was that a structured improvisation was in fact possible. My response to this is that *Chamber* succeeded in presenting masculinity as problematic and in aligning men with embodiment. But the necessary desire to articulate this very context curtailed the possibility of the movement spontaneously shifting to another context or to another dynamic or to another realm of the unexpected. This degree of indeterminacy is what an unstructured improvisation can offer and while indeterminacy was present in *Chamber,* it did not dominate. What came to dominate in the final analysis was the structure of the work—the elements that remained immutable from performance to performance. Because of this, I think *Chamber* could be understood or interpreted from a more singular perspective. But the more ephemeral and

unexpected dancing moments that improvised dance can produce were less evident or distinct under the weight of the structure.

Renowned dance teacher Mary Fulkerson talks about a distinction, which Ramsay Burt identifies as that which exists:

> Between work that is 'trying to be like' something else and work that is just "trying to be". Although work that is 'trying to be like' can be pleasing through being familiar, it doesn't interest Fulkerson: 'It is work that tries "to be" which puzzles, angers, moves, challenges me and keeps my attention'. (Burt 1995: 71)

It is the hinge between the realms that Fulkerson describes, between the "trying to be like" and the "being" on which *Chamber* teetered. *Chamber* does have symbolic structure. The order of events and images were thought about and decided upon; certain images were developed as direct representational references to masculinity and the video imagery was incorporated as symbolic markers for the movement. In other words the context for the movement was deliberate and directly referential. But the movement was often not intentionally referential to the masculine order—even if it came to be seen that way by association. The structures were designed so that I would have limited control over the outcome and this was the offering to a possible alternative for masculine identity or construction. But despite this aim, my sense is that the movement was too fragile to rise above the rigidity of the structure. The context for *Chamber* was clear, but the alternatives were never fully realised.

I do not wish to undermine the original spirit, the impact or the achievements of *Chamber*. I feel it had integrity and power in dealing with the issues in the way it did. I also learnt how to create choreography in, from my perspective, a new way. To have completely handed over responsibility for all of the movement to the dancers, and to have built their contributions into a coherent piece was a very different approach for me. The challenge was always about finding how to communicate my intentions and needs in a format that facilitated their movement exploration. I could not *show* them what I wanted. Indeed, often I did not precisely *know* what I wanted. There was a substantial amount of trial and error and suspension of judgement about the appropriateness of rehearsal material—something that the dancers handled with good humour and sensitivity. Improvisation showed me how much greater the range of options were and how often the surprises in rehearsal were so much more powerful than any movement idea I might have presupposed. I afforded myself the space to sit with ideas, and work them through, until the intuitive recognition of the material was complete and resounding. As such this process offered me a valuable educational trajectory in my creative development and nurtured a strong felt understanding of a new creative methodology.

Chamber was a complex work. The sheer weight of time and thought that collected around it gave it a very dense quality. In engaging with both physical and theoretical perspectives, and their points of intersection, *Chamber* created an ongoing tension in its inception and realisation. There needed to be a mutual interaction between these two aspects, which ultimately gave the work much greater depth, but it was also a

constant shackle. As I was attempting to work intuitively in the studio, the theoretical concerns took time to assimilate. While the intentions inherent in *Chamber* may at times be complicated as a consequence of this interaction, my belief is that the work is far more mature and considered because of it.

RHIZOME/MYZONE: A CASE STUDY IN STUDIO–BASED DANCE RESEARCH
Kim Vincs

Dance practice has only recently begun to be articulated as a specific methodology for dance research. Implicitly, however, the idea that writing and dancing together define dance research has been embedded in the field for some time. For example, there is a longstanding tradition in postgraduate dance education of presenting performance work accompanied by a written minor thesis. A minor thesis typically describes documents and articulates the philosophy of the student's artwork. This structure assumes that dancing and writing function together to form a whole. However, attempts to clarify the methodological foundations of this assumption are a relatively recent development.

The debate about the relationship between practice and theory in dance research has been played out largely through the development of practice–based postgraduate programs, and this has taken place mainly in the UK and Australia. This direction has been driven by many factors, not least of which has been a migration of mid–career dance artists to the academy. This migration has come about because practice–based research programs provide the attractive combination of a situation in which artists can undertake their own creative development and the prospect of improved employment in the future.[1]

Dance research has always and inevitably involved a relationship with practice, but the traditional structure of dances as objects to be investigated, usually by someone other than the artist who made the work, is being deconstructed by dance practitioners undertaking practice–based research. This is producing a shift from dance as an object of investigation to dance as a means of investigating.

This deconstruction is both an historical shift attributable to the attraction of mid–career dance artists to the tertiary sector, and a shift that is in keeping with the current cultural and intellectual climate. We are no longer in the era of positivist, objectively verifiable research outcomes, at least in significant areas of the arts and humanities. Understandings of knowledge have shifted from positivist to subjective perspectives.

This is a different cultural moment that draws on a subjective understanding of knowledge. I like to draw my understanding of this cultural moment from French philosophers Gilles Deleuze and Félix Guattari. They model knowledge as a rhizome, a web of interconnecting elements in which 'any point of a rhizome can be

connected to anything other, and must be' (Deleuze and Guattari 1987: 7). Fields of knowledge are not separate from each other or from the pragmatic effects of subjectivity, identity and politics. To be a dance artist, for example, is not to engage solely with single activity, such as dancing, or perfecting technique, or exercising creativity, but involves constructing a simultaneous engagement with a multiplicity of elements. Engagement is never with one thing or one field of knowledge in isolation. Claire Parnett makes it clear that in:

> Desiring an object, a dress, for example, the desire is not for the object, but for the whole context, the aggregate. "I desire in aggregate" ... So there is no desire, says Deleuze, that does not flow into an assemblage, and for him, desire has always been a constructivism, constructing an assemblage 'agencement', an aggregate: "aggregate of the skirt, of the sunray, of a street, of a woman, of a vista, of a colour ... constructing a region". (Parnet 1996)

Subjectivity is inevitably and intricately woven into rhizomic structures of knowledge. To research dance in this context, one must go beyond isolating dance practices as texts to be read, to the idea of dance practice as a field in which rhizomic structures of knowledge are produced and integrally laced through with the subjectivity of the artist. Deleuze critiques understanding books as objects, or even texts, to be interpreted:

> There are, you see, two ways of reading a book: you either see it as a box with something inside it and start looking for what signifies, and then if you're even more perverse or depraved you set off after the signifiers. And you treat the next book like a box contained in the first, or containing it.... Or here's another way: you see the book as a little non–signifying machine, and the only question is 'Does it work, and how does it work?' (Deleuze in Buchanan 2000: 35)

Studio-based research in dance performs the same kind of critique. It shifts the focus of dance research from the idea that dance is a product, a repository of knowledge or ideas that can be interrogated and interpreted to the notion of dance as a field in which knowledge is produced. The subjectivity of the artist, itself a complex, rhizomic web, is a part of this field in which knowledge is produced.

I want to develop the idea that dancing and making dances forms a space or a substrate within which to think about dance. Rather than dances being the outcomes of thinking done previously, dances are the actual process of thinking, and this process is the core methodology of studio–based dance research. To develop this argument in a concrete way, I describe my own experience as a PhD student working in both practice and theory. Out of that journey, I will frame a methodological dilemma that arises out of the collision between practice and theory: to pursue an investigation of specific issues through making dances, or to explore what it is about making dances that inevitably sabotages and exceeds the most carefully targeted research questions.

Rhizome/MyZone: A Methodological Dilemma

When I began my PhD in dance through practice and exegesis, I will freely confess that I did not have a methodology in place to situate my dance practice in relation to the written exegesis that I was to produce. This was quite deliberate. I felt that I needed to produce some dancing in order to see which questions and issues the dancing brought forward. This, in essence, was my methodology. I made a series of dances, and gradually identified the issues each one presented, and the questions that they raised about dance. I then used these questions to fuel the making of further dances and the development of a methodology for the project as a whole.

The result of this was that when I was able to formulate a clear set of research questions and a methodological structure that could accommodate them, the studio work, and not a set of pre–existing questions had directed the nature of the research.

This emergent approach is highly significant to the point where I would suggest that it is perhaps the only constant one can count on in the field of practical research. In the arts, research methodology is often retrospective. This is a contentious idea, because the first rule of traditional research is normally to have a well defined research question and clear methodology before even gaining admission to research training degrees. But when studio practice is concerned, the rule is turned on its head because the nature of artwork is itself emergent. To try to impose a convergent framework on it, even with the best of possible intentions, is doomed to failure. Either one ends up with convergent, predictable, and ultimately unoriginal artwork, which, however conveniently it can be articulated in the exegesis, is of little value to the artistic discipline in question, or one ends up with a clear research paradigm, but badly behaved, unruly artwork that refuses to be contained within that paradigm.

A pragmatic answer is perhaps to say that it's all just too difficult, and artwork simply belongs outside the sphere of research. In this scenario, artwork may be included in a postgraduate degree, but it is assessed on the basis of its professional competency, rather than on the ideas it engages. This is an argument of equivalency. It says let's value artwork, but not pretend it can contribute to the field of research, except as an object to be evaluated.

Another pragmatic answer is to make art practice conform to the structures that dictate research methodologies in other fields. There may be some compromises to be made in the nature of the artwork, but, say the pragmatists, perhaps that is a small price to pay for entrée into the prestigious field of "research". This may be the answer that results in the least bureaucratic fuss and bother, but it doesn't develop art practice as a research field. If art practice can only do what other kinds of research can do, can only work with the same kinds of structures, methodologies and epistemological frameworks, and if it can only do this with a certain amount of mess, that is, a certain amount of compromise to its own nature, or, as it might be termed in scientific language, significant degrees of approximation, then the question becomes, why do it at all? It is only worth doing art practice-as-research, particularly given the difficulties and expense involved, if it can contribute something unique to the field of knowledge it operates in.

Neither of these approaches confronts the question of what dance practice can uniquely contribute to dance research. If dance practice is treated as a primary source of knowledge, rather than simply an object of study, what kinds of knowledge might that practice produce?

At the beginning of my research journey, despite having no clear methodology other than making a series of dances to see how I made dances, I did have an idea about how my exegesis would be related to the studio work. I assumed that writing an exegesis of my work would be a process of identifying and articulating discoveries I had made through making dances. In the words of Deakin University's Guide to Candidature for Higher Degrees by Research, the exegesis would 'elucidate the performance work and place it in a disciplinary context and would be ... in no sense a separate exercise in art theoretical discourse' (Deakin University 2001: 88).

This paradigm assumes that there will be a single, originary, philosophical and/or aesthetic stance, which the dances demonstrate. When I looked at my dances, however, I quickly began to appreciate that there was no single concern, or even a related set of concerns within them that I could articulate as the results of research. The intertextuality of my dances at the most simplistic levels, that is their references to diverse sign systems such as literary texts, conventions of contemporary dance as abstract design and as symbolic expression, autobiographical structures and historical discourses, immediately precluded any singular perspective that my dances could be understood to embody or demonstrate.

I could not reveal what had transpired in the dance work because there was not necessarily a core "effect" or core "concern" of the dance work to reveal. Rather, there were multiple effects and concerns embodied within the work, and these elements were not ideologically, philosophically or even aesthetically consistent. They worked with different languages, different frames of reference, and even different sets of values.

There seemed to me to be two possible responses to this dilemma. One approach would have been to set about making dances that functioned as interrogations of particular issues, ignoring or neglecting any other ideas the dances suggested. This would have made the task of the exegesis clear: to examine the extent to which the dance work successfully interrogated a particular set of issues, and to articulate the results of this interrogation. Alternatively, had I made the choice to reflect on the finished works, I could have written an exegesis that focused only on the elements of the dances relevant to my chosen set of issues, and considered everything else to be noise, interesting, but irrelevant to the task at hand.

The other approach to the dilemma was to eschew the idea that a dance work can or should be about investigating a finite and predetermined set of issues. To take this approach is to expect that the dances will examine a number of different concerns. This is not to say that such dances can't or don't interrogate issues, but rather to refuse to privilege any one of a diverse set of interrogations taking place simultaneously.

This second approach is essentially a decision to value the complexity and rich multiplicity of concerns in an artwork, and to undertake the task of developing a research methodology that can deal with that complexity. While it might perhaps be easier to

adopt an "issue-driven" analysis and to ignore everything in the dances that doesn't contribute to an examination of those particular concerns, this course of action is exactly the kind of pragmatism that strips artwork of what makes it different from other kinds of endeavours, and hence of what makes it valuable and worth doing.

I decided to adopt the second course of action and to develop a framework within which I could write about the diversity, internal disjunctions and heterogeneity I found in my dance works.

Deleuze and Guattari understand knowledge and subjectivity as rhizomic. Rhizomic structures are like the underground root systems of wild grasses that extend in all directions. Rather than progressing in the orderly manner of a tree (an arborescent system), in which each branch divides into two, each sub–branch divides into two, and so on, a rhizome is characterised by rampant growth in all directions at once. According to them, an 'assemblage is precisely this increase in the dimensions of a multiplicity that necessarily changes in nature as it expands its connections' (Deleuze and Guattari 1987: 8). In contrast to what they term arborescent systems, the rhizome:

> Operates by variation, expansion, conquest, capture, offshoots…. In contrast to centred (or even polycentric) systems with hierarchical modes of communication and pre-established paths, the rhizome is an acentred, non–hierarchical, nonsignifying system without a General and without an organizing memory or central automatom, defined solely by a circulation of states. (Deleuze and Guattari 1987: 21)

The idea of a "system without a General" seemed to correspond to the idea of an artwork without a single underlying concern or perspective. In a rhizome, elements of meaning are not hierarchically related. That is, meaning is not structured into the orderly pathways of the arborescent structure, where everything arises from a central structure (the trunk of the tree). In a rhizome any two elements of meaning may be connected to produce meaning. Thus, 'any point of a rhizome can be connected to anything other, and must be' (Deleuze and Guattari 1987: 7). One may connect one element to another, one idea to another, in any way one chooses. The defining characteristic of the rhizome is its functionality. Particular pathways are not prescribed, but rather whichever pathways are useful, whichever pathways make the elements of meaning function with each other, may be created.

Elements of meaning in a rhizome don't have to be ideologically or logically cohesive. Any element can be connected with any other element, regardless of whether those elements come from the same order or kind of meaning. Deleuze and Guattari suggest that all events, ideas, symbols and languages exist on a single level playing field. Ideas from diverse and heterogeneous fields of reference function with one another, without explaining or representing one another. Elements in a rhizome don't arise from pre-existing, foundational, or prior phenomena, but rather meaning and the illusion of depth arise from the interplay of these elements on what they call a plane of exteriority. In their words:

The ideal would be to lay everything out on a plane of exteriority of this kind, on a single page, the same sheet: lived events, historical determinations, concepts, individuals, groups, social formations. (Deleuze and Guattari 1987: 9)

An important consequence of understanding my dances as "planes of exteriority" was that nothing in the dances can be prior to anything else, and there is nothing prior to the dances. In contrast Godard talks about giving directions to a particular place in the city. Indicating a route, i.e., turn right, then after the post office turn left and so on, produces a set of instructions that is linear and time–dependent (Louppe 1996: 15). You have to do things in a certain order. The post office is prior to turning left. Turning right is prior to the post office. This is Deleuze and Guattari's arborescent structure, or tracing, in which a genetic axis or deep structure defines instructions for interpretation and specifies the rules by which the instructions must be followed.

The Map
The other option is to produce a map. In a map, everything is laid out on the same plane, on the page. The map is not time–dependent. It doesn't tell you what to read first, or in what order to put things together. It is an instrument for someone to use as they will. It doesn't dictate how one should use it:

What distinguishes the map from the tracing is that it is entirely oriented toward experimentation with the real. The map does not reproduce an unconscious closed in on itself; it constructs the unconscious. (Deleuze and Guattari 1997: 12)

When I construct dance as a plane of consistency, I am making a map, not a set of directions. I connect elements, but I don't indicate causal relationships. I do not, for example, say, 'I dance the way I do because it used to be painful to put weight on my right leg when I was four years old'. Rather, I place an image of myself in an iron calliper at age four alongside a discourse about dance training, a dance phrase, and a joke about Bob Dylan's singing voice. The connections are not prescribed, but laid out as a map for the reader to make use of. The dance becomes like Guattari's pocket calculator:

Imagine that someone offers you a little calculator to perform arithmetical operations. Is there communication there? A potential usage is transmitted to you. The performances it allows are established as soon as a certain competence relating to its use is acquired. In my view, the same thing happens with theoretical expressions that should function as tools, as machines, with reference to neither an ideology nor to the communication of a particular form of ideology. (Guattari 1995: 38)

Thinking about dances as maps, completely undermines the idea that an exegesis might report or articulate dances. How would one report on a map? It might be possible to say that it was a well drawn map, or an accurate map, or a map that included

more or less detail, but it is impossible to *say* what the information contained in the map is. It can have all kinds of uses, but no single meaning or content is communicated.

A map is not a representation of some prior, unifying idea, but rather something that connects elements. A map cannot be translated because there is nothing prior to it. One could translate all the symbols, identify all the roads and houses and buildings, but this doesn't translate how these elements are connected, which is where any "meaning" in the map lies. Similarly, I came to realise that if my dances were maps of subjectivity, they could not be read as representations of anything, for example, self, interiority, concepts, techniques or historical events. The dances were untranslatable because there was nothing prior to them to translate. The dances assembled elements of subjectivity such as specific bodies, dance techniques, choreographic genres, texts, histories, dance conventions, and events, to produce new coalitions between different elements and between different frameworks of meaning. There was no discovery that the dances embodied. Rather, the dances are productive, connecting a diverse set of previously unrelated elements of meaning. There is nothing prior to the dances that the dances articulate or communicate, which means that there can be nothing for the exegesis to summarise.

Dancing and Writing

If I were to give up imagining that the dances were prior to the exegesis, with the exegesis reporting on events (and having the last word), I would have to re–envisage the process of writing an exegesis. The dance and the writing had to function with one another one the same epistemological level, as a dance–writing machine rather than adopting a hierarchical structure in which one precedes and the other explains.

In making this shift, I had to confront the illocutionary and performative nature of writing. Language is illocutionary when its grammatical structure accomplishes something. For example, to say 'what are you doing?' is to ask a question. It is performative when something is achieved in the act of speaking. For example, to say 'I promise' is to promise.

Deleuze and Guattari argue that rather than language being means of communication, it is a means of exerting power. Rather than describing pre-existing things or events, they argue that language is already an action, an exercise in power that defines and normalizes some sets of relations and outlaws others:

> When a schoolmistress instructs her students on a rule of grammar or arithmetic, she is not informing them, any more than she is informing herself when she questions a student. She does not so much instruct as "insign", give orders or commands.... The compulsory education machine does not communicate information; it imposes upon the child semiotic coordinates possessing all of the dual foundations of grammar (masculine-feminine, singular-plural, noun-verb, subject of statement-subject of enunciation, etc.). (Deleuze and Guattari 1987: 75–76)

In relation to writing about dance, the very structure of the words one uses to de-

scribe this process—analysis, exegesis, discussion, and especially writing about dance—function in this way. All of these terms position the dance as a primary source that the words elucidate or articulate. The relationship between the two things becomes hierarchical: the dance produces; the writing articulates that production. This masks the productive elements of writing, and the articulatory aspects of the dance work. Ironically, the function of the linguistic structure is to mask its own active, productive nature and writing is allowed to masquerade as a passive "reporting" of dance.

Writing about dance is not as simple as communicating what happened in the dance, what it is about, or how it is made. Writing about dance performs certain functions, classifying and positioning the dance in certain ways. Rather than leaving this an unconscious and unacknowledged process in my work, I set about finding a way of making this process explicit and working with it.

Desire and Delirium

Coming to understand both writing and dancing as driven by desire rather than by a consistent logic or ideology was an important step in devising this strategy. In using the term "desire" I am referring to Deleuze and Guattari's understanding of desire as an immanent, productive process that distributes pleasure (Deleuze and Guattari 1987: 155). This is contrary to the Lacanian perspective that desire is lack[2]. In the psychoanalytical tradition, desire is theorised as being produced through the acting out of the Oedipus complex within each family. It is predicated on the idea of castration and a constant lack or unattainability. Deleuze and Guattari's idea of desire is very different because it is based on the idea of the assemblage of elements in which nothing is fixed, and there is no one template for how it is put together. Desire is never for a single thing, such as father, mother, or phallus as advocated by psychoanalytic models, but always about a multiplicity of elements linked by the individual:

> Delirium, linked to desire, is the contrary of delirium linked solely to the father or mother; rather we "desire" about everything, the whole world, history, geography, tribes, deserts, peoples, races, climates.... (Parnet 1996)

Desire, as Deleuze and Guattari understand it, is not limited to single fields of reference. It is not necessarily coherent in an ideological sense because it is heterogeneous, the linkage of a number of divergent elements. What defines desiring machines is precisely their capacity for an unlimited number of connections, in every sense and in all directions (Guattari 1995: 126). The machine, as Guattari describes it:

> Must be capable not of integrating, but of articulating singularities of the field under consideration to join absolutely heterogeneous components. It is not by absorption or eclectic borrowings that this can be achieved; it is by acquiring a certain power, which I call, precisely, "deterritorialization"—a capacity to look onto deterritorialized fields. I'm not keen on an approximate interdisciplinarity. I'm interested in an "intradisciplinarity" that is capable of traversing hetero-

geneous fields and carrying the strongest charges of 'transversality'. (Guattari 1995: 40)

Understanding both my dancing and my writing as desiring machines allowed me to acknowledge that both were heterogeneous enterprises. That is, there is not necessarily a coherent, homogenous point of view lying behind either one. Understanding desire as machinic in this sense separates out desire from ideology. No one system of meaning or political perspective is able to contain desire within its borders. Desire is activated by a diverse range of factors that do not necessarily come from the same frame of reference or system of meaning, for example, desiring machines may encompass signs, symbols, events, bodies, histories, organisations, circumstances and ideologies. Guattari writes:

> But, in my opinion, the analysis of the economy of desire implies a multivalent logic that legitimates the coexistence of discourses that cannot have axiomatic homogeneity. If you object and say that this is not what I said ten years ago, I answer, 'Too bad,' or even, 'So much the better.' Perhaps this is a good sign! Expressions of desire can simultaneously signify formally contradictory things, because they refer to various universes of reference. (Guattari 1995: 41)

Understanding both dancing and writing as desiring machines means that dancing and writing can no longer be considered in a hierarchical structure in which the writing describes the dancing. Instead, dancing and writing can be understood to function together, through a series of rhizomic connections. In this structure, the thesis becomes a dancing–writing desiring machine.

Making this shift enabled me to structure my writing differently to the traditional exegesis in which the dance work is reported, analysed and/or described. I structured my writing as a series of "deliriums". The idea of the deliriums, was to create a rhizomic logic on the page. I constructed the writing as a process of sliding across metaphors. I placed different regimes, to borrow Deleuze and Guattari's term, of writing together; symbolic, stream of consciousness writing, movement descriptions, explorations of dance theory, historical narratives and philosophical arguments (Deleuze and Guattari 1997: 7).

I can perhaps best describe these written/danced deliriums by describing an experience of moving. I'm lying down, so the habitual organization of standing is subverted. Any part of my body can initiate. Any part can take over. My knee might be moving diagonally across my body and up in a diagonal trajectory into space. The opposite shoulder, part of the torso, followed by hip and then upper leg might provide support into the ground for that action. Then my other elbow might take over, then my opposite foot as I roll onto my stomach for support. Perhaps the back of my head might then initiate, circumnavigating the space behind me. I might soften and curl in through my spine to support my knee expanding into space. It all happens smoothly and seamlessly. Suddenly something else has taken over, but it was never clear when the transition occurred. A foot could be working, or a hand or a hip

or a sternum, and it doesn't matter which. As long as the movement happens there are no demarcation disputes, and no territories to be contested between body parts.

The resulting work has its own internal flow, but no external imperative. It is not directed at reaching somewhere, that is, it is not goal directed in the sense of trying to reach an end point where the dance comes to mean/signify/produce a particular philosophical outcome. In the deliriums I wrote, I re–mapped the dances, which I had carefully examined in terms of their aesthetic, technical and ideological contexts, in a way that allowed me to move between theory, philosophy, history, analysis, aesthetics and my own experience to produce an interplay of subjectivity that plugged into my dances in multiple ways. The ultimate destination of such writing isn't as important as the territory it weaves through. It produces multiple connections.

The question in these deliriums is not what should or must go together, but in Deleuze and Guattari's words, 'whether the pieces can fit together, and at what price. Inevitably there will be monstrous crossbreeds' (Deleuze and Guattari 1987: 157). By this, I mean that, in juxtaposing what Deleuze and Guattari call 'not only different regimes of signs, but also states of things of differing status' (Deleuze and Guattari, 1997: 7), the integrity of the interiority of each field of reference, including the individual dances and dancing itself, is constantly at risk of cross–contamination. The purity of each discourse, artistic or philosophical, is jeopardised.

Perhaps, however, the problem really lies with the term analysis. Analysis in the traditional sense implies dissecting an artwork in order to explain it, or to explain how it is the kind of dance it is, and the assumption that this is possible is exactly what I was undercutting in developing this approach to writing about (I should probably say with) my dancing. I was instead positioning analysis itself as also alive, growing and fuelled by desire. In a Deleuzian context, analysis itself has the potential to be nomadic, roaming beyond the borders of the artwork that set it in motion and ranging outside the parameters of art itself. While it may be impossible to entirely divorce the notion of analysis from the notion of interpretation, once analysis is understood as a process of desire, it can never again be viewed purely as a representation or exposition of something else: that is, as an artwork.

The discussion, to this point, has linearity about it that I would now like to interrupt with another narrative about how I came to the work of Deleuze and Guattari. It was not just the identification of complexity and intertextuality in my dances that led me to consider desire as an organizing principle for both writing and dancing. It was also my experience as a choreographer.

The first excerpt from Deleuze's work that caught my attention, was the assertion that one never desires something or someone, but always rather desires an aggregate "an ensemble". Parnet suggests that for Deleuze and Guattari desire is imbricated in the nature of relations between elements. She continues:

> Deleuze refers to Proust when he says that desire for a woman is not so much desire for the woman as for a 'paysage', an environment, that is enveloped in this woman. Or in desiring an object, a dress for example, the desire is not for the object, but for the whole context, the aggregate, "I desire in aggregate"....

So, there is no desire, says Deleuze, that does not flow into an assemblage, and for him, desire has always been a constructivism, constructing an assemblage 'agencement, an aggregate: "aggregate of the skirt, of the sunray, of a street, of a woman, of a vista, of a colour…constructing a region'". (Parnet 1996)

When I read this excerpt from Parnet's interview with Deleuze, it occurred to me that choreography was also an aggregate, an assemblage. Choreography was not just about dancing and making dances. It was also about the desire to make a dance, the desire to be a choreographer, and the assemblage of a range of elements that were about constructing a subjectivity, not just making a dance. I thought, when I read Deleuze's description of desire as an aggregate, "yes, that's exactly what it's like when I make a dance". It occurred to me that my interest in choreography was less about producing dances as products than about generating elements of subjectivity. Moreover, these elements of subjectivity were not all contained within the framework of the dance language I was using. All kinds of elements of subjectivity were circulating in my dances that were, and were not, related to aesthetic traditions, dance conventions, and displays of choreographic ability. I suddenly saw the continuity between self and artwork, not in the modernist sense that art is an expression of the artist's interiority, but in the context of a bigger assemblage: in what, in a Deleuze and Guattarian context, one might call a dancing–thinking war machine.

Would I have come to the same conclusions had I been researching someone else's choreography? It is impossible to know for sure, but I suspect not because the initial connection I made between choreographing and the production of subjectivity came out of my subjective experience of being a choreographer, not out of my knowledge of dance as a field.

Deleuze and Guattari suggest that there is no unified, essential subject who speaks, but rather that subjectivity is produced from a range of cultural/social subjective capital. In their words:

> The collective assemblage is always like the murmur from which I take my proper name, the constellation of voices, concordant or not, from which I draw my voice…. To write is perhaps to bring this assemblage of the unconscious to the light of day, to select the whispering voices, to gather the tribes and secret idioms from which I extract something I call myself (Moi). I is an order word. (Deleuze and Guattari 1987: 84)

I came to understand my choreographic process as a similar process of gathering together elements of subjectivity. I gather together the specificity of my unique dancing body, my history, my experiences, my knowledge of dance, my desire to communicate, and I assemble them together on the plane of exteriority of a dance.

Adopting a Deleuze and Guattarian framework for understanding my dances as ways of producing subjectivity, shifted my focus away from the traditional dyad, process and product. Rather than documenting my dance–making processes or interpreting my finished dances, I came to understand my research project as con-

structing dances as actions, or, what Deleuze and Guattari would call "production" (Deleuze and Guattari 1987). That is, the dances are not processes, although processes are used to make them, and they are not products in the sense of being completed statements, repositories for information or sites of communication. Rather, they do things, and what they do is to bring together a range of ideas, stories and ways of moving to produce a danced subjectivity.

Dance, in this context, becomes an exchange of elements of subjectivity, a kind of circulating economy of the subject. More importantly perhaps, was the way in which my dances were means of producing an individual subjectivity. Suely Rolnik talks about the commodification of subjectivity as an inherent aspect of global capitalism. She describes subjectivities as:

> Ways of dwelling, dressing, conducting relationships, thinking, imagining—in short, maps of modes of existence that are produced as genuine "prêt-à-porter identities" (…ready to wear…) that can be easily assimilated, in relation to which we are simultaneously producers, spectators and consumers. (Rolnik 2002: 2)

She argues that capital captures the power of invention and that even artists, or perhaps especially artists, by virtue of the celebrity making process, are caught up in that capture as 'the quality of being artistic has become not only saleable but also, and especially, something that helps to sell or be sold' (Rolnik 2002: 7). The very identity of the artist, her subjectivity, has become commodified. The coining of the term "creative class" to describe a group of people who make inner city suburbs desirable to live in, before themselves being priced out of those same suburbs as they become prestigious and therefore expensive to buy in, is perhaps an example of this phenomenon.

For Rolnik, resistance involves aiming to protect 'life, in its infinite process of differentiation' (Rolnik 2002: 9). That is, the active invention of alternate scenarios, possibilities and identities is crucial in avoiding the easier, but ultimately dulling, anaesthetizing effect of the ready–to–wear luxury identity which is seemingly always (but rarely actually is) on offer through the acquisition of goods and services.

I am arguing here, for any kind of authentic identity. I am not suggesting that my dances represent some kind of nostalgic return to an authentic interiority that can be expressed. But they do refer to the material. That is, they refer to my material, physical body. When I am dancing and making dances, I find ways of foregrounding my unique, and hence unrepresentable, physicality. If corporeality and subjectivity are related[3], then the effect of my physical presence in my dances is to contribute unique elements of subjectivity. I produce a resistance to Rolnik's "ready made" subjectivity in my dances by particularizing, or materializing, the discussion. For example, *Kim's Style Guide for the Kinaesthetic Boffin* (Vincs 2001) brings together a set of subjective elements; my dancing body, a particular medical history, a set of assumptions about dance techniques, and a set of movement material, to produce a delirium in which the potential malleability of the body to change is in tension with its material-

ity which limits physical change. The dance provides no answer to this tension, but addresses it by particularizing the discussion. That is, it combines a unique set of subjective elements to produce a dance-d and written desiring machine that presents a uniquely structured subjective assemblage that plugs into this tension.

Outcomes

I began this Chapter by saying that I wanted to suggest a research methodology in which dancing and making dances becomes a space or a substrate within which to think about dance. My own research process led me on a journey from imagining that my dance practice could be described and theorised in writing to devising a methodological re–situation of writing in relation to dancing. I discovered a complexity and heterogeneity in my dance practice that drove me to adopt Deleuze and Guattari's philosophy to envisage a dance—writing—desiring machine in which dancing and writing function together, on the same epistemological level, rather than one translating or representing the other. I also came to re–constitute subjectivity in dance as a process of individuation and assemblage that challenges the sale of capitalised "ready-to-wear" identities by producing an individual, physically unique and material set of meanings.

These two outcomes of my research, one a methodological shift and the other a danced intervention in the production of subjectivity, made it inevitable that I would see dancing as a process for thinking about dancing. I came to see the fallacy in the attempt to translate, not just dance, but anything, be it writing or theory or history. There is no translation. There are only connections to be made with other things, both like and non–like. Whether I write, or whether I dance, I produce by assembling a group of functional elements around me. I don't translate, relate, or enumerate anything. When I write, I don't translate my dances but I create a new trajectory or line of flight. Ontologically, the dance might generate a written discussion, but the discussion always goes further than the original dance as other subjective elements, cultural tropes and histories impinge upon the discussion. When I dance, I don't translate some pre–existing idea I had about making dances. My body and my history come with me, but I graft them onto new systems of meaning, new elements of subjectivity, and new discourses that have no axiomatic consistency.

With this kind of understanding of dancing, dancing and thinking about dancing become actions that function with each other, connected to each other to form a thinking–dancing machine. There is no primacy of one activity or the other. The dances became an essential substrate or ground within which to think about dance. The outcomes are the dances themselves and also the thinking about dance that was done by making and writing about the dance. Making dances became a methodology for thinking about dance, not in the sense of the dance being an object to be observed (poked, prodded, documented and interpreted), but in the sense that the dancing functions with analysis and writing.

What did this methodology allow me to do? In developing an exegesis of my dance works, it allowed me a freedom of writing within which I found I was able to articulate the complexity of the dance works much more fully than a traditional

analysis would have done. I did undertake the exercise of writing a series of traditional analyses, which examined the historical dance context my work was made in, the notions of subjectivity extant in those historical and aesthetic traditions, and how my dances functioned in synergy and in opposition to those conventions. I then re–mapped my dances in written deliriums which allowed me to reorganize and, in Deleuze and Guattari's terms: de–stratify those analyses and re–assemble them in new ways.

Perhaps the significance of the work can best be described by the way in which this understanding of methodology enabled me to place the unique physicality of my choreographic practice at the centre of a discourse about subjectivity. This is to insert the material and the particular into a discussion about subjectivity: which is perhaps the point of making a delirium about subjectivity that is productive, can be used, but not reported or translated. This is to present knowledge itself in a material and specific way.

This is also the crux of the whole debate about studio art as research. Art practice is able to produce knowledge in a unique, material and specific way. It is not a generic kind of knowledge that can be mapped onto other fields or other works of art. This is the whole problem with art analysis that seeks to define categories to neatly organise artworks and must, in order to preserve its nomenclature, ignore the profound epistemological disjunctions that can occur between artworks of seemingly similar aesthetic, genre and content.

The typical modus operandi for studio practice in dance, and perhaps in any art-form, is to produce knowledge, identity and subjectivity in a unique material way. In the context of the picture Rolnik (2002) presents of capitalism as a system that captures and commodifies identity itself, the unique work of art can be understood as not just a welcome, but a necessary philosophical intervention.

8

A CORRESPONDENCE BETWEEN PRACTICES
Stephen Goddard

What characterises creative arts research practice in universities that offer doctoral degrees is the requirement not only to undertake a substantial practical project, but also a reflective exegesis that contextualises the methodologies and significant contributions of the research. The specific components of the exegesis are defined by each institution and re-negotiated by each candidate according to differing emphases. Fortunately, and by design, the function of each candidate's exegesis can be re-defined in relation to the practice it seeks to elucidate. And whilst the requirement to also present a substantial written component can initially appear as a burdensome or daunting prospect for those unfamiliar with the processes of critical reflection —to those who recognise its reflexive possibilities—the exegesis in parallel with the creative work of the project can provide another arena of creative practice. In this respect, the outcomes of both a creative arts-based project and its exegesis can be presented as significant contributions to knowledge in the field. Moreover, a third creative space opens. By interchanging and integrating the practice with the exegesis, it may be possible to generate a combined and reflexive research praxis. This chapter examines aspects of the practice-exegesis relationship with reference to my experience of undertaking and completing my doctoral research at Deakin University. I am, therefore, speaking from a position of having confronted and struggled with the practice-exegesis relationship from inside the playing field.

The result of my doctoral research was presented as a creative work and an exegesis. The research project was an autobiographical video production entitled, *Lorne Story*. This video production was in the form of a video postcard—an epistolary video reporting *on* the creative research practice *as* a creative *video-specific* research practice. The accompanying exegesis was also in the form of a report—a written letter reflecting *upon* the creative video research practice, and reflecting upon itself—as a creative *written* research practice. This approach suggested that both the practice and the exegesis are creative research practices—both separately and together. In my research, the relationship between the practice and the exegesis also developed as a correspondence *between* practices.

Just as each candidate designs their research project, it is possible (within enlightened institutions) for creative arts researchers to re-interpret and make sense of the

specified requirements of the exegesis. The first principle, the first permission, I established for myself, was that the practice-exegesis relationship needed to be re-negotiated. I wanted (and needed) the exegesis to fulfil the Deakin University higher degree by research requirements for creative arts-based practice. This included a description of the research project, an account of the procedures and techniques utilised, a comparative contextualisation in relation to the fields of inquiry, and a series of contributions based on the findings and conclusions. I also wanted the exegesis to be something other than separate from the creative practice. I needed to find a way in which the overall research process (as a narrative) could be considered as creative, systematic and based on generative research practices. As such, one of the methodological aims of the doctoral research was to focus on the possibilities of utilising video as a creative research practice, and the ways in which an exegesis could also function as a creative and reflexive research practice.

The Personalised Postcard

As a hybrid form of postcard, *Lorne Story* combines photography and moving images with a soundtrack that mixes composed music, location sounds and a personalised vocal address. As a video production, it functions in a variety of ways. It is a form of video postcard directed towards a specific addressee, a self-directed version of a director's video notebook, and for both myself and external audiences, it is also a reflexive travelogue and autobiographical video memoir. At each turn in the road, *Lorne Story* changes its form but retains its overall character as a personal communication.

After completing the editing of the video practice and at almost the final stage of writing the exegesis, I stumbled upon an image that seemed to not only reflect on my practice, but also its relationship with the exegesis. I was presented with a family photograph that was formed into a postcard. (Courtesy of the Goldman family, 1934.)

On first seeing this personalised postcard, I was initially fascinated in the way it functioned as a poignant family narrative. I then realised that there were formal and structural similarities between this personalised postcard and the ways in which *Lorne Story* functioned as a video postcard. Both feature separate spaces in which a personalised image forms the basis of a personalised form of address, and both were designed to be sent as a form of family correspondence. The personalised postcard was reinforced with cardboard and utilized a similar design to conventional postcards, with an area on the reverse side for writing, an address and a stamp. *Lorne Story* as a video postcard used a series of video tracks as layers for still and moving images, and an audio-track that featured music, location sound and a vocal address. Primarily at the beginning of the production, there is a direct address to the camera oriented towards a single addressee. Throughout the vocal and visual narration, there are reminders that the video postcard is addressed towards a family member across the waves. In this regard, *Lorne Story* also functioned as a gift and a sharing between family members across distances. The personalised images include the direct address to the camera, scenes recorded at family events, handheld dramatised (re-)enactments,

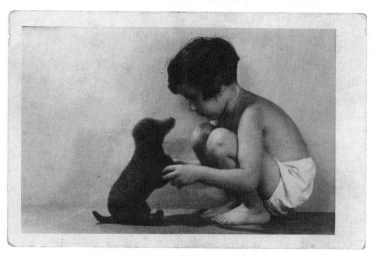

Family photograph as a postcard, 1934.

and photographs depicting familial beach holiday scenarios. These scenes are annotated by a personalised vocal address that parallels but never quite meets with the images. The vocal track is neither intended nor does it function as an explication of the images. (In much the same way, the exegesis does not function as an explanation of the creative practice.) Both technically and conceptually, the sounds and images are on separate tracks. This separation is similar to the traditional postcard in which photographic narration occupies one space and written narration another.

Being presented with this personalised postcard from 1934 was akin to being in-
troduced, for the first time, to a relative I never knew existed. It also provided a
comparative allegory for what I was seeking to develop with my own video postcard.
On one side, personal imagery, on the other, a space for reflection and an address.
In *Lorne Story*, site-specific reflections were improvised, written and performed as
both an interior monologue and as an external address. Discovering a parallel prac-
tice such as the personalised postcard brought into focus a series of correspond-
ences that encapsulated the reflexive relations between images and words *within* the
practice, and the creative interplay that also existed *between* the practice and the ex-
egesis. Within the practice, *Lorne Story* operated as a video-specific postcard, in which
sounds, images, words and meanings were in transit. Throughout the research proc-
ess, the relationship between the practice and the exegesis continued as a circulating
exchange. It became a dialogue between written words and recorded images. Within
these transitional movements, lay the possibility of drawing connections between
practices—between writing and video, and between the practice and the exegesis.

One of the assumptions associated with the practice-exegesis relationship is that
the exegesis is necessarily fortified by theoretical "underpinnings" or "groundings".
These terms are, in themselves, words that conjure anchors and only the semblance
of stability. The association of the written exegesis with the expectations of theo-
retical discourse is especially poignant in relation to the appointment of doctoral ex-
aminers, more familiar with the submission of a traditional written thesis. However,
even for those unfamiliar with the concept of the exegesis, the issues surrounding
the practice-exegesis relationship continue in the wake of previous debates concern-
ing the integration of theory and practice. The goal, as ever, continues towards a
hybridised activity of praxis. In relation to the mis-recognition and valorisation of
theory (over practice), Gilles Deleuze articulates the plea to, once again, reconsider
the collapse of the theory/ practice dichotomies because:

> Philosophical theory is itself a practice, just as much as its object. It is no more
> abstract than its object. It is a practice of concepts, and it must be judged in the
> light of the other practices with which it interferes. (Deleuze 1989: 280)

Deleuze properly includes and summons those who consider themselves as either
practitioners or theorists to a joint effort towards generating interactive dialogues
between conceptual practices. In this respect, terms and labels such as "practitioner"
and "theorist" are useful only as they become more indistinct and interchangeable.
During the process of my doctoral research project, I was more prepared to dis-
pense with singular notions such as researcher, theorist and practitioner, preferring
instead to adopt the "reflective practitioner" model used in the creative arts.

As a writerly practice, the exegesis can be as creative, fictive, and as full of playful
conjecture as the other creative practice (or practices) it seeks to elucidate. It was for
this reason that I decided to construct my exegesis as both a reflection on the video
practice and its own creative practice. Both were forms of epistolary correspond-
ence—letters, fashioned as corresponding research reports—directed towards a spe-

cific addressee and also directed towards a series of unknown (and unknowable) addressees. As letters, they sought to encourage a sympathetic exchange.

As a written document, the letter has historical associations with a culture of scholarship, erudition and learning. The tradition of sharing and disseminating academic research is based on the exchange of letters between peers. Initially, private letters were exchanged between colleagues as a form of communication, in order to test theorems and theses. Eventually these letters between peers entered the public domain through publication within scholarly journals. To continue within this tradition, I designed both the video practice and the exegesis as an epistolary reportage. This was in order to demonstrate that the practice could include its own exegetical meta-narrative, and that the exegesis was also a critical and creative narrative, linked to the practice it sought to report on. In both the practice and the exegesis, symmetries of correspondence echo.

As a practice, *Lorne Story* was a research correspondence in the shape of a video postcard. As a hybrid form, the video postcard enacted a meeting or a dialogue between writing and video practices. The exegesis was also an epistolary correspondence in the shape of a letter—a reporting on the origins and procedures of the practice, with a comparative analysis of its findings in relation to a series of intersecting contextual fields of research. Both were reflexive practices that foregrounded a meta-narrative critique.

The methodological approach adopted throughout the research practice was one of contextual comparison. As Deleuze suggests, 'the only true criticism is comparative ... because any work in a field is itself imbricated within other fields' (Deleuze 2000: 367).

My research was situated within and across the overlapping fields of autobiographical writing and subjective video practices. One of the aims and continuing concerns of contemporary creative arts research practice is the attempt to develop appropriate methodological strategies that link the exegesis and the research practice. This is part of a wider research strategy that recognises and values the role of a reflective practitioner within the process of a reflective practice (Schon 1995). Rather than relying only on the written component of an exegesis to demonstrate a reflective process, it can also be reflexively performed within the practice itself. For example, the first part of *Lorne Story* presents a subjective story about and around the seaside township of Lorne. In the second half, the videotape presents a reflexive analysis of the story, by returning to the site to record (on camera) the process of analysis.

One of the distinct advantages of video technology (compared to film), is its ability to provide instant audio-visual feedback via direct monitoring. It is possible to electronically see and hear what is being recorded whilst it is being recorded. With film, and its reliance on chemical processing, there is an inbuilt delay mechanism. Video also provides the possibility of replaying what was recorded in the same location as it was recorded. The idea of using one camera to record what another camera was replaying became the foundation of the meta-narrative in *Lorne Story*. Whilst the first part of the video production features a re-enactment of a beach holiday surfing accident, the second part includes a meta-narrative in which I sit on the shore

recording myself whilst watching and commenting on the previously recorded re-en-actments. Both the re-enactments and the meta-narrative commentaries are recorded at the site of the original adolescent incident.

The meta-narrative that occupies the second half of *Lorne Story* both questions and adds annotations to the re-enactments and to my uncertain recollection of the original events. The meta-narrative does not provide a coherent, explanatory master narrative. It merely provides another perspective on the events surrounding my ado-lescent fall from grace. After the passage of more than thirty years, an un-tethered surfboard becomes a symbolic shield representing a slippery set of floating memo-ries. The meta-narrative becomes another testimonial version and adds a few more pieces to a jigsaw puzzle that remains incomplete.

By integrating a narrative with its meta-narrative monitoring and critique, *Lorne Story* generated a series of fragmentary stories. Many of these stories were devel-oped by alternating between a written and video version of a director's notebook. In this respect, both the video production and the written exegesis were two parts of the same practice. I was attempting to trace the ways in which writing and video technologies mediated and recorded my memories, stories, annotations and analyses. To this end, I used the video camera as a form of memory detector, sweeping the shoreline for lost trinkets and fragments of memory. Elements from this video ver-sion of a field diary frequently found their way into the video production. They were also included as source material for analysis in the written exegesis. Recollections that originated as written notebook entries were also transformed into the script and integrated into both the video production and the exegesis. Whilst the final doctoral submission presented the creative project and the exegesis in two separate forms, I always wanted the video production and the exegetical writing to be considered as complementary corresponding practices. Both were epistolary reports generated from video and written field diaries.

Through the process of annotation and combination, a form of reflective and reflexive video exegesis was integrated *into* the video production. I was attempting to present and integrate the reflexive processes of the practice-exegesis relationship by including elements of the exegesis into the practice. This meant that the exegesis was also the site for a creative epistolary narrative that reported on itself and the overall research journey.

As a methodological strategy, it was useful to integrate the narrative of the re-search process into both the practice and the exegesis. This was only possible by considering and designing both as congruent creative practices. In particular, this approach was based on highlighting the ways in which a video-specific practice can generate and integrate a reflexive exegesis. It also recognized that the research proc-ess of structuring and writing an exegesis is, itself, a narrative. The overall narrative of the research process includes the story of the practice-exegesis relationship, and the ways in which both the practice *and* the exegesis reflect upon the chronology of the research process. Ultimately, a correspondence occurs *between* the practice and the exegesis, as a series of interactive dialogues.

Resisting Explanation

Within my research practice, the exegesis was described in a number of ways: it was a written accompaniment, a supporting document, and an elucidation. This was a strategy to negate the assumption of explanation. Not everything in the video practice or the exegesis was explicable. It was neither necessary nor possible. As Walter Benjamin suggests, it 'is half the art of storytelling to keep a story free from explanation as one reproduces it' (Benjamin 1968: 89). In this respect, a storyteller performs with the same technique as a magician. They both seek to reveal and conceal with the same sweeping gesture.

Both the practice and its exegesis are narratives that resist complete explanation. The role of an exegesis is not to attempt an analysis or critical interpretation of the work, but to present a sense of the creative decision-making process(es) within the context of the research practice. These workings in the margins are usually invisible to an audience, and also somewhat invisible to the practitioner, if they remain unexamined. As a form of behind-the-scenes reporting shaped as a letter, my own exegesis was a continuation rather than a summation of the practice. I was unable to consider the exegesis as an ending. An exegesis can neither exist as the final word, nor an end to meanings.

Whether it is photographic or videographic, a letter or postcard is always accessible to multiple audiences, erasure, defacement and destruction in a postal or delivery system that can never guarantee transmission. Whether it is its physical arrival as a communiqué, or the passage of its intended or floating meanings, a postcard need not reach its intended destination. As a video postcard, *Lorne Story* also refused to arrive at either fixed destinations or guaranteed meanings. The meanings produced by sounds and images can never be assured, because they are in a process of constant oscillation between the audience and the screen. As with the video practice, the exegesis developed a personal form to suit the research purposes. The development of the structure and form of the exegesis, and its relation to the research project, was an attempt to integrate a creative research project with an exegesis. The integration occurred across a series of interactive inter-dependent practices: as epistolary forms of correspondence, as a hybrid mix of subjective styles of address, as the consequence of the written and videographic notebooks and as reflexive forms of reporting. Both the practice and the exegesis also collaborated as interlocking travelogues, reporting on the research trajectory. As an example, the Preface to the exegesis functioned in much the same way as the opening direct address of the video practice. Both provided an opening movement—an overture to the journey that follows.

As a research practice, *Lorne Story* integrated reflective and reflexive stories, storytellers, and storytelling strategies within the practice. At no time was there a singular privileged narrator, either inside the diegesis or outside the practice. As one of the multiple subjectivities, I was at the same time a producer of meanings and produced by the practice. In much the same way, the exegesis did not present singular or conclusive explanations of the video practice. It was an extension of the practice, contextualised across a series of fields. As with the video practice, the exegesis developed and generated its own narrative by utilising a reflexive methodology.

What makes visual, performative, and media arts-based research so distinctive are the ways in which they conduct their enquiries beyond the sphere of written discourse. Inevitably, the ideas, methods and processes investigated through the practice of *Lorne Story* were not reducible to writing. As a video-specific production, the audio-visual elements existed beyond written language. And when writing the exegesis, I was not attempting to translate from sounds and images, but to correspond in another mode. Nevertheless, the requirement to present the exegesis using typeface and paper raised some troublesome issues. For example, how could my known and unknown addressees refer, on the one hand, to the practice as a continuous video, and on the other, balance this with the written exegesis? What would happen, if inadvertently or by habit, the addressees or the examiners decided to initially pick up and then remain with the written exegesis rather than play the video production? To provide audiences with the sense of how to navigate through the materials, I used the Preface to set the scene, indicate the length and format of the video production, and suggest a pathway. Although I recommended a specific linear route that started with the Abstract, progressed to the video, and returned to the exegesis, I knew that interruptions and cross-examination might occur. Ultimately, I decided to integrate elements of the exegesis into the practice, and elements of the practice into the exegesis.

Currently, with CD ROM, DVD and the computer as a site for delivery and presentation, there are possibilities for specific forms of arts-based practice to combine written, performed and audio-visual exegeses in a singular space of convergence. Perhaps in the future, the role and form of the academic exegesis may well be transformed with the development of new and appropriate forms of documentation and presentation.

I have tried to suggest that one of the ways in which reflective practitioners engaged in creative arts-based research can develop their practice, is by developing reflexive methodologies that examine their own procedures and operating assumptions. As a form of storytelling, *Lorne Story* could not have been produced without its video-specific technologies and a methodology that foregrounded subjective and reflexive strategies. Similarly, the overall research orientation could not have been developed without the existence of the practice-exegesis model and the possibility of integrating one with the other. Whatever was developed or discovered throughout the research process was generated not only through the practice, but also in the relationship between the practice and the exegesis. In that space, it was possible to consider video not merely as an extension of the photographic postcard, but as an inimitable mode of communication in which sounds, images and writing contributed to a distinctive form of research practice.

The possibility of imaginatively integrating a creative practice with a creative exegesis may well be considered as one of the strategies that characterises and differentiates creative arts-based research. As a distinctive methodological approach, it also recognizes that the development of the practice-exegesis relationship generates a mutual inter-dependence and a correspondence between practices.

Within our own practices, and in the spaces between the practice and the exegesis,

it is possible for a reflective practitioner engaged in a reflexive practice to generate a dialogue and to address this discourse towards a community of peers. In *Lorne Story*, the movement from reflective story to reflexivity and the movement between video postcard and the written letter, was an attempt to not only link a cast and crew of subjectivities, but to connect with the exegesis and with external subjectivities. As ever, the desire was, and is, to find commonalities and correspondences, across the waves.

Acknowledgements

Thanks to the Goldman family for permission to reprint the images.

CREATING NEW STORIES FOR PRAXIS: NAVIGATIONS, NARRATIONS, NEONARRATIVES
Robyn Stewart

Navigator, Navigations, Navigating

Research: It's all about navigation really. In my country we drive on the left hand side of the road. Our directions, rules, pathways and processes are geared to this activity. When these are disrupted feelings of instability and insecurity pervade. To drive on the right, my certainties as a driver are disrupted, I feel out of control, destabilised and lost. To survive I went orienteering.

My senses are heightened to cater for a new approach; I establish new ways of recognition and behaviour, I learn to read new cultural codes, I concentrate on finding my way through a foreign process until eventually I naturalise this and become a confident, comfortable driver again: on the wrong side of the road.

On a recent journey through Europe we developed a collaborative way to support each other as we travelled, by creating new ways of mapping, new codes, languages, customs and strategies. We asked questions, we observed acutely, we planned systematically. In our small car, our cultural space, we created a third space, a place of hybrid practices that crossed cultural boundaries of language, visual codes, currency conversions and national customs. We did this by associating these to our cultural conventions, things we knew and understood, and translating them accordingly. Our survival mantra became "What's my name? What side of the road am I on? Where am I going?"

Identifying Landmarks

> By looking into the soul of another we often find ourselves delving just as deep into our own private worlds of identity and place (Cowell 1997: 46).

As I grow as researcher, artist and teacher I have become acutely awareness of how I have managed to recognise and navigate my learning processes and problem solving capacities. As a reflective practitioner (Alverson & Skolberg 2000, Bartlett 1989) I believe that these negotiations and connections strongly underpin my pedagogical praxis. So when the challenge to develop studies in research for the visual artist arose, I brought to the task an awareness and mapping of my practices, understandings of

the studio and the classroom together with the need to see how others practice. I began to ask artists about what they do and how they conceptualise their practice as research. From these beginnings, courses have grown that explore processes for studio-based research in the visual arts. This process of collaboration is illustrated briefly using extracts from stories by others who have worked with me in this process.

My conceptual foundations grew from an awareness of the fit between my knowledge and practice in the studio and classroom, my experience in implementing traditional quantitative research methods and the challenging necessity, as a graduate student, to construct and rationalise a qualitative methodology to best fit my research project at that time. The outcome of this exploration became known as *Neonarrative Method* (Stewart 1994, 1996). My research practice continues as a process of continuous discovery, filled with correspondences and contradictions, intuition and surprise, serendipity and discipline.

Having been trained in qualitative (Carr & Kemmis 1986, Connelly & Clandinin 1987, Eisner 1979, Goetz & le Compte 1984) and quantitative research methods and processes in the 1980's (Campbell & Stanley 1963), I initially learnt to see my practice from a distance, speaking as an observer, looking at and on practice rather than approaching it from within. In line with prevailing calls for objectivity, my voice was at worst withheld and at best muted in the process of reporting about other's ways of living as artists and teachers within their lifeworlds. Yet more recently, the resonance of new methodological discussions (Lawrence-Lightfoot & Hoffmann Davis 1997, Jeffries 1997) that urge researchers to recognise the subjective nature of research and to position themselves clearly within the work, was something I embraced and, I thought, adopted for my ongoing practice.

However, four years ago, the level to which I had naturalised the "objective" approach was brought home to me rather strongly following my presentation of a research paper addressing the processes of neonarrative construction. A perceptive student observed that my voice was silent throughout the paper. What a salient and apocryphal moment! I was suddenly aware of a personal gap between my ideological position and the actualities of my praxis. It became clear that, despite my claims for centrality, I was actually writing out my position within the research process as artist, researcher and teacher. This comment signalled my apocalypse and while I remain convinced that the methods of neonarrative are useful to draw together ways we talk about our practices as practitioner researchers, artists and teachers, I am also conscious of the need to include myself in the storying.

I realise that the conceptualisation, design and development of the neonarrative method was a pivotal process in my researcher development and that it continues to inform the basis upon which are built my current understandings of the kinds of research methods that are useful for me as artist and teacher. My approach to practitioner-based research is to conceptualise it as critical, reflective, investigative praxis. Praxis, for me, involves the crucial and inextricable meld of theory and practice. Thus practitioner-based research is concerned with processes for theorising practice, using appropriation, pastiche and collaboration as basic tenets.

In moving creatively into our practice we are fundamentally concerned to develop

new knowledge, to challenge old beliefs and to speculate on the "what ifs" of our concepts and processes. For the arts practitioner, whether studio or classroom based, new knowledge is made in the context of and challenge to the history, theory and practices of our relevant field. The research function for developing and extending knowledge is judged on the outcome of the research, which synthesises, extends or analyses the problematics of the discipline (Guba & Lincoln 1989). As one of my research students, Chicako Urata has observed:

> The process employed in creating my works of art usually comes from look-ing, finding, arranging, thinking, researching, drawing and creating. The dif-ficulty of handling the materials may reflect my life experiences in both Japan and Australia. Experiences that were difficult in a cultural sense. I am looking at the 'possibility' and 'freedom' of the installation (space), because there is no boundary (limitation) in the space. When you face multiculturalism and cultural difference, I don't see the boundary or ending there, I believe that it is a starting point. Experiences contribute to the development of personal identity through recording and theorising aspects associated with these experi-ences. My cultural identity is unique and complex. There are always two ways of thinking, behaving, speaking and viewing. I express the characteristics in my work of art. (Urata 1999: 46)

In a rapidly changing world of multiculturalism, post colonialism and globalisation, notions of hybridity increasingly inform our praxis.

Plotting a Course

As an artist, researcher and teacher, I have long been made conscious of (and some-times criticised for) my diverse and hybrid approach to praxis. As educator, studio practitioner, theoretician and culturalist, I bring a many faceted approach to this field (Nelson, Treichler & Grossberg 1991, Polanyi 1985). As a teacher with an initially trained and practised pedagogy for grades one to twelve, I have a broad understand-ing and interest in learning processes in the visual arts. These became highlighted when as a young academic I worked between theory and practice and across fine arts and art education. As a teacher of art educators, I learned to deal with adults learning about the arts and their making, within a climate of adult uncertainty, lack of arts literacy, and sometimes an antipathy towards the arts. As a teacher of artists, I con-tinue to grapple with the nexus between theory and practice, provoking students and colleagues to work as informed, inquiring and reflexive practitioners. Consequently, my concerns are informed at many levels by processes for effective and meaningful art education (Eisner 1979, Chalmers 1990, Goodson 1988).

While my work now explores the possibilities of research for the artist as studio practitioner, it is framed by my activities as a teacher of artists. Through my teach-ing, I approach practitioner-based research as a way of working, investigating and theorising what it is to practice in the studio as researcher (Dissanayake 1990, Van Maanen 1990, Turner & Bruner 1986). In this process, my classroom has become

synonymous with my studio, functioning as a laboratory for research (Weirsma 1995). I see that my hybrid practice includes crossing over between spaces and places, exploring and practising in diverse and often foreign fields, retaining an excitement about change and difference, practising simultaneously as artist/researcher/teacher.

My work reflects the outcomes of collaborations with artists and students. Its process explores and suggests possibilities and sources for practitioner-based research practices. It recognises that practices in the arts and education by their very nature, are underpinned by structure and improvisation, order and creativity, experience and intuition. This approach draws heavily upon qualitative research methods from perspectives and discourses of social science inquiry (Berger & Luckman 1981, Carr & Kemmis 1986, Crites 1986, Goetz & le Compte 1984, Carlgren & Lindblad 1991). Through research and teaching, I work to delineate processes and methods of inquiry with a blend of artistic resonance, literary principles and scientific rigour. The emphasis lies in discovering and exploring alternative ways of conceptualising and understanding research and its practices.

The scaffold for this approach to practitioner-based research, is to consider the essences of traditional research models in order to understand and critique their scope, breadth and parameters. In this way, we can become better able to seek out relevant models for praxis, to appropriate terms and processes and to research knowledgeably within the field. The process is likened to a simulacra in the paradoxical sense of being simultaneously the same and different to traditional and established research models. Its emphasis is largely qualitative, demonstrating and playing with the interconnectedness between differing methodologies as a kind of intertextuality, a bricolage (Stewart 1994, 1996, Weinstein & Weinstein 1992, Brewer & Hunter 1989).

I see the nature of practitioner-based research as hybrid in that although it finds its base in qualitative methods; its practices blur the boundaries of aesthetics and experience in an effort to capture and reflect the complex dynamics involved in the phenomenology of artistic practice (Marton 1981). The practitioner researcher, whether artist or teacher, takes central place in seeking to uncover, record, interpret and position, from an insider's perspective and experience, the processes they use within the context of professional contemporary practices in the field. Their stories, when placed in historical, social and cultural contexts, form a neonarrative, a new story shaped through autobiography as a portrait-of-self that mirrors and situates their experience. This reflects a process for theorising practice. Helen Mayes provides illustration through an explanation of her artistic process:

> When I draw and transfer the larger images from the smaller ones, I am not merely enlarging each drawing. I am rediscovering the lines and all of the marks associated. I am always beginning afresh … to make something unfamiliar familiar. Research is about finding, not searching. My theory has been about finding answers to questions regarding my practice. The collection and analysis of data describe all the problems, revelations, mistakes, thoughts, highs, lows and regrets involved. My studio time seems to be constantly filled with tests and challenges which naturally needed to be solved. The materials

and processes cause the friction and influence the outcome. My actual process of drawing has its own system of dialogue too. Not only that, but, I produce a dialogue when working with the materials. (Mayes 2000: 41)

The relationships between studio and theory form meaning-rich partnerships. They resonate within and across our fields, as arenas for presentations of credible and compelling stories. These stories address processes for exploring the aesthetic, empirical (experience-based) and ethical dimensions of what it is to practise in the studio as artist, musician, writer, performer, dramatist, dancer, teacher (Chatman 1981). These are processes of border crossings that come together as bricolage. The resulting stories create a third space by melding theory and practice into a neonarrative, a new story that is different or richer than those that had gone before.

Intersections and Roundabouts

The pathways of my practice recognise and conceptualise the phenomenological and autobiographical nature of studio-based research in the arts. From these grew a many-faceted approach based in bricolage. This is a process of looking more closely at the practices and positions of artists as researchers while identifying avenues of appropriation from a variety of qualitative research methods (Weinstein & Weinstein 1992, Stewart 1994, 1996). Its process hopefully reflects something of the enigmatic artistry of the essence of image production, reception and transmission. Such an eclectic approach is in keeping with visual arts practise for the artist, teacher and viewer.

"Bricolage" is a term that offers a way to describe what we do. Here it refers to approaches to research that use multiple methodologies. These consist of a pieced together, close-knit set of practices providing solutions to a problem in a concrete situation. The construction changes and takes new forms as different tools, methods and techniques are added to the puzzle. For example, the methodology of cultural studies is a bricolage that is pragmatic, strategic, self-reflexive practice. In creating a bricolage, the bricoleur appropriates available methods, strategies and empirical materials or invents or pieces together new tools as necessary. The choice of research practices depends upon the questions asked. The questions depend on their context, what is available in that context, and what the researcher can do in that setting (Weinstein & Weinstein 1992).

A bricoleur is familiar with and works within and between competing and overlapping perspectives and paradigms. To do so, they read widely and become knowledgeable about the many interpretive paradigms that can be brought to a problem. The possibilities are vast and reflect the diverse ways of artistic practices. Research models to draw on include Feminism, Marxism, Cultural Studies, Constructivism, which may encompass processes of phenomenography, grounded theory, visual analysis, narratology, ethnography, case and field study, structuralism and poststructuralism, triangulation, survey and other research approaches.

As you see, I am arguing that if we are going to play in the field of research we need to understand many research methods. We need to appreciate that each has

limits and strengths in order to make a fit between the models selected and the particular needs of the paradigm under investigation. We need to use research as an interactive process shaped by our personal histories, gender, social class, biography, ethnicity and race. The resulting bricolage will be a complex, dense, reflexive, collage-like creation that represents the researcher's stories, representations, understandings and interpretations of the world and the phenomena under investigation. This bricolage will connect the parts to the whole, stress meaningful relationships that operate in the social worlds and situations studied.

Bricolage is hybrid praxis. It presents an approach that places the researcher's discourse and practices within another space, between artist and product, producer and audience, theory and practice so that it becomes the space for reflection, contemplation, revelation. The bricoleur is positioned within the borderlands, crossing between time and place, personal practice and the practice of others, exploring the history of the discipline and it's changing cultural contexts. Bricolage enables us to collage experience, to involve issues of knowledge and understanding, technology, concept, percept, skill and cultural and discipline experience. The bricoleur appropriates aspects of research methodologies which best suit the task at hand, travelling between various research disciplines in an attempt to build the most appropriate bridge between aesthetics and experience through processes of production documentation and interpretation. The bricoleur is seeking to explore, reveal, inform and perhaps inspire by illuminating aspects of insider praxis within their field. As Jill Kinnear explains:

> [Visual] research deals with and intensifies elements of research and language that have always been part of the practice of an artist. In the studio I found I was constantly trying to reconcile images, beliefs, facts and ideas, resulting in almost permanent turmoil. (Kinnear 2000: 42)

I am concerned also, to bring together practice and research as purposeful practice. This is to do with creating intentional meaning through a process of rigorous planning, documentation, interpretation, analysis and storying. These processes are underpinned by constant emphasis on the ongoing and critical dialogues between studio and theory, process and product, that are crucial for practitioner-based research. Emphasised is the rigour and discipline of creating art, and the imagination, skill and foresight that enrich the research of the bricoleur.

Orienteering Lifescapes
The important issue here is where to begin? Where does the emphasis for practitioner-based research lie? As practitioners we have a strong base in autobiography as a means of linking art and life. Not only does autobiographical method give us voice, it enables us to write aspects of our lives in a special kind of way (Butt 1985, Plath 1987, Denzin 1989, Elbaz 1987, Goodson 1988, Hawke 1996). Its methods enable us to explore of the variances of decision making within our field and the diversity of creative experiences. Autobiography is a qualitative application, which

enables us to consider influences and meaning and their roles in collecting the kinds of data necessary to explore and demonstrate personal knowledge. Autobiographical method enables a personal investigation of the self: self-research, self-portrait; self-narrative. Deborah Mitchell elaborates this aspect further:

> The stitches and embossing I use to create my work become spontaneous narratives. In my work the stitches and embossing tell the story though the story is more like a conception of feelings and fleeting thoughts than a particular figurative image. Each small piece is part of a memory. (Mitchell 1999: 18)

Autobiography enables the practitioner to apprehend artistic practice by revealing personal experience, in the context of life stories, as the basis of research. It makes rationalisation possible by the revelation of personal reflection, interweaving self-consciousness with experience. Thus the researcher becomes the principal investigator of their professional endeavours. Autobiographical method describes a way to explore the practitioner and their concepts involving the self, identity, history, time, narrative, interpretation, experience and knowledge. It allows us to attend to issues that give meaning to our thoughts and actions as practitioners by picturing personal experience as a way of understanding aspects of reality. Through it, we can systematically take slices of our lives.

By using (auto)biography as personal history, and viewing events within an historical context, we are able to better understand a personal situation by bringing forward prior, related experience. Consequently, the composition of biographical material presents a way of encouraging reflexivity in studies about the visual arts and art education. The process uncovers aspects of personal and cultural influences from family, nature, educational and social conditions, and material things. Such an approach provides a foundation and reference to explain why people act the way they do:

> This is about who is speaking. You or me? The call of the void and the voice of the artist. It is not a verbal language. It is the unknown (but very known). It is expression. Someone calls me and I reply. Wordless, but with something to say. I have discovered how to embrace the void without exposing it to too much light. Others have too.
>
> Breathe in breathe out.
>
> It is possible to explore the nature of the muse without articulating it in language that is detrimental. (Prescott 2000: 34)

It is important to realise that while researchers use biography and autobiography to prompt reflection they rely on the subjective verbal and written expressions of meaning that result. Consequently the languages of (autobiography cannot be taken as simply windows into the "real" world of "real" interacting participants. The languages used reflect the imaginative bricolage of methods people use to rearrange

truths to create texts. Thus, autobiographical statements can be presented as a mix of fictional and non-fictional accounts of lived experiences over time.

Tracing New Stories

The process of neonarrative offers a way to investigate and reveal the many different ways our lived experiences can be described within a cultural scene. It offers a way to link theory with culture and contemporary studio and classroom practice. Neonarratives describe the spaces between and the crossovers that link practice and theory. Their process and construct enables the exploration, explanation and presentation of insider views as authentic ways to understand what seem to be changing practices within the field. Neonarrative method is used to develop new stories to account for the cultural conditions that surround and mediate contemporary art and education, teaching and learning. These tales from the field can be gathered from a number of participants using and blending their biographical stories (Smith 1994) to create an inter-text of experience, or as autobiography to represent the practitioner as resident expert. In either case it offers an interdisciplinary socio-cultural research framework, understood in terms of the contemporary theoretical contexts that provide the socio-cultural dimensions of the study.

Neonarrative method creates a bricolage of processes that centre on the gathering of data reflecting perspectives from players within the field. The research method employs reflection and phenomenography, in which interdisciplinary notions of interpretation, description and comparison are engaged. The approach is useful in that it moves beyond individual facts to perceive general patterns, among existing links, from which to infer broad characteristics. Such an interdisciplinary approach offers a way to link art, teaching and life by taking into account current knowledge in relevant and related fields. It is oriented towards people's ideas about the world and their experiences of it. It models one way to approach the task of identifying, constructing and situating methods for research using links and pathways, the bricolage, involved in packaging the components of a process for research.

Neonarrative method presents a process for analysing what actually happened according to the people involved. The narratives collected become the tools from which knowledge is built (Nespor & Barylske 1991). The experiences, approaches and responses of individuals are recorded and documented and analysed for their unique or shared qualities. Perceptions, values, insider stories, experiences and accounts inform the materials collected. It is a collaborative process and can be used with clusters of participants or as self-research where the supporting stories are found among published writers, artists and educators whose words, images and interpretations add meaning and context to the issues concerned.

The Neonarrative approach is guided by narratology, the study of stories. This is a qualitative method that offers an interpretive reconstruction of an aspect of a person's life. The resulting neonarrative is concerned with developing a plausible meaning-giving account that blends the personal histories of the people concerned with the social histories of their field. This is a process that theorises praxis.

Narratives may be interpreted as essential aspects of social life that enable the

passing on of knowledge without being necessarily concerned with the legitimacy of such knowledge (Spence 1982, Van Maanen 1988). They are essentially tales of the field with a focus on the personal everyday nature of experience of those involved. Important themes identified within the studies can be explored to uncover, interpret and reconstruct significant events that have contributed to the framing of particular aspects of activity in people's lives. A new story (neonarrative) is constructed when the processes that inform the conditions under investigation are theorised and reconceptualised. To do this requires a plurality of approaches designed to enable such a reconceptualisation. This bricolage of approaches is then situated by information gathered from the field. This information may be gathered from history or theory books and articles, personal journals, letters, artworks, catalogues, conversations, observations and other sources.

Mapping a Neonarrative

The research sequence for the construction of neonarratives incorporates (auto)biographical data and collected texts. These two types of account are storied within the contemporary world. This kind of investigation forms an empirical study in that it is designed to observe reality, treating the participants as natural philosophers, embedded in a cultural system and critical of it. It is an attempt to look at the world as people experience it, and to hear it through their narratives, tracing how experience modifies reality. The storytellers focus on key events or experiences in their artistic development or teaching experiences that they feel have strongly shaped their actions. These stories serve as elements for the construction of a neonarrative that consolidates yet recognises differences within it.

There are five phases in this process. These involve identification of the research method, the establishment of the collaborative process, the collection, transcription and review of data (biographical, theoretical, visual, case studies and or other forms), analysis of the data and synthesis into neonarratives. Each phase accesses the autobiographies, stories and other data in a way that is independent, sequential and based on temporal logic.

The data are first transcribed and sorted into salient themes relating to the literature before being systematically structured into narratives constructing and illustrating the experiential quality and explanations within the environmental, cultural and social scenes where the action occurs. A further analysis organises the data into clusters of thoughts. These initial steps provide the essential materials that define the emergent themes.

A thematic approach to the content and narrative construct is used to uncover, reconstruct, organise and highlight the emerging stories and relevant anecdotes. Each theme is used hermeneutically to deconstruct the stories being studied. Themes enable the segmentation of data into categories of phenomena that form chunks or clusters of information. The data can then be further categorised substantively, relating to particular persons or sites, or theoretically, in relation to particular types or aspects of the social process. Interactions identified among and between themes through the accounts of participants add to notions of the inter-subjectivity and

wider accessibility of the narrative. In recognising that we are each culturally located the attitudes and sentiments transmitted by culture are viewed as the framing devices which shape our knowledge and interactions in the lifeworld.

Relevant statements made in support of each of the themes are selected to contribute to each narrative. At the completion of the initial selection and data entry process, each narrative is carefully edited to create as coherent a statement as possible. At the completion of each thematic story, a narrative reduction is created, encapsulating the main threads of the story. These reductions are then used to create the summary narrative at the end of this stage of the analysis. The final phase produces the neonarratives as an amalgam of data and theory to create new stories that are different or richer than those that had gone before. These emerging stories can then be used persuasively to support and reveal the work we do.

Approaching a Destination

Neonarrative method can be used to create as a third space, a storying place that links practice and theory. It is there that the experiences and knowledge of the practitioner can be compared and positioned among the theories from the field that frame the actions of the people involved. Taken into account, is the human element that influences our understanding of aspects of our world. In a sense, neonarrative method illustrates a phenomenographical approach to qualitative research that embraces numerous personal meanings and gives voice to experience. This is derived from the context of direct experience, linking perceptions and interpretations of reality with meaning structures. Its construct is an enabling process to provide distinctive insights linking the individual and their socio-cultural environment.

The experience of developing the neonarrative method has been a journey, a process of navigation, of learning to consider and articulate my praxis in research in meaningful ways. The journey has been challenging and at times confronting and the outcomes have convinced me that understanding processes for researching our own practice within the contexts of our field is a revealing and empowering process:

> It is in the studio that all work becomes a realisation, and not without hiccups and practical dilemmas. One idea or concept may work wonderfully on paper and in the mind, and may have pages to back it up theoretically, yet it may fail horribly in the studio. It is your practical work, the "final" result of your research that is on show. It must be struggled with and manipulated so it works both mentally and visually. So what it looks like and what it means has a common ideal. It is when the written and the theory dances with the practical and the visual, creating work which not only has importance and meaning but also validation. (Plowmann 2000: 35)

My argument linking artist/researcher/teacher centres on the notion that if we, as practitioners, can understand and situate our practice, then we own the practice. We can use the notion of research as a way to develop better understandings of the changing and significant roles of artist, artworks and agency in this rapidly chang-

ing world. Perhaps this is a way to enhance the ability of our students and ourselves through the process of collaboration, to move forward as effective, informed and prepared practitioners. To be an aware, knowledgeable and articulate practitioner surely is an enabling paradigm.

Acknowledgements

My thanks to my colleagues, students and fellow explorers Jill Kinnear, Adrian Cowell, Nick Plowmann, Helen Mayes, Christine Prescott, Katrina Laurie, Deborah Mitchell, Chikaco Urata and Bridget Boville, collaborators all, whose research endeavours over the past four years have taught me much about practitioner praxis in the arts.

10

FOUCAULT'S 'WHAT IS AN AUTHOR': TOWARDS A CRITICAL DISCOURSE OF PRACTICE AS RESEARCH

Estelle Barrett

A vexed issue for many artistic researchers is related to the need for the artist/researcher to write about his or her own work in the research report or exegesis. In the creative arts, the outcomes that emerge from an alternative logic of practice are not always easy to articulate and it can be difficult to discuss the work objectively given the intrinsically emotional and subjective dimensions of the artistic process. How then, might the artist as researcher avoid on the one hand, what has been referred to as "auto-connoisseurship", the undertaking of a thinly veiled labour of valorising what has been achieved in the creative work, or alternatively producing a research report that is mere description or history? [1]

I suggest that a way of overcoming this dilemma is for creative arts researchers to shift the critical focus away from the evaluation of the work as product, to an understanding of both studio enquiry *and* its outcomes as process. I will draw on Michel Foucault's essay 'What is an author' to explore how we might move away from art criticism to the notion of a critical discourse of practice-led enquiry that involves viewing the artist as a researcher and the artist/critic as a scholar who comments on the value of the artistic process as the production of knowledge.

In adopting such an approach, practitioner researchers need not ignore or negate the specificity of studio enquiry, including its subjective dimension and those emergent methodologies, which I have argued earlier in this book, constitute the generative strength that distinguishes practice as research from more traditional approaches. In order to elaborate the relationship and the need for a balanced focus between the more distanced approach made available through Foucault's account of author function and these intrinsic aspects of artistic enquiry, I will turn later, to Donna Haraway's notion of "situated knowledge" (1991 1992). In her critique of the scientific method and what she views as its false claim to objectivity, Haraway suggests that scientific approaches to research are implicated in social constructionist accounts of knowledge that result in the effacement of the particularities of lived experience from which situated knowledge emerges. To ground this discussion in the specificity of practice, I would also like to consider the making of Pablo Picasso's *Demoiselles d'Avignon*, and to set up a hypothetical scenario in which we recast Pablo Picasso the artist, as Picasso the researcher—one who is responsible for both

the studio work and the accompanying scholarly discussion of it.

Discourse as Practice

A key aspect of Foucault's conception of discourse is that it refers not only to language, but to language *and* practices that operate to produce objects of knowledge. Foucault was concerned not only with understanding the particular historical contexts that allow certain regimes of truth to prevail at any time, but also with the apparatuses or discursive formations—webbed connections that link knowledge, power, institutions, regulations, philosophical and scientific statements, administrative and other practices—that regulate conduct, and support or determine what counts as knowledge. In this context, since human subjects can only work within the limits of discursive formations and regimes of truth, the idea that individuals are the primary source of meaning tends to be negated or rendered invisible. Foucault contends that whilst things may have material existence in the world, they cannot have meaning outside of discourse (Foucault 1972). Stuart Hall summarise Foucault's ideas thus:

> This subject of discourse can become the bearer of the kind of knowledge which discourse produces. It can become the object through which power is relayed, But it cannot stand outside power /knowledge as its source and author. (Hall 1997: 55)

These aspects of Foucault's thought provide a backdrop for his conception of "author function" (Foucault 1991). I believe that an application of his elaboration of this may help artist/researchers to achieve a degree of critical distance in the discussion of their practice as research projects. It may also help practitioner researchers to locate their work in the field of theory and practice both within and beyond the specific field of creative endeavour and to identify the possible gaps in knowledge that their research projects might address.

Whilst Foucault's view of author as *function* rather than as individual consciousness, opens up an alternative approach for practitioners to talk about their own work, this requires a shift in conventional ways of thinking about artwork and the artist. Foucault tells us that the understanding of author as function is often undermined by a tendency to privilege more traditional notions of "the work" as an entity and the artist as a unique creator of the work. Such a view prevents us from examining the procedures and systems that allow a work to operate as 'a mode of existence, circulation and functioning of certain discourses within society' (Foucault 1991: 108). The "man-and-his-work" form of criticism still holds sway, refusing the idea of art and art practice as an interplay of meanings and signifiers operating within a complex system. Contemporary criticism still defines author in same way, insisting on a unity of writing that neutralises or resolves contradictions. This applies equally to the visual and other arts. Galleries and publishers operate as gatekeepers ensuring that "inferior" works are removed from visibility, those that contradict the main body of work are excluded and works written or made in different style are often removed. In commentaries, references to the author's death are frequently removed so that the

author/artist/genius is bestowed an aura of timeless permanence and immortality.

Foucault questions the prevailing view of "author" as attribution, and of "the work" as the discourse of an individual with a deep motive or creative power and contends that such a view is a "psychologising" or a projection of operations or procedures that allow a text/artwork to come into being and to circulate as discourse (Foucault 1986: 111). Within the context of artistic research, adopting Foucault's definition of author-and-work as 'mode of existence, circulation and functioning of certain discourses within society' requires us to consider not whether the work is "good' or "bad", but to focus on the forms the work takes and the institutional contexts that allow it to take such forms. In this context, "circulation" may refer to the work's audience and subject positions that the work may permit individuals to occupy and "function" may refer to the social, ideological and other uses (and abuses) to which the work may be put.

Let us consider for example, a rendering of the nude in painting—Picasso's *Demoiselles d'Avignon*—to which I will return later in this chapter. Whilst the contribution this work has made to modern painting is unquestionable; the work bears methodological, ideological and philosophical traces of many antecedents. For example, it contains "intertextual" references to Ingres' 1863 painting *The Turkish Bath* —and if we are to take into account notions of idealisation in traditional nude painting, we may go back even further in history to Plato. Leo Steinberg's (1988) account of this work suggests that *Demoiselles* emerged not solely, but largely from a series of extrapolations and transgressions that took the Ingres' work as one of its starting points. By drawing on sketches from Picasso's preparatory studies for the painting and other examples of Picasso's work, Steinberg's account demonstrates that Picasso was aware of the discursive and methodological fields through which his artistic process was operating. Had Picasso been working within the context of practice-as-research, the task of mapping these discursive fields would, in the first instance, have fallen on the artist rather than the critic.

I am suggesting that Foucault's notion of author function is a useful tool for practitioners who choose to take on the dual role of artist/researcher. We cannot be certain of all of Picasso's motives and intentions, nor is it necessary for us make such a claim. Indeed Picasso himself has commented, 'A picture comes to me from miles away: who is to say from how far away I sensed it, I saw it, I painted it? And yet the next day I can't see what I have done myself' (Chipp quotes Picasso 1968: 273). Picasso's comment points to the difficulty of articulating understandings of both the processes and outcomes of creative production. An application of Foucault ideas on author as function provides the artist/researcher with an analytical framework and a partial solution to completing the task.

Let us turn from Picasso, to a further consideration of the context of practice as research. Foucault's terms "apparatuses", "operations" and "procedures" readily evoke an experimental and investigative scenario. More specifically, they can be related to investigative methods. If we recall that Foucault's "discourse" refers both to language *and* practice, it is possible to relate the terms not only to the materials and methods of studio enquiry, but also to conceptual considerations that must

be confronted in the design and implementation of the research project. Materials, methods *and* theoretical ideas and paradigms may be viewed as the apparatuses, or procedures of production from which the research design emerges. They are not the sole invention of the individual artist/researcher as we have seen, but are forged in relation to established or antecedent methods and ideas. Robyn Stewart has observed in an earlier chapter of this book, how practitioner-based research involves considering the essences of traditional research models in order to understand, critique and appropriate them according to need. 'Its emphasis is largely qualitative, demonstrating and playing with the inter-connectedness between differing methodologies as a kind of intertextuality, a bricolage'. Stewart's notion of bricolage, which highlights the relationship between material processes and discourse and the way in which creative practice operates intrinsically as a mode of enquiry, is not antithetical Foucault's ideas concerning author as function.

Engaging critically with aspects of Foucault's account of author function provides the practitioner researcher with an framework through which the artist researcher can reflect, in a more distanced way, on how practice operates as knowledge production, and how the outcomes of studio enquiry emerge in relation to established knowledge and broader institutional discourses. In the closing section of 'What is an author', Foucault presents a set of questions that, with appropriate application, constitute a programme for critical reflection on the research process. He suggests that, within the power/knowledge nexus, and where cultural production is so regulated by institutional and other disciplinary regimes and apparatuses, it no longer makes sense to focus on the author as the sole creator of meaning. A more generative analysis would involve asking a different set of questions related to the contexts in which a work might operate:

> We would no longer hear the questions that have been heard for so long: Who really spoke? Is it really he and not someone else? With what authority and originality? And what part of his deepest self did he express in his discourse? Instead there would be other questions, like these: What are the modes of existence of this discourse? Where has it been used, how can it circulate, and who can appropriate it for himself? (Foucault 1991: 118-119).

Author Function

I would like to present a sketch of how Foucault's ideas concerning author function may have more specific application or translation within the context of studio enquiry. The table presented below is by no means exhaustive, but I hope will assist artists in their discussion of the research process.

Foucault's Author Functions	Application in Practice as Research
Groups together and defines a certain number of texts/works according to their homogeneity and filiation. (Foucault 1991: 107)	The researcher identifies and assesses methodological, conceptual and other links in works produced in the current and previous projects.
Differentiates and contrast works from works of others in order to authenticate and show reciprocal explication. (Foucault 1991: 107)	The researcher traces the genesis of ideas in his/her own works as well as the works/ideas of others; compares them and maps the way they inter-relate; examines how earlier work has influenced development of current work; identifies gap/contribution to knowledge/discourse made in the works.
Establishes relationships amongst texts in terms of concomitant utilization. (Foucault 1991: 107)	The researcher assesses the work in terms of the way it has extended knowledge and how his/her own work as well as related work has been, or may be used and applied by others.

Characteristics of Works that Carry Author Function

Foucault outlines a number of characteristics of works that carry the author function. These can be applied to extend the framework for analysis and discussion of the research. He describes these characteristics in the following way:

- They are objects of appropriation and can be used/applied by others;

- They guarantee the work a certain status so that it is received as having validity;

- Such characteristics are not the spontaneous result of singular motive of an individual, but are the outcome of specific and complex operations;

- They are linked to juridical and institutional systems that determine and articulate the system of discourses;

- They do not affect all discourses in the same way at all times and in all types of civilizations. (Foucault 1991: 108-110)

Without being too prescriptive, the characteristics that the author function bestows on discourse can be extrapolated and applied as a critical method for evaluating one's own creative output as well as that of others. They provide a set of objective criteria for grounding practice within the university research context and the general field of research and for articulating possible applications of the outcomes of studio

enquiry. I'd like to stress that this approach can be used in ways that need not ef-
face what is particular and innovative in the practice as research project, but to test
particularities that emerge in relation to established theory and practice. Foucault,
himself, suggests that traditionally, discourse (writing and by extension, art) was not
viewed as a product, a thing, a kind of goods, but was understood as an *act* situated
in a field between the sacred and profane, the licit and illicit. This alludes to the
transgressive potential of discursive practices and texts, which in the past, according
to Foucault, subjected them to appropriation, and their originators to punishment.
It could be said that transgressive and revolutionary dimensions of creative practice
can still attach to discourses that contain the author function. However, we might
argue that today, they are often appropriated as "innovations" to be transformed and
commodified within the system of exchange and capital.

The Dispersed Selves of Author

Another useful notion in Foucault essay, is that of the "dispersed selves" of author.
He tells us that the author's name is not related to whether it designates the self as
the subject (creator) of discourse. It does not refer purely to a real, singular indi-
vidual, but is trans-discursive and can give rise simultaneously to several selves and to
several subject positions that can be occupied by others (Foucault 1991: 107). How
might this be applied in the exegetical discourse of artistic research?

Let us return to the earlier discussion of Picasso's *Demioselles d'Avignon,* We can
say that the trans-discursive dimension of the author function relates to the way in
which the author or artist and his or her work operate as bearers of discursive prac-
tices that are antecedent to the research context and which may also refer to several
paradigms or schools of thought. The notion of the dispersed selves of author
provides a springboard for reflecting on the multiple positions the researcher must
occupy in reporting and writing up of the studio process and its outcomes. The
table below indicates the way in which Foucault's ideas about this aspect of author
function may be extended and applied as an aid to maintaining a more distanced and
critical approach to research writing.

Foucault's Dispersed Selves	Application in Practice as Research
The self that speaks in the preface and indicates the circumstances of the treatise or the work's composition (Foucault 1991: 112).	The researcher locating him/herself in the field of theory and practice in the literature review.
The self that makes generalisation that may later be made or taken up by others who accept the same system of symbols and constructs (Foucault 1991: 112).	The researcher adopting an approach and articulating the rationale for methodological and conceptual frameworks; the one who argues and demonstrates and uses terms like "I conclude", "I suppose" as they relate to the hypothesis and design of the project.

The self that peaks to tell the work's possible meaning, the obstacles encountered, the results obtained and the remaining problems. This self is situated in the field of already existing and yet to appear discourses (Foucault 1991: 112).	The researcher discussing the work in relation to: lived experience, other works; application of results obtained; contribution to discourse; new/ transgressive possibilities; obstacles encountered and the remaining problems to be addressed in future research.

Founders of Discursivity

In his discussion of author, Foucault refers to a special group in which he places thinkers such Marx and Freud. He calls this group 'founders of discursivity' (Foucault 1991: 114) and suggests they are different from (for example) novelists or artists who produce texts that in his view, only open the way for resemblances and analogies. I believe the emergence of artistic enquiry as a research paradigm challenges this binary. Further, I am suggesting that practitioner-researchers might appropriate Foucault's ideas concerning foundational discourses as a set of additional criteria for assessing the value of their own work and in doing so, may reveal some of the limitations of Foucault's position in relation to what constitutes a separation of theory and practice and the privileging of particular modes of discourse in his account of author.

Foucault characterises founders of discursivity the following way:

- They are not just authors of their own works, but produce the possibilities and rules for the formation of other texts;

- They make possible not only analogies and resemblances, but differences and divergences with respect to their own texts concepts and hypotheses;

- They make possible the creation of something other than their discourse, but which nevertheless belongs to what they have founded;

- The acts they found are on equal footing with future transformations and become part of the modifications made possible;

- The founding act can be reintroduced to validate and be validated by the transformations. (Foucault 1991: 114-115)

The possible applications of these points for assessing the outcomes and significance of research are be self-evident and as mentioned earlier, may well be applied in artistic research to challenge Foucault's classification.

How might Picasso's *Demioselles d'Avignon* and critical commentaries on the work help to illuminate *and* critique Foucault's position? Let me turn now, to William Rubin's (1994) account of this work. Referring again to Picasso's preparatory draw-

ings, Rubin suggests that the painting found its genesis and was an extension the *vanitas* genre. He uses Erwin Panofsky's iconological method to comment on the symbolic significance of the medical student holding a scull in one of Picasso earlier studies. He links this analysis to other symbolic elements in both the preparatory studies and the completed work—as well as psycho-biographical accounts of Picasso's life—to argue that the painting is an allegory concerning physical degeneration and death (Rubin 1994: 58). Steinberg puts forward a different reading of the work, (though what I am presenting here is simplification of this erudite essay for the purpose of my argument). Steinberg's analysis leads him to conclude that Picasso's painting is a refusal of traditional distanced, idealised and decorative renderings of the nude in painting in favour of a direct confrontation with sexuality, or an immediate *experience* of the sexual encounter (Steinberg 1988). He draws on a vast body of earlier commentary and refers to yet other artistic antecedents to extend this thesis:

> The *Demoiselles* has been historicized and surrounded by a vast, varied ancestry. The influences imploding on this great masterpiece have been found to include not only Iberian and African art, to say nothing of Cézanne's compositions of bathers; we learned that they included Caravaggio's *Entombment*, Goya's *Tres de Mayo*, Delacroix's *Massacre at Scio* and *Femmes d'Alger,* and Ingres' *Turkish Bath.* (Steinberg 1988: 71)

So the list goes on. However, Steinberg declares (highlighting how cross-analysis of different works by a single artist can be illuminating), 'The best commentary on Picasso is another Picasso' (Steinberg 1988: 22). From Steinberg's account, we may safely deduce that Picasso must have been aware of at least some of the influences mentioned and that the making of this painting must have involved sustained critical engagement with philosophical and antecedents including those related to material and technical demands of painting—in particular—painting of the nude. We can further surmise that this task involved locating the work at hand in relation to those discourses and testing his creative vision and lived experience against them. However, on the basis of the way in which this work has ruptured and transformed thought and practices and continues to validate and be validated in ongoing discourses and practices, there may also be a case for placing Picasso within the category of "founders of discursivity".

In any event, I believe that application of author function and Foucault's notion of founders of discursivity can be a useful instrument for reflection and discussion in the context of artistic research. It facilitates both historical analysis as well as the task faced by artists of situating their own work in the broader field of theory and practice. Moreover, the criteria that relate to founders of discursivity may act as useful measures for considering the impact and significance of research outcomes.

But what of the artist's subjective concerns and particularities of artistic research not accounted for in Foucault's framework? Foucault is not silent on the topic of the subject or self in discourse. Indeed, his notion of author function is intended to give us a better understanding of how the subject or self is constructed and positioned in

discourse, its points of insertion, functioning and dependencies on the system, and how a subject emerges out of discourse. However, this account does not provide an adequate consideration of the relationship between the particularities of lived experience and discourse.

Situated Knowledge

Because creative arts research is often motivated by emotional, personal and subjective concerns, it operates not only on the basis of explicit and exact knowledge, but also on that of tacit knowledge. An innovative dimension of this subjective approach to research lies in its capacity to bring into view, particularities of lived experience that reflect alternative realities that are either marginalised or not yet recognised in established theory and practice. Foucault's approach does not adequately deal with the relational aspect of practice and how subjective agency is implicated in the creation of discourse. As I mentioned in the introduction to this book, emerging discourses on the artistic process go some way to redressing this inadequacy. In his work *Material Thinking*, Paul Carter (2004) helps to extend understandings of the subjective and relational dimensions of the artistic process. He describes this process as one that involves a decontexualisation from established or universal discourse to instances of particular experience. In staging itself as an artwork, the particularity of experience is then returned to the universal. Carter suggests that "material thinking" specific to artistic research produces a record of the studio process as a means of creating new relations of knowledge subsequent to production. Material thinking is, in his own words, 'a call to discursive arms' (Carter 2004: 184). Also useful for understanding this emergent aspect of artistic research, and the dynamics of the circulation of artistic products is Barbara Bolt's notion of "materialising practices", which implies an ongoing performative engagement and productivity both at moments of production and consumption (Bolt 2004). Bolt draws on Martin Heidegger, to suggest how new knowledge emerges from human involvement with objects in the world, as she notes in an earlier chapter of this book:

> Heidegger argues that we do not come to "know" the world theoretically through contemplative knowledge in the first instance. Rather, we come to know the world theoretically only after we have come to understand it through handling. Thus the new can be seen to emerge in the involvement with materials, methods, tools and ideas of practice.

As I have elaborated in the introduction to this book, rather than constituting a relationship between circulating discourses (Foucault) or image and *image*/text (that is, between image and established discourse/theory), *materialising practices* constitute relationships between *material processes* and text, of which the first iteration is necessarily the researcher's own self-reflexive mapping of the emergent work *as enquiry*. In artistic research, a dialogic relationship between studio practice and the writing of the creative arts exegesis is crucial to articulating and harnessing studio methodologies for further application beyond the field of creative arts so that the practice as

research extends the general field of research and is validated alongside other more traditional forms of research derived essentially from the scientific method.

Philosopher of science, Bruno Latour suggests that science is a process of amassing inscriptions in order to mobilise power. A great deal of scientific research is based on inscriptions: science predominantly works through study of graphs, maps, tables and data rather than actualities (La Tour 1986). These inscriptions and cascades of inscriptions (inscriptions which refer to each other, rather than material realities) are a process by which the optical consistency required to maintain immutability of ideas across time and irrespective of where they are located or applied, is achieved. Invention of the printing press and other technologies of reproduction of inscriptions or "immutable mobiles" has sped up the spread of errors or inaccuracies so that knowledge becomes less and less tied to real conditions. Scientific inscriptions work like Foucault's webs of discourse or regimes of truth; they form a panopticon determining what counts for truth, what conduct is permitted and what is not. La Tour observes:

> People before science and outside laboratories certainly use their eyes, but not in the same way. They looked at the spectacle of the world, but not this new type of image designed to transport the objects of the world, to accumulate them ... (La Tour 1986: 10)

Inscription results in displacement of experience in favour of representation and discourse.

In her essay, 'Situated knowledges: the science question in feminism and the privilege of partial perspective' (1991), Donna Haraway reveals the inadequacy of such methods for grounding knowledge in lived experience. She calls for a "successor science" that takes account of the structure of facts and artefacts (Haraway 1991: 185). Just as I would recommend reading Foucault's essay 'What is an author' as an aid to developing more critical and distanced accounts in practitioner research, I suggest that Haraway's essay provides a rationale and guide for re-inserting the self and lived experience into accounts of the research process. She asserts that in order to test embodied or real relations to events and objects in the world against those accounts given in established discourse and to unmask doctrines of objectivity that threaten our sense of historical subjectivity and our embodied accounts of truth, we need to look at the issue of the relations of bodies to language (Haraway 1991: 196).

The problem confronting the practitioner researcher is how to have simultaneously, an account of radical historical contingency for all knowledge claims of knowing subjects, and a critical practice for recognising our own semiotic technologies for making meanings (Haraway 1991: 187). Like La Tour, Haraway is critical of the social constructionist underpinnings of dominant accounts of knowledge and exposes science's false claim to objectivity. She observes that the scientific search for universal laws and claims of objectivity are reductionist and constitute a negation of particularities of embodied vision. Moreover, social constructionist accounts of irreducible difference lead to relativism and a state in which only power can deter-

mine what counts as truth. Together, these accounts of knowledge constitute a 'god trick' that endorses the conquering gaze from nowhere claiming the power to see and not be seen – and the view from everywhere, which is effectively the same thing (Haraway 1991: 188). Haraway suggests that an alternative to relativism and reductionism emerges from an acknowledgement of, 'partial, locatable, critical knowledges sustaining the possibility webs of connections called solidarity in politics and shared conversations in epistemology (Haraway 1991: 191).

A recognition that objectivity can only be partial, calls for re-admitting embodied vision and positioning in research. Embodied vision involves seeing something from somewhere. It links experience, practice and theory to produce situated knowledge, knowledge that operates *in relation* to established knowledge and thus has the capacity to extend or alter what is known.

Haraway questions the binary often set up between theory and practice. She declares, 'Theory is bodily, and theory is literal' (Haraway 1992: 299). Her explanation of what she terms a "reflexive artefactualism" that produces effects of connection, of embodiment and of responsibility (Haraway 1992: 295) can be understood as material thinking – practices involving bodies. Haraway observes further:

> Always radically and historically specific, always lively, bodies have a different kind of specificity and effectivity; and so they invite a different kind of engagement and intervention. (Haraway 1992: 298)

Let us return, finally, to Picasso's *Demioselles* and to Steinberg's and Lisa Florman's (2003) commentaries on the painting. Towards the end of his essay, after garnering an impressive body of criticism and engaging in a close formal analysis of the work, Steinberg comments:

> Let the truth be known.... The other day, I learned from a well-informed New Yorker (excuse the redundancy) that the secret is out: Picasso in 1907 had contracted VD, and painted the *Demoiselles* to vent his rage against women. (Steinberg 1988: 71)

Notwithstanding all the other possible interpretations, and any intentions the painter may have had, it seems that this work, often hailed the birth of Cubism emerged not only from antecedent practices and ideas, but also from the particularities and passions of lived experience, from situated knowledge, that could not be expressed in any other way than by the forging of a new visual language; that is, by an extension of the possibilities of discourse made possible through practice. Yet, Florman, (drawing on Christopher Green's analysis of *Demoiselles*) emphasises that before Steinberg's essay, these possibilities remained largely inchoate:

> Before [his] essay, the *Demioselles d'Avignon* was the birthplace of cubism, the marker of the epochal shift from content to form in modern painting. After Steinberg's essay, it has become the marker of an epochal shift to a new kind

of engagement with sexuality, one whose immediacy was unprecedented in the history of painting. (Florman 2003 quotes Green: 789)

Florman's engagement with Rubin's and Steinberg's account of Picasso' painting is illuminating as much for its thesis, which suggests that *Demoiselles* is a study in both detachment and immediacy that emerges through self-discovery predicated on *experiencing* the work (the work that the painting *does*), but also for it's relevance to the issue of objective and subjective positioning of the artist as researcher through the research writing. Florman notes: 'it is experiencing that allows us to think with the other' (Florman 2003: 777). Experiencing the painting, she continues, becomes an activity in which we may be overcome by the extreme otherness of the sublime, or chose a more conceptual modality of engagement in order to maintain some degree of detachment. Florman suggests further, that it is the instantiation of these *two* positions through the alternating style (one more poetic and one more prosaic) of Steinberg's account that allows us to experience the painting more fully. This seems to reflect precisely the situation faced by the artist/researcher who is required to discuss his or her own work as artistic research.

(A version of this paper was presented at the Research into Practice Conference at Hertfordshire University in July 2006.)

11

RUPTURE AND RECOGNITION: IDENTIFYING THE PERFORMATIVE RESEARCH PARADIGM
Brad Haseman

There has been considerable debate around how best to articulate a research methodology that is most congenial to artists, designers and other creative practitioners. A number of possible terms have been proposed to describe this model of enquiry: "practice as research", "practice-based research", "practice-integrated research", "studio research" and so on. However, in recent years, "practice-led research" has become a prominent term for effectively describing the research approach that enables practitioners to initiate and then pursue their research through practice.

Carole Gray has been a principal architect in this, defining practice-led research as:

> Firstly, research which is initiated in practice, where questions, problems, challenges are identified and formed by the needs of practice and practitioners; and secondly, that the research strategy is carried out through practice, using predominantly methodologies and specific methods familiar to us as practitioners. (Gray 1996: 3)

Of all the emerging nomenclatures, I believe Gray's "practice-led research" is an effective and serviceable term. It describes what practitioner-researchers do, captures the nuances and subtleties of their research process and accurately represents that process to research funding bodies. Above all, it asserts the primacy of practice and insists that because creative practice is both ongoing and persistent; practitioner researchers do not merely "think" their way through or out of a problem, but rather they "practise" to a resolution.

Much has been written about practice-led research and its finer textures do not need to be restated here[2]. However within the broader research environment, the question of methodological rigour continues to trouble practice-led research. How will it be possible for the person who is both a researcher and creative practitioner to take his or her place at the research table in a way which ensures that the primacy of practice and the embedded epistemologies of practice are respected and valued, and at the same time produce research which is recognised and respected for its rigour by the other researchers within and beyond the field of the creative arts?

Currently there is a strong alignment between practice-led research and some re-

search strategies and methods from the qualitative tradition. For example, reflective practice, action research, grounded theory and participant-observation all inform practitioner-research generally. However, the important point to make is that practice-led research can not merely be subsumed under the qualitative research framework. Practice-led research employs its own distinctive research approach with its own strategies and methods, drawn from the long-standing and accepted working methods and practices of artists and practitioners across the arts and emerging creative disciplines. These distinctive qualities point us towards an entirely new research paradigm, which elsewhere, I have argued can be best understood as performative research[3].

This chapter takes up the challenge to articulate the performative research paradigm. It sets out to show how significant developments in practice-led research, including inventive methods of collecting and analysing data, alternative forms of reporting research and feedback loops operate to distinguish the performative methodology from qualitative research methodologies. Drawing on a case study, David Fenton's *Unstable Acts*, I exemplify the "inventive" work-in-progress that characterises this new methodology.

Recognising Alternative Forms of Reporting Research

Central to the argument for an alternative methodology for the Creative Arts is an insistence by practice-led researchers, that research outputs and claims to knowledge be reported through symbolic language and forms *specific* to their practice. Such a move challenges traditional ways of representing research findings. Practice-led researchers believe it is folly to seek to only "translate" the findings and understandings of practice into the numbers (quantitative) and words (qualitative) modes preferred by traditional research paradigms. They argue that a continued insistence that practice-led research be reported primarily in the traditional forms of research (words or numbers) can only result in the dilution and ultimately the impoverishment of the epistemological content embedded and embodied in practice. Thus the researcher-composer asserts the primacy of the music; for the poet it is the sonnet, for the choreographer it is the dance, for the designer it is the material forms and for the 3-D interaction designer it is the computer code and the experience of playing the game which stands as the research outcome.

These "symbolic orders of knowing" conform with established definitions of research. The OECD definition, which is quoted in all of the documentation from the Australian Department of Education, Science and Training, states:

> Research and experimental development (R&D) comprise creative work undertaken on a systematic basis in order to increase the stock of knowledge, including knowledge of man, culture and society, and the use of this stock of knowledge to devise new applications. (OECD 2002: 30)

In the UK the definition of research is even more tightly aligned with the alternative research outputs from practice-led researchers, where "research" for the purpose of the 2008 Research Assessment Exercise is to be understood as:

Original investigation undertaken in order to gain knowledge and understanding. It includes ... the invention and generation of ideas, images, performances, artefacts including design, where these lead to new or substantially improved insights and the use of existing knowledge in experimental development to produce new or substantially improved materials, devices, products and processes, including design and construction. (RAE 2006)

Given the acceptance of alternative research outputs within the research framework, it is perhaps surprising that the research field is so slow to recognise alternatives to qualitative and quantitative research methodologies.

Rupture: Beyond Qualitative Research

One way to understand the developments wrought by practitioner-researchers from the arts and design is to see them as part of the ongoing project to clarify the materials and methods of qualitative research. After all, a number of qualitative researchers are making similar arguments. Judy Norris acknowledges that 'many were drawn to qualitative research as we came to realise how much life was squeezed out of human experience when we attempted to make sense of it in a numeric, non-contextual way' (Norris 1997: 89). However, constrained by the capacity of words to capture the nuances and subtleties of human behaviour, there has been a call by some scholars and researchers for 'texts that move beyond the purely representational and towards the presentational' (Denzin 2003: xi). This has resulted in proposals for qualitative researchers to use symbolic forms such as poetry, fiction writing, theatre, performance, dance, music and the visual and graphic arts to represent their claims to knowledge (Norris 1997: 87-115). For instance, in their speculations about the future of qualitative research Mary M. Gergen and Kenneth J. Gergen write:

> Investigators are invited into considering the entire range of communicative expression in the arts and entertainment world—graphic arts, video, drama, dance, magic, multimedia, and so on—as forms of research and presentation. Again, in moving towards performance the investigator avoids the mystifying claims of truth and simultaneously expands the range of communities in which the work can stimulate dialogue. (Gergen and Gergen 2003: 582-583)

Yvonna Lincoln and Norman Denzin too, applaud this development and relish the instability created by these "messy" forms of research arguing they have 'reshaped entirely the debates around "appropriate" scientific discourse, the technical and rhetorical conventions of scientific writing, and the meaning of research itself' (Lincoln and Denzin 2003: 7).

Not all qualitative researchers are relaxed about this radical turn in their discipline (see Snow and Morril, 1995), but there is plenty of evidence to support Lincoln and Denzin's assertions. They are correct in assessing the impact of this move; understandings and assumptions about research are being reshaped and radically. But to contain these impulses to a radical fringe of qualitative researchers seriously understates the

significance of these innovations introduced by artists, designers and others who have been researching in and through their practice. Their methodological developments have implications for the whole field of research, for they represent fundamentally different research procedures to those that operate in both the quantitative and qualitative orthodoxies. In fact there is evidence enough to recognise that we stand at a pivotal moment in the history and development of research. Practice-led researchers are formulating a third species of research, one that stands in alignment with, but separate to, the established quantitative and qualitative research traditions. I believe this shift is as significant as the development of qualitative research at a time when qualitative researchers noted that the physics of their research was different from the physics of their quantitative colleagues. At that moment qualitative researchers created a rupture with the quantitative orthodoxy. They claimed a new space, marked it "qualitative research" and began refining its protocols and procedures.

One defining feature of that split centred around the way the two camps represented their knowledge claims. As Thomas Schwandt makes perfectly clear: quantitative research is 'the activity or operation of expressing something as a quantity or amount—for example, in numbers, graphs, or formulas' (Schwandt 2001: 215). On the other hand, qualitative research, with its concern to capture the observed, interpreted and nuanced properties of behaviours, responses and things refers to 'all forms of social inquiry that rely primarily on … nonnumeric data in the form of words' (Schwandt 2001: 213).

I would argue that it is time for practitioner researchers to make a similar move to the one made by qualitative researchers in the last century. Just as the qualitative researchers asserted different forms of representation of knowledge claims so practice-led researchers need to do the same now. We need to mark out a third paradigm, one that pivots on the methodological innovations detailed above, especially around the alternative forms we use to report our research findings.

Recognition: The Performative Research Paradigm

But what should we call such a research paradigm—one which asserts that the dance, the novel, the design and so on is an outcome of research? One possible way forward is provided by J.L. Austin's (1962) notion of performativity. For Austin, performative speech acts are utterances that accomplish, by their very enunciation, an action that generates effects. His influential and founding example of the performative: ('I take this woman to be my lawful wedded wife') enacts what it names (Austin 1962: 121). The name performs itself and in the course of that performing becomes the thing done.[4] In the double articulation involved in creative arts research, practice brings into being what, for want of a better word, it names. The research process inaugurates movement and transformation. It is performative.

In this third category of research—alongside quantitative (symbolic numbers) and qualitative (symbolic words)—the symbolic data, the expressive forms of research work performatively. It not only expresses the research, but in that expression becomes the research itself. When research findings are presented as such utterances, they too, perform an action and are appropriately named "performative research".

It is not qualitative research: it is itself—a new paradigm of research with its own distinctive protocols, principles and validation procedures.

Schematically the three research paradigms can be represented thus:

Quantitative Research	Qualitative Research	Performative Research
'The activity or operation of expressing something as a quantity or amount – for example, in numbers, graphs, or formulas' (Schwandt 2001: 215).	'All forms of social inquiry that rely primarily on qualitative data … i.e., nonnumeric data in the form of words (Schwandt 2001: 213).	Expressed in non-numeric data, but in forms of symbolic data other than words in discursive text. These include material forms of practice, of still and moving images, of music and sound, of live action and digital code.
The scientific method	Multi-method	Multi-method led by practice

The Multi-Methods of Performative Research

The table above not only draws a distinction between the three paradigms based on the way research outcomes are expressed, but also differentiates the methods of data collection and analysis which are appropriate to each paradigm. Much has been written about the "scientific" methods of qualitative research which are able to meet the rigorous requirements of validity, reliability and truth hunting. Over the past fifty years qualitative researchers have identified and catalogued a wide range of mixed methods designed to gather the evidence they need to crystalise the knowledge claims which can be made through their heuristic and interpretative practices.

Practice-led researchers operating within the performative paradigm have found they too, need to engage a range of mixed methods, especially those which are instigated by and led from the demands of their practice. They take their lead in this from the second part of Gray's formulation, namely that in practice-led research 'the research strategy is carried out through practice, using predominantly methodologies and specific methods familiar to us as practitioners' (Gray 1996: 3). This is a radical and bold innovation, for it not only affirms the primacy of practice in the research process, but it proclaims that the techniques and tools used by the practitioner can stand as research methods in their own right. This places considerable power with the practice-led researcher. Certainly, it means there is a need to identify and validate existing methods of practice (and perhaps even discipline them somewhat), but it is these methods, specific to practitioners, that become the spine of the research process. Acknowledging and validating them means that practice-led researchers don't always have to turn to the arsenal of methods from other traditions in order to justify their research.

Unstable Acts: Case Study - Exemplifying Multi-methods Led by Practice

To illustrate the performative nature of practice-led research, I will detail PhD candidate, David Fenton's study of the relationship between the live performer and the mediated screen images in contemporary interdisciplinary theatre. From this case study, I will discuss the four methods which emerged out of the needs of Fenton's research and then relate them to the methodological innovation demanded by the performative research paradigm.

As a successful theatre director and practice-led researcher Fenton designed a study which incorporated three creative development periods across 2004, 2005 and 2006. The purpose of his study was to examine the form and processes of contemporary theatre- making, focussing particularly on the interrelationships resulting from the interplay of the live performer and mediated screen images. This raised many subsidiary questions around ideas of the original and copy. His practice-led investigations challenged traditional understandings of mimesis and the positioning of the audience in performance. The study resulted in a new theatre work *Unstable Acts*, staged at the Creative Industries Precinct at the Queensland University of Technology in August 2006. In these cycles of practice-led exploration and rehearsal, four methods for gathering data were used by Fenton; the enquiry cycle from action research, reflective practice, a post-performance reception study and action tracking and fixing. These are briefly described below.

1. Enquiry Cycle from Action Research

As Fenton worked across multiple creative development periods, he devised and revised his work in a succession of workshops and rehearsals. Such recursive and iterative creative development is akin to the enquiry cycle of self-reflection, which is fundamental to action research. The enquiry cycle involves:

> Planning a change
> Acting and observing the process and consequences of change
> Reflecting on these processes and consequences, and then
> > Replanning
> > Acting and observing
> > Reflecting, and so on ... (Kemmis and McTaggart 2003: 381)

Fenton is not alone in using the enquiry cycle to structure and inform the creative research process. In fact, practice-led researchers see this enquiry cycle as the most serviceable feature of action research and have few qualms adopting and adapting it to serve their purposes. They are content to scavenge methods as their practice demands and are little troubled that they are not using the entire apparatus of action research and its other defining features (Kemmis and McTaggart 2003: 384-388).

2. Reflective Practice

Fenton acknowledged a debt to Donald Schön for his work in reflective practice, convinced that Schön's arguments for "knowing-in-practice" are compelling and of

central importance to the practice-led research. Experienced practitioners, including Fenton as a Theatre Director, can be confounded by what Schön calls "overlearning" resulting in practice, which becomes narrow and rigid. The antidote is to use reflection-in-action and reflection-on-action processes through which the practitioner can:

> Surface and criticize the tacit understandings that have grown up around the repetitive experiences of a specialised practice, and can make new sense of the situations of uncertainty or uniqueness which he may allow himself to experience (Schön 1983: 61).

Reflective practice is further enriched when it is coupled with the notion of "double-loop learning" proposed by Schön and Argyris. They argue that while it is the effectiveness of single-loop learning that enables us to avoid continuing investment in the highly predicable activities that make up the bulk of our lives, it is double-loop learning that can change the values that govern behaviour, that change 'the governing variables (the "settings") of one's programs' (Schön and Argyris 1974: 19). Reflective Practice, with its accompanying "loops" of feedback and critique, offers practice-led researchers in Theatre and the other creative arts a coherent framework within which they can develop the methods and tools for deepening and documenting their emerging understandings of practice. Fenton used improvisation, spontaneous journaling and digital video feedback as methods of capturing reflection-in-action, while reflection-on-action was undertaken using pre and post-journaling, digital video editing and citation journaling. It is common for practice-led researchers to adopt and adapt methods from other fields too, if they are appropriate. For example Fenton found the Model of Structured Reflection (MSR), originally developed for nursing by Christopher Johns (2000), to be an effective way of systematically and methodically deepening reflection on his directorial practice. The Model of Structured Reflection is particularly useful, for it adopts the twin perspectives of "looking in" and "looking out" and most importantly for artists, offers a series of prompts for reflecting on the aesthetics and ethics of practice.

3. Post-Performance Reception Study

During the final season of the work, which embodied his research findings, Fenton decided it was important to gain a measure of how audiences "read" his work, *Unstable Acts*. He adopted a post-performance reception study to assess this. The post-performance reception study involves two related surveying instruments to gather audience feedback. Firstly it uses a pre-coded questionnaire to survey audiences and secondly, it employs focus groups. As is typically the case, these questionnaires and focus groups gather relevant data, which is analysed using a semantic differential scale. From this analysis, Fenton is able to capture the meanings audiences made in response to *Unstable Acts*, as well as assess how one of his key discoveries, the concept of "digital mimesis" is read in action.

4. *Action-tracking and Fixing*

This method of data gathering was specific to the needs of Fenton's research project. One important task for the practice-led researcher/director is to find a way of tracking and recording dramatic action as it evolves in rehearsal. In traditional directorial practice, which realises an extant script, the play text becomes the master document and serves as the pivot for the action. As action is devised and rehearsed, decisions are noted in a "prompt copy", which becomes the record of tracked changes and final fixed action. In this way the prompt copy becomes a key method of data gathering, a tool for action-tracking and fixing. However, Fenton found that when devising an interdisciplinary work without a script, the established method for action-tracking and fixing, the prompt copy, broke down. Instead a new method of documentation for tracking and fixing the action was required. Fenton's response was to develop a matrix to track each of the symbolic codes of the performance. Five codes were woven through the matrix and patterned into the final and performances: screen product, music, gesture, artefact and light. The matrix method of action-tracking and fixing, which replaced the prompt copy in Fenton's study, exemplifies how a research method can be created directly from the specific methods familiar to and regularly used by the director-researcher.

In summary, it may be seen that although it provides a very useful way of "mapping" the research, there are also some pitfalls in elaborating upon the multi-methods of practice-led research in this way. For example, focussing on and emphasising only four pieces of any research machinery may divert attention away to what is most important, namely the ways in which the research accounts for the relationship between theory and practice and seeks to understand and improve both. It is clear too that practice-led research is a complex and evolving research strategy and there is no one "cookie-cutter" template (characterised by the four methods discussed) that can be applied across disciplines and projects. However, these four methods do illustrate the methodological traditions from which the emerging strategy of practice-led research can draw. Both of the first two methods listed, the enquiry cycle and reflective practice arise directly from the arsenal of approaches developed by qualitative researchers. The enquiry cycle is recognised as being the dominant feature of action research, and it is clear there is a strong overlap between it and practices which deepen reflection. Stephen Kemmis and Robin McTaggart who have been writing for over twenty-five years on action research, note that 'Participatory action research (not always by that name) frequently emerges in situations where people want to make change thoughtfully—that is after critical reflection' (Kemmis and McTaggart 2003: 346). Of course (and often to the chagrin of traditional action researchers), practice-led researchers rarely follow these methods slavishly, preferring to adapt existing methods to suit their purposes.

The third method, a post-performance reception study, uses questionnaires and focus groups to gather descriptive and inferential statistics to measure audience response. Clearly this method belongs to the quasi-experimental methods of quantitative research, demonstrating once again that practice-led researchers will use

methods from across the research paradigms to inform or test the assumptions or outcomes of practice.

Something different happens when we attempt to trace the genealogy of the fourth method, action-tracking and fixing. This tool did not exist as "a research method" until Fenton, as a theatre director/researcher, formalised it from his practice-led approach. The creation of this original method is clear evidence of Gray's belief that practice-led research not only draws on specific methods familiar to us as practitioners, but in doing so, generates new methods and strategies of investigation. Now that Fenton has identified and reported on this technique in his own study, it is likely that others will follow his lead, applying action-tracking and fixing to their own research in Theatre and perhaps in other performing arts such as Dance.

How then can we best describe the relationship of these four research methods to the distinctive research approach practice-led researchers are establishing? Clearly there is a mix—the qualitative heritage is evident and recognised together with the quantitative approach adopted in the post-performance reception study. Could practice-led research be best understood as a "mixed methods" research design, the purpose of which, it has been suggested, is to:

> Build on the synergy and strength that exist between quantitative and qualitative research methods in order to understand a phenomena more fully than is possible using either quantitative or qualitative methods alone. (Gay, Mills and Airasian 2000: 490)

Perhaps, but such a move does not adequately account for those idiosyncratic research methods, such as action-tracking and fixing, which practitioner researchers extract directly from their usual working practices. Just as Fenton has made a methodological contribution by charting the innovative method of action-tracking and fixing, practice-led researchers from all disciplines have similar opportunities for methodological innovations from their particular disciplinary approaches. In fact these innovations are likely to be among the major contributions to knowledge of practice-led research and the performative paradigm. The strength of practice-led research is its capacity to forge new, hybrid or mutant research methods that are specific to the object of enquiry.

The Promise and Practice of Performative Research

It is important to acknowledge that proposals for a third research paradigm are hardly new. In 1988, Peter Reason was making such an argument around co-operative enquiry, an approach which is "*with* and *for* people rather than *on* people" (Reason 1995: 1). This involves:

> Establishing an aware and self-critical movement between experience and reflection which goes though several cycles as ideas, practice and experience are systematically honed and refined. (Reason 1995: 6)

The impulses which resulted in Peter Reason's formulations are also to be found in the performative research paradigm. It too, values the conditions of participatory and holistic knowing, critical subjectivity and knowledge in action that Reason (1995: 9-14) offers as indicators of the rupture with traditional research paradigms. However, these discontinuities with previous world views and methods are extended in the Performative Research paradigm to the very way in which research is reported and knowledge claims proposed and examined.

By claiming a "third space", performative researchers can stand aside from the assumptions of qualitative research and gain the clear air they need to clarify the conceptual architecture and protocols of performative research in its own terms. It is likely that we will be surprised by what we come to understand. The process of establishing a research question and problem formation, the approach for undertaking a "literature review", the criteria for gathering and presenting documentation and the ways media-rich outputs are catalogued and distributed are all likely to take us into new and exciting spaces with solutions which stand apart from the qualitative tradition, but at the same time meet the credibility tests for all good research. Practice-led researchers need to articulate the ways in which their research meets the conditions of transparency, (its clarity of structure, process and outcomes) and transferability - namely, its usefulness beyond the specific research project and how its principles enrich and inform other researchers and fresh contexts.

As this progresses, it will become sharply evident that while practice-led research builds directly out of a researcher's professional practice, it is more than an individual's professional practice alone. With its emergent, but nevertheless systematic approach, practice-led research promises to raise the level of critical practice and theorising around practice in a more rigorous and open way than professional practice alone is able to achieve. And as evidence of this, while the outputs of performative research will certainly include the material forms of practice: images, music and sound, live action digital code and so on, there will be an additional commentary commonly referred to as an exegesis.

From the Greek *exegeisthai*, exegesis can be understood as an explanation or interpretation of the creative or artistic work. This use of the term can be problematic, implying that the researcher has to say things twice, once in the work itself and then again as an explanation or interpretation of that work. However if we take an alternative understanding of exegesis 'that it is, at root, a leading or guiding out of a complexity' (dictionary.com: 2003) then we have a more open and rich field of possibilities for practice-led researchers to complete their contribution to knowledge.[5] It is also common for practice-led researchers to compliment their exegesis with appropriate documentation drawn principally from the methods they use to map and interpret the progress and findings of their research.

All of these issues require further thorough investigation and scholarly reporting if the promise and potential of performative research is to be fully recognised and realised. Nevertheless, the potential is significant and potentially far-reaching, for it is likely that performative research, with practice-led research as its principal research strategy, will have applications far beyond the creative arts, design and related

creative disciplines such as fashion and media. For performative research is aligned with the processes of testing and prototyping so common in user-led and end-user research. Indeed if it lives up to its potential, we could quickly see performative research adopted as the principal research methodology for fields as diverse as online education, virtual heritage, creative retail, cultural tourism and business-to-consumer interaction. This suggests that performative research, along with its practice-led advocates, will not have to struggle too hard for recognition in the current research environment that favours commercialisation and impact.

12

THE EXEGESIS AS MEME
Estelle Barrett

I would like to suggest that the notion of the "meme" is a useful one for addressing a number of key questions relating to creative arts research generally, and to the exegesis in particular. These questions are as follows:

- What is it?

- Why do we need it?

- What can it do within the context of a knowledge economy?

- How do we judge its success and value?

What is to follow is prefaced by an acknowledgment that the field of creative arts is a heterogeneous one, and that not all those who would call themselves artists, may choose to practice or seek recognition within a research framework. However, those who do seek endorsement of their practices by pursuing a higher degree and other forms of practice-based research within the university, are working in a relatively new discipline of research and will thus inevitably be subject to evaluation according to criteria that relate to research and the knowledge economy in general.

Definition of Meme
Let us start with a brief definition of "meme" which will be extended as this chapter proceeds. In his description of memes, Richard Dawkins (1981) observes that survival of such entities is dependent on the capacity for self-replication, fitness or the likelihood of being replicated and fecundity or speed of replication to produce critical mass and ensure stability. An evolutionary advancement on their biological counterparts, memes can be described as cultural replicators. Drawing on Dawkins earlier work, Richard Brodie (1996) describes memes as the basic building blocks of culture; ideas that form themselves into distinct memorable units and which are spread by something as simple as communicating. It should be noted that the cultural artefact—the tune, painting, poem, for example—is not the meme itself, but is a

vehicle by which the meme, an idea or internal representation is externalised. Within this context, the exegesis may be viewed both as a replication or re-versioning of the completed artistic work as well as a reflective discourse on significant moments in the process of unfolding and revealing. As "meme" it operates both as a noun—an artefact in its own right, and a verb—a re-enactment of the artefact as process. As such, it has the potential to reflect and map the logic from which a particular model of representation has emerged. Through this double articulation, the exegesis becomes a vehicle for validating the process of studio enquiry and elaborating the value of its outcomes.

The evolution, stability and successful application of ideas and knowledge derived from research depend on how well such knowledge is replicated and understood by others. However, the replication mechanisms that have traditionally valorised and validated creative arts practices have focussed on product rather than process. Moreover, such mechanisms have tended to rely on the mystification of artistic products as commodities rather than an elucidation of creative arts practices as alternative modes of understanding the world and of revealing new knowledge.

An understanding of the meme as a vehicle for fixing ideas in our collective consciousness allows us to recognise how conventional valorisation of the artefact as product proceeds at the expense of an appreciation of the value of creative processes as modes of revealing—in other words as modes of enquiry and research.

Replication as Valorisation
An appraisal of conventional means of valorisation bears this out. Paradoxically, the process that valorises art as commodity is at the same time a process of mystification rather than illumination. The more a work is reproduced in catalogues, books, magazines, on chocolate boxes and T-shirts, and sold and resold in by dealers, the greater is the aura of awe and mystique that surrounds it. This is particularly pertinent to the visual arts as demonstrated in Brian O' Doherty's (1986) description of the modernist gallery and its discourses as "white cube", one which I suggest, continues to have relevance. O' Doherty points out that the conventional gallery with its white walls, sealed windows, polished floors and light emanating from the ceiling can be likened to a church or tomb:

> The ideal gallery subtracts from the artwork all cues that interfere with the fact that it is "art". The work is isolated from everything that would detract from it own evaluation of itself. (O'Doherty 1986: 14)

In this context the work is given a sense of eternal sameness, a hermetically sealed repository of its maker's divine inspiration. The viewer of the work also relinquishes time and lived experience within the frame of sympathetic magic or mystique that is created. The idea of artist as genius, enhanced through modernist discourse has also added to the auratic nature of art that continues to dominate general perceptions. Indeed many artists themselves subscribe to the mystification process through their reluctance to discuss the origin and situated meanings of completed works. On the

other hand, artists are also often critical of institutional discourses on art that are removed from the experience of making and the individual consciousness of the maker. Hence Picasso observed that:

> A painting ... has always a certain significance, at least as much as the man who did it. As soon as it is bought and hung on the wall takes on quite a different kind of significance and the painting is done for. (Chipp quotes Picasso 1968: 272)

Picasso's comment relates to the tendency of institutional discourses to be dislocated from the studio process and its experiential, conceptual and intellectual framework. Michel Carter suggest a further disengagement of discourses from the process of inquiry results from the implication of such discourses in market forces through their focus on art works as precious objects. Whilst art historians and critical commentators may present a divergence of views on philosophical value of artistic output, Carter observes: 'intellectual interest can quickly get transformed into economic interest. New meanings are equated to new [monetary] values' (Carter 1990: 115).

Whatever their intellectual benefits, one could argue that conventional forms of criticism tend to focus on the finished product rather than material, intellectual and cognitive processes that produced it. The meme itself, or the internal representation of ideas that produced the artwork is then obscured by the vehicle in which it is carried. I should like to emphasise that this is not a denial of the intrinsic and generative value of the artworks and their capacity, in some instances to stand alone as an object of knowledge. However I do believe there is a need for a shift in current perceptions of the role and status of the creative arts in the knowledge economy and that the exegesis is a crucial vehicle for effecting this shift.

The exegesis as an illumination and replication of the meme or internal representation can adjust the critical focus and thus has the potential to valorise and validate the mode of inquiry as one worthy of recognition alongside research approaches belonging to more generously supported disciplines in the university and broader cultural arena. To put it another way, the exegesis is a means of articulating a more profound rationale for institutional recognition and support of creative arts research.

New Frontiers of Research

In proposing this, I draw on Elliot W. Eisner's view that we need new ways of representing ideas and of illuminating the world and domains of knowledge. Eisner observes that a growing recognition of the limits of traditional ways of representing the world has given rise to a search for alternative approaches to transform and represent the contents of consciousness. Researchers are recognising that scientific inquiry is just one species of research and that 'research is not merely a species of social science' (Eisner 1997: 261). Dissatisfaction with positivism and behaviourism as reductive modes of knowing has also come from within the science disciplines themselves. In his work entitled, The Discontinuous Universe (1972), Werner Heisenberg states that the knowledge of science is applicable only to limited realms

of experience and the scientific method is but a single method for understanding the world. Moreover, the notion of scientifically-based knowledge as statements of ulti-mate truth contains an inner contradiction since 'the employment of this procedure changes and transforms its object' (Heisenberg 1972: 189). The work of Heisenberg and others reveals that knowledge is relational and that different models of inquiry will yield different forms of knowledge.

Eisner supports the idea that creative arts-based inquiry has a role to play in ex-tending new frontiers of research. He draws on the work of J. Schwab and others in proposing the centrality of practical and experiential knowledge (Eisner 1997: 261). Understood through the Greek term *phronesis*, this form of inquiry requires deliberation and "wise moral choice" or what I would call the attribution of value based on unfolding action and experience. In this framework one can say that the exegesis illuminates particular knowledge and data derived from interacting with the environment (material and social) and then discusses it in relation to what is already presented in theory and general domains of knowledge. I would like to return to the meme analogy to suggest that the potential for innovation lies in this relational aspect of creative arts practice.

Evolution of Creative Arts Research: What the Exegesis *is* and what it can *Do*

Dawkins tells us that evolution occurs through the differential survival of replicating entities. The implication here, is that evolution occurs through change as an adapta-tion to the demands of the environment. Brodie comments further:

> Evolution requires two things: replication with a certain degree of fidelity, and innovation, and a certain degree of infidelity. (Brodie 1996: 68)

The element of infidelity is a crucial one since it implies a departure from customary ways of thinking and doing things. This helps us to understand why and how crea-tive arts practices change over time. It also highlights an important function of the exegesis. In addition to answering the crucial question: "What did the studio proc-ess reveal that could not have been revealed by any other mode of enquiry?", the exegesis provides the opportunity for creative arts researcher to elucidate why and how processes specific to the arts discipline concerned mutate to generate alternative models of understanding. At the same time, the researcher is also able to elaborate the significance of these models within a research context. Unlike those valorisation or replication processes that focus mainly on the economic and aesthetic value of creative works, the creative arts exegesis as meme, is a differential replication that emphasises processes of enquiry and their potential for innovative application be-yond the production of the works themselves.

The importance of this task for creative arts researchers is reflected in observa-tions made by Lauchlan Chipman in his paper, 'What governments can't know: the knowledge economy and the market' (Chipman 2002). Chipman points out that the information age to which we belong is one in which knowledge is rapidly replacing primary and industrial production as the basis for global economy. 'Knowledge is

becoming the basic building block underlying wealth' (Thurow quoted in Chipman 2002: 10). Chipman suggests that in a knowledge economy, it is necessary for a large number of people to comprehend the creative output of others in order for such outputs to be sufficiently taken up for the enhancement of society. Within the context of research, "output" refers not only to the products of creative arts practices which may be judged by conventional criteria of artistic merit, but also to the experimental and material processes through which such products are externalised.

Elsewhere, I have suggested some possible reasons for the slow recognition and acceptance of the value and validity of creative arts research (Barrett 2002). One of these relates to the dominance of instrumental and rationalistic modes of thinking within contemporary society. Social philosopher Pierre Bourdieu (1990) contends that social and institutional systems that make up society or the habitus, operate according to two forms of logic: rational logic and an alternative logic, which may be understood as the logic of practice. Bourdieu explains that rationality achieves privileged status by a process of appropriating and subsuming, into its own logic, knowledge and cultural capital generated through practices that employ the alternative logic of practice. (Bourdieu 1990: 56). The exegesis can counteract this cultural "forgetting" by tracing and highlighting the logic of specific experiential inquiry. A second issue is related to the lack of a critical mass of discourses that expound the merits of creative arts research. For the exegesis to achieve success as replicator or meme, there will need to be continued efforts to promote and publish the outcomes of research in as many ways as possible.

To conclude, I propose that an understanding of the creative arts exegesis as meme is a useful way of illuminating what the exegesis is and what it has the potential to do. Its fitness for promoting the stability of a creative arts research discipline and advancing the successful evolution of creative arts research may be judged both according to criteria of scholarly rigour, as well as its capacity to replicate and elucidate the value of studio enquiry processes and their applications within the in the general field of research.

(*This chapter was first published in Text,* Special Issue (Website Series) 3 [On-line] http://www.griffith.edu. au/school/art/text/speciss/issue3/content.htm)

NOTES

Chapter 1

1 Jeremy Bentham: *Defence of Usury: Shewing the Impolicy of the Present Legal Restraints on Pecuniary Bargains in a Series of Letters to a Friend. To Which is Added a Letter to Adam Smith, Esq.; LL.D. on the Discouragements opposed by the above Restraints to the Progress of Inventive Industry.* See: www.econlib.org/LIBRARY/Bentham/bnthUs3.html accessed October 6 2006.

2 Paul Carter, (2004) *Material Thinking: The Theory and Practice of Creative Research*, Carlton, Vic: Melbourne University Publishing: 6-11.

3 See Paul Carter's *Material Thinking: The Theory and Practice of Creative Research*, especially pages 9-10 & 185-191.

4 Jeremy Bentham: *Defence of Usury: Shewing the Impolicy of the Present Legal Restraints on Pecuniary Bargains in a Series of Letters to a Friend. To Which is Added a Letter to Adam Smith, Esq.; LL.D. on the Discouragements opposed by the above Restraints to the Progress of Inventive Industry,* www.econlib.org/LIBRARY/Bentham/bnthUs3.html accessed October 6 2006.

5 See http://grad.cgu.edu/~combsc/glossary.html accessed October 6 2006.

6 See http://grad.cgu.edu/~combsc/glossary.html accessed October 6 2006.

7 See Paul Carter's *Solution: A Public Spaces Strategy, Victoria Harbour, July 2002: 5.* Available from the author by agreement with Lend Lease Pty Ltd.

8 see John Knowles, ed, *The Life and Writings of Henry Fuseli*, 3 vols, H. Colburn, London, 1831, vol 1, 136- 137, quoted by Joseph Viscomi in 'William Blake, Illuminated Books, and the Concept of Difference', http://sites.unc.edu/viscomi/concept.htm.

9 A full account of this project is in Paul Carter's (2005) *Mythform: The Making of Nearamnew at Federation Square*, Miegunyah Press.

Chapter 2

1 For a full account see B.Bolt *Art Beyond Representation: The Performative Power of the Image*, I.B.Tauris, 2004, Chapter 4.

Chapter 4

1 The video of *27 seconds* is a documentation of a stage dance work.

2 Chinese philosophy divides the life span into 12 (conception, babyhood, infancy, child-

hood, adolescence, "Kuan Tai" meaning matriculation, adulthood, maturity, retirement, decline, final years, burial). Harry R. Moody and David Carroll in their book *The Five Stages of the Soul* (1998), identify steps along the *spiritual passages that shape our lives* as the call, the search, the struggle, breakthrough, and return.

3 I refer specifically to Western contemporary dance. Eastern cultures have a significant history of celebrating the mature performing artist; for example Kazuo Ono continues to perform at the age of 80 plus.

4 A movement phrase using the directives: 'Grab, search, discard, measure, sob, ricochet, wait.'

5 Laban's movement theory describes the quality "wring" as sustained (temporally), strong (weight), and indirect (spatial pathway).

6 I began rehearsals with the dancers in January 1998 and shot the final footage in September 1998. After the location shoot in June, we returned to the studio and developed a live performance draft (presented in August that year). This included projected footage from location that informed the final shoot in terms of what 'pick-up' material was required, and a performance memory for the dancers to call on in front of the camera.

7 In 1997 I attended an intensive workshop with American improvisation artist, Lisa Nelson, which culminated in a performance entitled *Before Your Eyes*, at Dancehouse, Melbourne. Lisa, also a video artist and editor of the journal *Contact Quarterly*, is interested in exploring the connections between vision and kinaesthetic memory to inform her performance practice. She often works with eyes closed to recall the 'sensation of the image' (Nelson, 1992).

8 The dancer's performance narrative relates to how each dancer connects and makes sense of their actions in performance. In a sense, it is a thought and felt storyline that locates and supports the performer in their performance reality. Drawing on imagery, memory, sensation, spatial connections, focal points of contact ... it is the weaving together of physical and intellectual stimuli, reconciling the 'steps' into a journey, bringing an attentiveness to each moment of performance.

9 Quoting Steve Paxton, discussing contact improvisation during a workshop at the South Australian College of Advanced Education, Adelaide, 1985.

10 At the age of twelve I performed a dance solo to Henry Mancini's Pink Panther theme.

11 There were only three set movement sequences for this work: the central "trauma" phrase; and two phrases (choreographed by Fiona and myself respectively) based on specific phrases highlighted in the soundscape ("Wait, focus down, make them move, back and forth, waving, perfectly still, just the bows moving"). These latter phrases became the starting points or anchors for improvisation on the day of shooting, and functioned in the same way as the 12 stages' "Grab, search" phrase in providing connecting dynamic/kinaesthetic frameworks with personalized variations.

12 The indoor theatre at Kyabram offered a "classic" proscenium arch setting (red curtains, stage apron) reflecting the live performance location of my story and my history as a performer, and playing on the ambiguity between stage space and screen space.

13 Paul Huntingford is a sound editor and musician who collaborated with me as camera operator and picture editor on dance video/performances *Point of View, Lay Bare, Chiaroscuro* and a short 16mm film *Betrayal*.

14 Francis Treacey is a Senior Lecturer in the media department at Deakin University and my co-supervisor for this Masters research. In 2001 we collaborated on the teaching of a new

dance video unit (*Dance Video: Choreography and the camera*) designed for the collaborative arts stream of the Bachelor of Contemporary Arts.

15 The "rewind phrase" was a movement sequence created from actions I wanted to take back, such as a kick, a punch, an unkind comment. This sequence was then learnt and performed in reverse so that outward movements came back into the body.

16 "Jog" here refers to the manual control on video playback machines, which allows the editor to shift forward and back over small sections of tape, usually to isolate the starting point of a particular frame or sequence.

17 These fragments were drawn from two main phrases I had choreographed: 1) the 'assertive driving' phrase was a larger travelling sequence designed for the climax of the work in which the whole group crosses and interweaves in a more high-risk fashion. The phrase which moved across from UL (upstage left) to UR, falls and cartwheels into a spin downstage, then hops/barrel rolls across to DL, before descending into a rolling phrase on the floor; 2) 'Katie's time shift' phrase was a variation on images drawn from the 'rewind' phrase and images selected from personal stories offered by the dancers.

18 The 'bin' is the desktop folder in which the editor stores their separate shots or 'clips'.

19 An audience member sitting on the extreme left of the auditorium had a choice or shots, either downstage right to upstage right, or the diagonal from downstage right to upstage left. (Note that the stage directions refer to the dancer's point of view, i.e. opposite to audience). It is for this reason that I chose to shoot the performances from the extreme right and left of the second row of the auditorium.

20 'I picked out certain phrases … and often they were the embellishments around the actual facts, they were the hesitations or things they repeat, or the quality of their voice. And also some of the active things like the ideas of falling or the 'searching beneath the skin to the bone' (Reid quoted in Norris 2000).

Chapter 5

1 This research was undertaken in the collections of The British Library, London, the Bodleian Library, Oxford, the Real Biblioteca del Monasterio de El Escorial, the Biblioteca Nacional, the Real Academia de la Historia in Madrid and the Österreichischen Nationalbibliothek.

Chapter 6

1 For a more detailed account of new directions in research regarding masculinity and attempts to define the term see Connell, 2000, chapters 1 and 2.

2 This was an obvious and straightforward choice under the circumstances but in practice it proved extremely difficult to find three male dancers appropriate to the challenge. To begin with there are far fewer male than female dancers. The male dancers also needed to be reasonably mature so as to draw on a depth of experience as well as feeling confident about exposing aspects of personal experience. Finally, the process was long and slow requiring commitment and patience. The rewards for the dancers were in the creative extension the process offered and in the chance to develop a very personal engagement with movement and performance.

3 The dancers who are improvising in this open-ended fashion are determining the chore-

ography in the moment of its actualisation and thus can be credited with the outcome in the same way a singular and premeditated choreographic intention might be.

4 Ideokinesis is the process of experiencing or generating movement in response to an idea, an image or a sensation which is usually based on anatomical information.

5 My standard instruction in response to the length of these improvisations would be to encourage them to spend longer in the state and to spend time searching for fresh material each night.

Chapter 7

1 The extent to which a research degree improves the employment prospects of dance artists is a complex issue. I am not suggesting here that artists always enter research programs with the explicit intention of gaining employment in the University sector. Although some do, these are usually artists already employed in the tertiary sector, and given the extent to which the tertiary dance sector has contracted over the last five years, it is unlikely that artists are entering research degrees en masse believing that these degrees will result in jobs in the short term. The point I am making is that the attraction of time to immerse oneself in one's practice and to confront and work through issues it raises is often value added by the possibility that research degree may, in the future, become a pathway to more stable employment in the University sector.

2 In Lacan's analysis, desire is an ever-present longing to fill a lack that is experienced at the heart of subjectivity because the very formation of the subject has involved an abdication of 'the magical feeling of oneness it had in the imaginary' (Mansfield 2000: 45).

3 For a full discussion of this issue, see Vincs 2002: 56–73.

Chapter 10

1 Robert Nelson, 'Doctoralness in The Balance: The Agonies of Scholarly Writing in Studio Research Degrees', *Text Special Issue*, No 3 April 2004.

Chapter 11

1 I wish to acknowledge the important role my QUT colleagues Daniel Mafe and David Fenton have played in helping to clarify the ideas developed in this chapter.

2 See for example Gray and Malins, 2004, *Visualising Research* and the special themes issue 'Practice-led Research' No 118, of *Media Information Australia,* (February 2006).

3 See Brad Haseman (2006) 'A Manifesto for performative research', *Media International Australia Incorporating Culture and Policy*, Theme Issue "Practice-led Research", No 118: 96-106.

4 In this discussion it is critical to distinguish performativity from performance. Whilst performance is a deliberate "act" such as in a theatre production or performance art, performativity is an iterative and citational practice that brings into being that which it names. Through such ongoing practices a sedimentation or materialisation occurs.

5 For an introduction to key issues related to the exegesis please see N. Krauth, (2002) 'The preface as exegesis' available at http://www.gu.edu.au/school/art/text/april02/krauth.htm.

REFERENCES

Introduction

Balkema, A. and Henk, S. (eds.) (2004) *Artistic Research*, Amsterdam: Redopi.

Balkema, A. and Henk, S. (eds.) (1997) *The Intellectual Conscience of Art*, Amsterdam: Redopi.

Barrett, E. (2004) 'What does it meme? The exegesis as valorisation and validation of creative arts research', *Text,* Special Issue (Website Series) 3 [On-line] http://www.griffith.edu.au/school/art/text/speciss/issue3/content.htm accessed November 20 2005.

Blaikie, N. (2000) *Designing Social Research: The Logic of Anticipation*, Cambridge: Polity Press.

Bolt, B. (2001) *Materializing Practices: The Work of Art as Productive Materiality,* Ph.D.Thesis Murdoch University.

Bolt, B. (2004) *Art Beyond Representation: The Performative Power of The Image*, London: I.B. Tauris.

Bourdieu, P. (1977) *Outline of a Theory of Practice,* Cambridge: Cambridge University Press.

Bourdieu, P. (1990) *The Logic of Practice*, Oxford: Polity Press.

Bourdieu, P. (1993) *Sociology in Question*, R. Nice. (trans), London: Sage.

Brookfield, S. D. (1986) *Understanding and Facilitating Adult Learning: A Comprehensive Analysis of Principles and Effective Practices*, San Francisco: Jossey-Bass.

Bryson, N. (1983) *Vision and Painting: The Logic of the Gaze*, London: Macmillan Press.

Carter, P. (2004) *Material Thinking,* Carlton, Vic: Melbourne University Press.

Chen, S.E. and Cowdroy, R.M. et al. (eds.) (1995) *Reflections on Problem-Based Learning,* Sydney, P.B.L. Network.

Chipman, L. (2002) *What Governments Can't Know: The Knowledge Economy and the Market,* St Leonards, N.S.W.: Centre for Independent Studies.

Chipp, H. B. (1968). *Theories of Modern Art,* Berkley: University of California Press.

Danto, A. C. (1973) *Analytical Philosophy of Action,* Cambridge: Cambridge University Press.

Danto, A.C. (1997) *After the End of Art: Contemporary Art and the Pale of History*, Princeton: N.J Princeton University Press.

Eisner, E.W. (1993) 'Understanding the future of educational research', *Educational Researcher*, Vol 22 No 7: 5-11.

Eisner, E.W. (1997) 'The new frontier in qualitative research methodology', *Qualitative Inquiry*, Sept, 1997, Vol 3 No 3: 259-266.

Freire, P. (1970) *Pedagogy of the Oppressed*, Seabury Press, New York.

Grenfell, M.I. and James D. et al (1998) *Bourdieu and Education: Acts of Practical Theory*, London: Falmer Press.

Heidegger, M. (1977) *Basic Writings*, D. Farrell Krell (ed.), San Francisco, Harper and Row.

Iggulden, A. (2002). *Women's Silence: In the Space of Words and Images*, (unpublished Ph.D Thesis), Deakin University.

Ihde, D. (1979) *Technics and Praxis*, Dordrecht: Reidel.

Kessel, F., Rosenfield, P., Anderson, N.B. (eds.), (2003) *Expanding the Boundaries of Health and Social Science*, Oxford: Oxford University Press.

Kolb, D. A. (1984) *Experiential Learning as the Source of Learning and Development*, Englewood Cliffs, N.J. Prentice-Hall.

Laurrilard, D. (1993) *Rethinking University Teaching: A Framework for The Effective Use of Educational Technology*, London: Routledge.

Perry, G. (2004) *Midnight Water: A Memoir*, Sydney: Picador.

Perry, G. (2001) *Water's Edge and the Water's Edge Writing*, (unpublished Ph.D Thesis), Deakin University.

Polanyi, M. (1961) *Knowing and Being: Essays by Michael Polanyi*, (ed.) M. Grene, 1969, London: Routledge and Kegan Paul.

Polanyi, M. (1966) *The Tacit Dimension*, Garden City, N.Y.: Doubleday.

Stewart, R.A. (2003) 'Praxis as bricolage: modelling practitioner-based research' *International Research Conference Proceedings CD-ROM, In SEA 31ˢᵗ World Congress*, New York, August 2003.

Vincs, K. (2002) *Rhizome/MyZone: The Production of Subjectivity in Dance*, (unpublished Ph.D thesis), Deakin University, Melbourne.

Chapter 1 - References

Bentham, J. (1787) *Defence of Usury: Shewing the Impolicy of the Present Legal Restraints on Pecuniary Bargains in a Series of Letters to a Friend. To Which is Added a Letter to Adam Smith, Esq.; LL.D. on the Discouragements Opposed by the Above Restraints to the Progress of Inventive Industry*. See: www.econlib.org/LIBRARY/Bentham/bn-thUs3.html accessed October 6 2006.

Carter, P. (2002). *Repressed Spaces: The Poetics of Agoraphobia*, London: Reaktion.

Carter, P. (2002) *Solution: A Public Spaces Strategy, Victoria Harbour, July 2002* Available from the author by agreement with Lend Lease Pty Ltd.

Carter, P. (2005) *Mythform: The Making of Nearamnew at Federation Square*, Carlton, Vic: Miegunyah Press.

Carter, P. (2005) *Material Thinking: The Theory and Practice of Creative Research*, Carlton, Vic: Melbourne University Publishing.

Frenkel, M. (1986) *Federal Theory*, Canberra, Australian National University.

Freud, S. (1960) *The Interpretation of Dreams*, trans. J. Strachey, New York: Basic Books.

Knowles, J. (ed) (1831) *The Life and Writings of Henry Fuseli*, 3 vols, H. Colburn, London, 1831, Vol 1: 136-137, quoted by Joseph Viscomi in 'William Blake, Illuminated books, and the concept of difference'. See http://sites.unc.edu/viscomi/concept.htm accessed October 6 2006.

Whitehead, A. N. 'Glossary of Whitehead Terminology' at http://grad.cgu.edu/~combsc/glossary.html

Chapter 2 - References

Bolt, B. (2004) *Art Beyond Representation: The Performative Power of the Image*. London. I.B.Tauris.

Bolt, B. (2004) 'The exegesis and the shock of the new', *Text*, Special Issue (Website Series) 3 [On-line] http://www.griffith.edu.au/school/art/text/speciss/issue3/content.htm accessed May 29 2006.

Carter, P. (2004) *Material Thinking: The Theory and Practice of Creative Research*, Carlton, Vic.: Melbourne University Press.

De Freitas, N. (2004) 'Towards a definition of studio documentation: working tool and transparent record', *Selected Working Papers in Art and Design*, No 2. [On-line] http://www.herts.ac.uk/artdes1/research/papers/wpades/vol2/freitasfull.html, accessed May 29 2006.

Gray, C. and Marlins, J. (2004) *Visualizing Research—A Guide to the Research Process in Art and Design*, London: Ashgate.

Heidegger, M. (1977) *Basic Writings*, D. Farrell Krell (ed.), San Francisco: Harper and Row.

Heidegger, M. (1996) *Being and Time*. trans. J. Stambaugh, Albany: State University of New York Press.

Hockney, D. (2001) *Secret Knowledge: Rediscovering the Lost Techniques of the Old Masters*, London: Thames and Hudson.

Ihde, D. (1979) *Technics and Praxis*, Dordrecht: Reidel.

Judovitz, D. (1988) 'Representation and its limits in Descartes; in H.J. Silverman and D. Welton (eds.) *Postmodernism and Continental Philosophy*, Albany: State University Press of New York: 68-84.

Levinas, E. (1996) 'Martin Heidegger and ontology', *Diacritics*, Vol 26 No 1: 11-32.

Sullivan, G. (2005) *Art Practice as Research: Inquiry in the Visual Arts*. Thousand Oaks, Cal.: Sage Publications.

Chapter 3 - References

Barthes, R. (1993) *Camera Lucida*, trans. Richard Howard, London: Vintage.

Goldsmith, A. (2002) 'Homer and the Holocaust', *Australian Book Review*, November 2002.

Henke, S.A. (2000) *Shattered Subjects: Trauma and Testimony in Women's Life Writing*, London: Macmillan.

Klass, D., Silverman, P.R. & Nickman, S. L. (eds.) (1996) *Continuing Bonds: New Understandings of Grief*, Taylor and Francis, Washington DC.

Perry, G. (2004) *Midnight Water: A Memoir*, Sydney: Picador.

Perry, G. (2001) *Water's Edge and the Water's Edge Writing*, (unpublished Ph.D Thesis), Deakin University.

Chapter 4 - References

Albright, A. C. (1997) 'Feminist theory and contemporary dance', in S. E. Friedler and S. B. Glazer (eds.), *Dancing Female: Lives and Issues of Women in Contemporary Dance*, Amsterdam: Harwood Academic Publishers: 139–152.

Bartenieff, I., Davis, M., et al. (1970) *Four Adaptations of Effort Theory in Research and Teaching,* New York: Dance Notation Bureau.

Bazin, A. (1950-55) 'The evolution of the language of cinema.' A. Bazin and H. Gray, (eds.), *What is Cinema?*, Berkely: University of California Press.

Bromberg, E. (2000) 'Thoughts on video dance.' *Dance Screen 2000*, Monaco: IMZ.

Clark, V. A., Hodson, M. & Neiman, C. (1984) *The Legend of Maya Deren: a Documentary Biography and Collected Works*, F. Bailley Price (Director of Photography), H. Melton (General Editor), New York: Anthology Film Archives/Film Culture.

Daly, A. (1992) 'Dance history and feminist theory: reconsidering Isadora Duncan and the male gaze', in L.Senelick, (ed.), *Gender in Performance: The Representation of Difference in the Performing Arts*, Hanover, University Press of New England: 239–259.

Deren, M. (1960) 'Cinematography: the creative use of reality', in G. Mast, M. Cohen and L. Braudy, (eds.), *Film Theory & Criticism: Introductory Readings*, New York: Oxford University Press: 59–70.

Dyson, C. (ed.), (1994) *The Ausdance Guide to Australian Dance Companies*, Canberra: Australian Dance Council.

Grosz, E. (1994) *Volatile Bodies: Toward a Corporeal Feminism,* Bloomington, USA: Allen & Unwin.

Hay, D. (1994) 'Ages of the avant-garde'. *Performing Arts Journal.* Vol 46: 26–27.

Huntingford, P. (2001) Interview with Dianne Reid, 1st February 2001, Melbourne.

Jones, A. (1992) 'Postfeminism, feminist pleasures, and embodied theories of art', in J. Frueh, C. L., Langer & A. Raven, (eds.), *New Feminist Criticism: Art, Identity, Action*, New York: Harper Collins Publishers: 16–41.

Kaltenbrunner, T. (1998) *Contact Improvisation*, Aachen: Meyer and Meyer Publishing.

Mahrer, M. (2001) Interview with Dianne Reid, 6th February 2001, Melbourne.

McGrath F. (2001) Interview with Dianne Reid, 1st February 2001, Melbourne.

Merleau-Ponty, M. (1962) *The Phenomenology of Perception*, London, Routledge and Kegan Paul.

Mitchell, T. (2001) Interview with Dianne Reid, 25th January 2001, Melbourne.

Moody, H. R. & Carroll, D. (1998) *The Five Stages of The Soul,* Rider, London: Ebury Press.

Nascimento, C. T. (2000) 'Defining dance for the camera as a genre', *Dance on Camera,* Vol 3 No 3: 4-7.

Nelson, L. (1992) 'The sensation is the image', *Writings on Dance,* Vol 14: 4–16.

Norris, V. (2000) *Interview 1 with Dianne Reid,* 26th October 2000, Perth.

Rainer, Y. (1994) 'Ages of the avant-garde', *Performing Arts Journal,* Vol 46: 33–35.

Reid, D. (2001) *Folding on Forever,* (unpublished Masters Thesis), Deakin University.

Rosenberg, D. (2000) 'Video space: a site for choreography', *Leonardo,* Vol 33 No 4: 275–280.

Sacchero, Viviana (2001) Interview with Dianne Reid, 16th May 2001, Melbourne.

Satin, L. (1996) 'Being danced again: Meredith Monk, reclaiming the girlchild', in G. Morris (ed.), *Moving Words: Re-writing Dance,* London Routledge: 121–140.

Simondson, H. (1995) 'Stranger in a strange land', *Is Technology the Future for Dance?,* Melbourne: Ausdance.

Steinman, L. (1986) *The Knowing Body: The Artist as Storyteller in Contemporary Performance,* Berkeley: North Atlantic Books.

Tykwer, T. (dir), (1999) *Run Lola Run,* Germany: Sony Pictures Classics/Bavaria Film International/X-Filme Creative Pool Productions, 75 mins.

Van Itallie, J.C. (1994) 'Ages of the avant-garde' in *Performing Arts Journal.* Vol 46 35: 12-57.

Warshaw, R. (1982) What Are We Teaching?' *Contact Quarterly.* Vol 7 No 3/4: 19–21.

Wright Wexman, V. (1999) *Jane Campion: Interviews,* Jackson: University Press of Mississippi.

Chapter 5 - References

Bal, M. (1994) *On Meaning-Making: Essays in Semiotics,* Sonoma, California: Polebridge Press.

Barthes, R. (1985) *The Responsibility of Forms: Critical Essays on Music, Art, and Representation,* R. Howard (trans.), Toronto, U.S.A.: Collins Publishers.

Barthes, R. (1978) *A Lover's Discourse: Fragments,* Richard Howard (trans.) Hill and Wang, New York.

Betterton, R. (1996) *Intimate Distance: Women, Artist and the Body,* London: Routledge.

Bryson, N. (1983) *Vision and Painting: The Logic of the Gaze,* New Haven: Yale University Press.

Flanagan, S. (1989) *Hildegard of Bingen, 1098—1179: A Visionary Life,* London: Routledge.

Florence, A. P. and Foster, N. (eds.), (2000) *Differential Aesthetics: Art Practices, Philosophy and Feminist Understandings,* Aldershot, England: Ashgate Publishing Ltd.

Foucault, M. (1983) *This Is Not A Pipe,* James Harkness, (ed. and trans.), London: University of California Press, London.

Kelly, M. (1996) *Imaging Desire,* U.S.A.: M I T Press.

Kendrick, L. (1999) *Animating the Letter: The Figurative Embodiment of Writing from Late Antiquity to the Renaissance,* U.S.A.: Ohio State University Press.

Maggi, A. (1997) 'Performing/annihilating the word: body and erasure of a Florentine mystic', *T.D.R.,* Vol 4, Winter: 110-125.

Mertens, J. (2000) *"Wachten Op De Prins…": Negen Eeuwen Adellijk Damesstift Munsterbilzen,* (Exh., cat. 23rd Sept- 3rd Dec 2000, Landcommanderij Alden Biesen), Belgium: Bilzen.

Meskimmon, M. (1996) *The Art of Reflection: Women Artists' Self-portraiture in the Twentieth Century*, London: Scarlet Press.

Mitchell, W.J.T. (1980) 'The language of images', *Critical Enquiry*, Vol 6, No 3, Spring, Illinois, U.S.A.: The University of Chicago Press: 539-565.

Parker, R. and Pollock, G. (eds. and intro.), (1987) *Framing Feminism: Art and the Women's Movement 1970—1985,* London: Pandora Press (Routledge & Kegan Paul Ltd).

Pollock, G. (1994) 'Inscriptions in the feminine' in M. C. de Zegher, (ed.) *Inside the Visible: An Elliptical Traverse of 20th Century Art: In, of, and from the Feminine*, (exh., cat. Institute of Contemporary Art, Boston, 30th Jan to 12th May, 1996): 67-87.

Wally, B. (1995) *A Cycle in Time: Nancy Spero and Leon Golub at The Residengalerie Salzburg,* (Exh., cat. Residengalerie Salzburg, from the 12th August to the 3rd December, 1995).

Weir, K. (1998) *Read My Lips: Jenny Holzer, Barbara Kruger, Cindy Sherman*, (Exh., cat. National Gallery of Australia, 6th June to 9th August, 1998).

Chapter 6 - References

Burt, R. (1995) *The Male Dancer. Bodies, Spectacle, Sexualities*, London: Routledge.

Buchholz, E. L. (1999) *Goya*, Cologne: Konemann Verlagsgesellschaft mbh.

Connell, R. W. (2000) *The Men and the Boys*, Sydney: Allen & Unwin.

De Spain, K. (1995) 'A moving decision:, notes on the improvising mind', *Contact Quarterly,* Vol 20, No 1: 48-50.

Dempster, E. (1985) 'Imagery, ideokinesis and choreography', *Writings on Dance,* No 1: 18-22.

Gardner, S. (1996) 'Spirit of gravity and maiden's feet', *Writings on Dance* No 5: 48-61.

Goldstein, L. (ed.), (1994) *The Male Body: Features, Destinies, Exposures,* Ann Arbor: University of Michigan Press.

Grosz, E. (1994) *Volatile Bodies. Toward a Corporeal Feminism*, St Leonards, NSW: Allen & Unwin.

Heckes, F. (1998) *Reason and Folly. The Prints of Francisco Goya*, Melbourne: National Gallery of Victoria.

Middleton, P. (1992) *The Inward Gaze. Masculinity and Subjectivity in Modern Culture,* London: Routledge.

Rothfield, P. (1994/5) 'Philosophies of movement', *Writings on Dance,* No 11/12: 77-86.

Rutherford, J. (1988) 'Who's that man?' in R. Chapman and J. Rutherford (eds.) *Male Order: Unwrapping Masculinity*, London: Lawrence and Wishart.

Seidler, V. J. (1989) *Rediscovering Masculinity: Reason, Language and Sexuality*, London: Routledge.

Chapter 7 - References

Buchanan, I. (2000) *Deleuzism: A Metacommentary*, Edinburgh: Edinburgh University Press.

Deakin University (2001) *Guide to Candidature: Higher Degrees by Research.*

Deleuze G. & Guattari F. (1987) *A Thousand Plateaus: Capitalism and Schizophrenia*, Minneapolis: University of Minnesota Press.

Guttari, F. (1995) *Chaosophy*, New York: Semitext(e).

Louppe, L. (1996) 'Corporeal sources: a journey through the work of Trisha Brown', Sally Gardner (trans), in *Writings on Dance*, Vol 15, (Winter): 6-11.

Parnet, C. (1996) '*L'Abécédaire de Gilles Deleuze, Avec Claire Parnet* (Gilles Deleuze's ABC Primer, with Claire Parnet)', directed by Pierre-André Boutang (1996), Overview prepared by Charles J. Stivale, Romance Languages & Literatures, Wayne State University. Available: http://www.lag;ab.wayne.edu/Romance/FreD_G/ABC1.html, accessed September 18, 2001.

Rolnik, S. (2002) 'Life on the spot', *World Dance Alliance, Global Dance, 2002, Conference Reader*: 1–16.

Vincs, K. (2001) *Kim's Style Guide for the Kinaesthetic Boffin*, Melbourne: Gasworks Theatre.

Vincs, K. (2002) *Rhizome/MyZone: The Production of Subjectivity in Dance*, (Unpublished PhD Thesis), Deakin University, Melbourne.

Chapter 8 - References

Benjamin, W. (1968) 'The storyteller: reflections on the works of Nikolai Leskov' in Arendt, H. (ed.), *Illuminations*, Harry Zohn (trans.), London: Collins/Fontana Books.

Deleuze, G. (1989) *Cinema 2: The Time Image*, trans. Hugh Tomlinson and Robert Galeta (trans), Minneapolis: University of Minnesota Press.

Deleuze, G. (2000) 'The brain is the screen: an interview with Gilles Deleuze', Marie Therese Guirgis (trans) in Flaxman, G. (ed) *The Brain is the Screen: Deleuze and the Philosophy of Cinema*, Minneapolis: University of Minnesota Press.

Goddard, Stephen, (2002). *Lorne Story: Reflections on a Video Postcard*, Video, PAL, 107 minutes, Thesis (Ph.D.) Deakin University, Victoria, Australia.

Schön, D.A. (1995) *The Reflective Practitioner*, New York: Basic Books.

Chapter 9 - References

Alverson, M. & Skolberg, K. (2000) *Reflexive Methodology—New Vistas for Qualitative Research*, London: Sage.

Bartlett, L. (1989) 'Images of reflection: a look and a review', *Qualitative Studies in Education*, Vol 2 No 4: 1-7.

Berger, P. & Luckman, T. (1981) *The Social Construction of Reality*, London: Allen Lane.

Brewer, J. & Hunter, A. (1989) *Multimethod Research: A Synthesis of Styles*, Newbury Park CA.: Sage.

Butt, R. (1985) 'Biography and Personal Practical Knowledge'. Paper presented at the annual meeting of the Canadian Society for the Study of Education, Montreal, P.Q.

Campbell, D. & Stanley, J. (1963) *Experimental and Quasi-Experimental Designs for Research*, Chicago: Rand McNally College Publishing Co.

Carlgren, I.& Lindblad, S. (1991) 'On teachers' practical reasoning and professional knowledge: considering conceptions of context in teachers' thinking', *Teacher and Teacher Education.* Vol 7 No 5/6: 507-516.

Carr, W. & Kemmis, S. (1986) *Becoming Critical: Education, Knowledge and Action Research*, London: Falmer.

Chalmers, F.G. (1990) 'Art education and the promotion of intercultural understanding', *Journal of Social Theory in Art Education,* Vol 10: No 1: 20-29.

Chatman, S. (1981) 'What novels can do that films can't (and vice versa)' in W. Mitchell (ed.), *On Narrative,* Chicago: University of Chicago Press: 117-136.

Connelly, M. & Clandinin, J. (1987) 'On narrative method, biography and narrative unities in the study of teaching', *The Journal of Educational Thought,* Vol 21 No 3: 130-139.

Connelly, M. and Clandinin, J. (1990) 'Stories of experience and narrative inquiry', *Educational Researcher,* Vol 19 No 5: 2-14.

Cowell, A. (1997) *Defining and Expressing a Valid Personal Reality,* (unpublished research report), University of Southern Queensland.

Crites, S. (1986) 'Storytime: recollecting the past and projecting the future' in T.Sarbin (ed.), *The Storied Nature of Human Conduct,* New York: Praeger: 152-173.

Denzin, N.K. (1989) *Interpretive Biography,* London: Sage Publications.

Dissanayake, E. (1990) *What is Art For?,* Seattle: University of Washington Press.

Eisner, E. (1979) 'Recent developments in educational research affecting art education', *Art Education*: 12-15.

Elbaz, R. (1987) *The Changing Nature of the Self: A Critical Study of The Autobiographical Discourse,* Iowa: University of Iowa Press.

Goetz, J. and le Compte, M. (1984) *Ethnography and Qualitative design in Educational Research,* Orlando, Fla: Academic Press.

Goodson, I. (1988) 'Teacher's life histories and studies of curriculum and schooling' in I.F.Goodson (ed.) *The Making of Curriculum: Collected Essays,* Philidelphia, Falmer Press: 71-92.

Guba, E. and Lincoln, Y. (1989) *Naturalistic Research*, Beverly Hills, C.A.: Sage.

Hawke, D. (1996) 'Autobiography as an approach to research of artistic practice', *Australian Art Education,* Vol 19 No 3: 31-36.

Hoffmann Davis, J. (1997) 'Perspective talking: discovery and development' in S. Lawrence- Lightfoot and J. Hoffmann Davis, *The Art and Science of Portraiture,* San Francisco: Jossey-Bass Inc.

Jefferies, J. (1997) 'Autobiographical patterns', *N. Paradoxa,* Issue 4: 1-6.

Kinnear, J. (2000) The Ratio of Distance, (unpublished MVA thesis), University of Southern Queensland.

Marton, F. (1981) 'Phenomenography: describing conceptions of the world around us', *Instructional Science* Vol 10: 177-200.

Mayes H. (2000) *Drawing Thought,* (unpublished research report), University of Southern Queensland.

Mitchell, D. (1999) *Stitching Memories,* (unpublished research report) University of Southern Queensland.

Nelson, C.,Treichler, P.A. & Grossberg, L. (1992) 'Cultural studies' in L. Grossberg, C. Nelson & P.A. Treichler (eds.), *Cultural Studies*, New York: Routledge: 1-16.

Nespor, J. & Barylske, J. (1990) 'Narrative discourse and teacher knowledge', *American Educational Research Journal*, No 28 Vol 4: 805- 823.

Parkin, F. (1985) 'Meaning systems and class inequality' in P. Worsley (ed), *Modern Sociology: Introductory Readings,* Second Edition, Ringwood, Vic: Penguin Books.

Plath, D. (1987) 'Making experience come out right: culture as biography', *Central Issues in Anthropology*, Vol 7: 1-8.

Plowmann, N. (2000) (unpublished research report), University of Southern Queensland.

Polanyi, M. (1985) *Personal Knowledge,* Chicago: University of Chicago Press.

Prescott, C. (2000) *Reason For My Hot Capsule(?),* (unpublished research report), University of Southern Queensland.

Spence, D. (1982) *Narrative Truth and Historical Method,* New York: Norton & Company.

Smith, L. M. (1994) 'Biographical method' in N. K. Denzin and Y. S. Lincoln, (eds.), *Handbook of Qualitative Research*. Thousand Oaks, CA.: Sage Publications.

Stewart, R. (1994) *Neonarratives of Visuality: Contemporary Aesthetic Constructs about Artistic Learning.* (unpublished Ph.D. Thesis), The University of Queensland.

Stewart, R. (1996) 'Constructing neo-narratives: a qualitative research process for the visual arts', *Australian Art Education*, Vol 19 No 3: 37-47.

Tsoutas, N. (1996) Preface in R. Butler (ed.), *What is Appropriation? An Anthology of Critical Writings on Australian Art in The '80s and '90s,* Sydney: IMA and Power Publications.

Turner, V. & Bruner, E. (eds.) (1986) *The Anthropology of Experience,* Urbana: University of Illinois Press.

Urata, C. (1999) *My Best Blossom,* (unpublished research report), University of Southern Queensland.

Van Maanen, M. (1988) *Tales of the Field: On Writing Ethnography,* Chicago: University of Chicago Press.

Van Maanen, M. (1990) *Researching Lived Experience: Human Science for An Action Sensitive Pedagogy,* University of Western Ontario: Althouse Press.

Weinsteinm, D and Weinstein, M.A. (1992) 'Georg Simmel: sociological flaneur bricoleur', *Theory, Culture, Society*, Vol 8: 151-168.

Wiersma, W. (1995) *Research Methods in Education,* sixth edition, Massachusetts: Allyn and Baker.

Chapter 10 - References

Bolt, B. (2004), *Art Beyond Representation: The Performative Power of The Image*, London and New York: I.B. Tauris.

Carter, P. (2004) *Material Thinking*, Carlton, Victoria: Melbourne University Press.

Chipp, H.B. (1968) *Theories of Modern Art*, Berkley: University of California Press.

Florman, L. (2003) 'The difference experience makes in "The Philosophical Broth-el".' *Art Bulletin*, Vol 85 No 4: 769-83.

Foucault, M. (1991) (first published in 1984) 'What is an author' in Paul Rabinow (ed.) *The Foucault Reader,* London: Penguin: 101-120.

Foucault, M. (1980) *Power/Knowledge,* Brighton: Harvester.

Foucault, M. (1972) *The Archaeology of Knowledge,* London: Tavistock.

Foucault, M. (1982) 'The subject and power', *Critical Enquiry* Vol 8 No 4: 777-789.

Haraway D. (1991) 'Situated knowledges: the science question in feminism and the privilege of partial perspective' in Donna Haraway, *Cymians, Cyborgs and Women,* New York: Free Association Books.

Haraway D. (1992) 'The promises of monsters: a regenerative politics for inappropriate/d others' in L. Grossberg, C. Helson and Paula A. Treichler (eds.) *Cultural Studies,* London and New York: Routledge: 295-337.

Latour, B. (1986) 'Visualization and cognition: thinking with eyes and hands', *Knowledge and Society: Studies in the Sociology of Culture Past and Present,* Vol 6: 1-40.

Nelson R. (2004) 'Doctoralness in the balance: the agonies of scholarly writing in studio research degrees', *Text Special Issue,* No 3 April.

Picasso, P. (1968) 'Cubism', in B. Herschell *Theories of Modern Art,* Berkley: University of California press: 271-278.

Rubin, W. (1994) 'The genesis of *Les Demoiselles d'Avignon',* special issue of *Studies in Modern Art,* No 3, New York: Museum of Modern Art: 13-144.

Steinberg, L. (1988) 'The philosophical brothel', *October,* Vol 44, Spring: 7-74.

Chapter 11 - References

Argyris, C. (1993) 'Introduction: action and learning', *Knowledge for Action: A Guide to Overcoming Barriers to Organizational Change,* San Francisco: Jossey-Bass.

Argyris, C. and Schön, D. A.. (1974) *Theory in Practice: Investigating Professional Effectiveness,* San Francisco: Jossey-Bass.

Austin, J. L (1962, 1955). *How to Do Things with Words.* Full paper appears at: http://uccstuff.com/FALL2003/j-l-austin.pdf.

Denzin, N. (2003) *Performance Ethnography: Critical Pedagogy and the Politics of Culture,* Thousand Oaks: Sage.

Denzin, N. and Lincoln, Y. (2005) *The SAGE Handbook of Qualitative Research,* Thousand Oaks: Sage Publications.

Dictionary.com
http://dictionary.reference.com/wordoftheday/archive/2004/12/23.html accessed October 30 2006.

Gay, L. R., Mills, G. E. and Airasian, P. W. (2000) *Educational research: Competencies for Analysis and Application* (6th ed.) Englewood Cliffs, N.J.: Prentice Hall.

Gergen, M. and Gergen, K. (2003) 'Qualitative inquiry, tensions and transformations' in K. Norman, N. Denzin and S. Yvonna (eds), *The Landscape of Qualitative Research: Theories and Issues,* Thousand Oakes: Sage: 575-610.

Gray, C. (1996) *Inquiry Through Practice: Developing Appropriate Research Strategies,* http://www2.rgu.ac.uk/criad/cgpapers/ngnm/ngnm.html accessed January 12 2005.

Gray, C. and Malins, J. (2004) *Visualising Research,* Ashgate.

Haseman, B. (2006) 'A manifesto for performative research', *Media International Australia incorporating Culture and Policy*, theme issue, "Practice-led Research", No 118: 98-106.

Johns, C. (2000) *Being and Becoming a Reflective Practitioner*, London: Blackwell.

Kemmis, S. and McTaggart, R. (2003) 'Participatory action research' in N. Denzin and Y. Lincoln (eds.) *Strategies of Qualitative Inquiry* (2nd ed.), Thousand Oakes: Sage: 336-396.

Lincoln, Y. and Denzin, N. (2003) *Turning Points in Qualitative Research: Tying Knots in a Handkerchief*, Walnut Creek: Altamira Press.

Norris, J. (1997) 'Meaning through form: alternative modes of knowledge representation' in J.M. Morse (ed.) *Completing a Qualitative Project: Details and Dialogue*, Thousand Oakes: Sage: 87-115.

OECD. (2002) *Frascati Manual*, Fifth edition, 2002, para. 63, page 30.

Reason, P. (1995) 'Introduction' in P. Reason, *Human Inquiry in Action : Developments in New Paradigm Research*, London: Sage: 1-17.

Research Assessment Exercise (RAE) (2006) 'Definition of research and eligible outputs 2008', http://www.rca.ac.uk/pages/research/definitions_of_research_3091.html accessed September 2006.

Schön, D. A. (1983) *The Reflective Practitioner: How Professionals Think in Action*, New York: Basic Books.

Schwandt, T. (2001) *Dictionary of Qualitative Research*, Thousand Oakes: Sage.

Snow, D. and Morril, C. (1995) 'Ironies puzzles and contradictions in Denzin and Lincoln's vision for qualitative research', *Journal of Contemporary Ethnography*, Vol 24, No 3: 358-362.

Chapter 12 - References

Barrett, E. (2002) 'Studio enquiry as valid research', paper presented at Inaugural Research on Research Conference RMIT University, 14 February 2002.

Bourdieu, P. (1990) *The Logic of Practice*, Oxford: Polity Press.

Brodie, R. (1996) *Virus of the Mind: A New Science of The Meme*, Seattle: Integral Press.

Carter, M. (1990) *Framing Art*, Marrickville NSW: Southwood Press Pty. Ltd.

Chipp, H.B. (1968) *Theories of Modern Art*, Berkley: University of California Press.

Dawkins, R. (1981) 'Selfish genes and selfish memes' in D. R. Hofstadter and D. C. Dennett (eds.) *The Mind's I: Fantasies and Reflections on Self and Soul*, Sussex: Harvester: 124-146.

Eisner, E.W. (1993) 'Understanding the future of educational research', *Educational Researcher*, Vol 22 No 7: 5-11.

Eisner, E.W. (1997) 'The new frontier in qualitative research methodology', *Qualitative Inquiry*, September, Vol 3 No 3: 259-266.

Heisenberg, W. (1972) 'The representation of nature in contemporary physics' in S. Sears and G.W. Lord (eds.) *The Discontinuous Universe*, New York: Basic Books: 123-189.

O'Doherty, B. (1986) *Inside the White Cube*, San Francisco: The Lapis Press.

CONTRIBUTORS

Estelle Barrett
Deakin University
Estelle Barrett is Senior Lecturer in the School of Communication and Creative Arts at Deakin University where she has teaches Visual Theory. Her research interests include representation and subjectivity, psychoanalysis, body/mind relations, and affect and embodiment in aesthetic experience. She has an active interest in visual communication and creative arts research. She has published reviews and articles in *Real Time, Artlink, Text, Social Semiotics, Double Dialogues and The International Journal of Critical Arts* as well as presenting at national and international conferences.

Barbara Bolt
University of Melbourne
Barbara Bolt is a senior lecturer in Visual Media at the University of Melbourne in Victoria. She is a practicing artist who has also written extensively on the visual arts in both popular and academic publications. Her book, *Art Beyond Representation: The Performative Power of the Image* was published by the UK publisher I.B.Tauris in 2004. As an arts writer, she has been published in Australian art magazines including *Artlink, Eyeline, Craftswest* and *Real Time* as well as in international refereed journals such as *Cultural Review, Hypatia, Womens Philosophical Review* and *Social Semiotics*. Additionally she has had essays on art published in edited books including *Differential Aesthetics: Art Practices and Philosophies: Towards New Feminist Understandings* (Ashgate, 2001) and *Unframed: The Practices and Politics of Women's Painting* (I.B.Tauris, 2004).

Paul Carter
University of Melbourne
Paul Carter is a writer and artist based at the University of Melbourne, where he is Professorial Research Fellow within the Faculty of Architecture, Building and Planning. His recent publications include *Repressed Spaces: The Poetics of Agoraphobia* (Reaktion Books, 2002) and *Material Thinking: The Theory and Practice of Creative Research* (Melbourne University Press, 2004). In 2005 Melbourne University Press with Miegunyah Press published *Mythform: The Making of Nearamnew*, a richly-illustrated

account of the plaza artwork at Federation Square, Melbourne, a 7,500 square metre ground design made in collaboration with Lab architecture studio, featuring over 70 square metres of engraved text. In 2004 Carter was part of a design team including Taylor, Cullity & Lethlean, Peter Elliot Architects, and James Hayter and Associates that won the Australian Institute of Landscape Architects National Excellence for Planning Award for North Terrace Precinct (Adelaide). He is currently collaborating with Taylor, Cullity & Lethlean on an integrated public artwork concept for parts of the University of Sydney public domain.

Stephen Goddard
Deakin University

Stephen Goddard teaches film and video in the School of Communication and Creative Arts at Deakin University. His teaching includes personal, experimental and documentary production and the relations between screen practitioners and their practices. As a practicing film and video-maker, his research is based on issues associated with autobiography and narrative subjectivity. He has presented illustrated lectures at national and international conferences such as the University Film and Video Association, the International Auto-Biography Association, and Double Dialogues.

Brad Haseman
Queensland University of Technology

Brad Haseman is Professor and Director of Research for the Creative Industries Faculty at QUT where he has been a strong advocate for practice-led research. He has worked as a teacher and researcher for over thirty years pursuing his fascination with the aesthetics and forms of contemporary performance and pedagogy. Most recently he served as guest editor for a themed issue on *Practice-led Research* for Media International Australia (February 2006) and co-edited *Innovation in Australian Arts, Media and Design* (Post Press, 2004). In 2004 he received a Distinguished Teaching Award for Postgraduate Supervision at QUT and in 2005 co-convened the national conference *Speculation and Innovation: Applying Practice-led Research in the Creative Industries*.

Annette Iggulden
Deakin University

Annette Iggulden has exhibited extensively throughout Australia. For several years she worked as a sessional tutor and lecturer in arts practice and theory at Swinburne and Deakin University (Melbourne and Warrnambool). Her growing interest in women's silence and the use of words and images in her own practice led to research for a PhD in Visual Arts at Deakin University. Since her art residency at Hill End N.S.W. in 2003 she has explored the notion of a "gendered" landscape. She is also presently working on a project with the Australian National University, Limited Editions and Book Studio (Canberra), to consider the "silence" surrounding the violence of women and another collaborative project with the author Gaylene Perry, on the subject of grief.

Shaun Mcleod
Deakin University

Shaun McLeod is a Melbourne-based contemporary dancer and choreographer who has worked with Australian Dance Theatre (Adelaide), Danceworks (Melbourne) and One Extra (Sydney) as well as presenting numerous independent projects. He has an interest in both structured choreography and improvised dance, but particularly in the interface between the two in live performance. His choreographic work has included *In Visible Ink* (1995), *Cowboy Songs* for the 1997 Bodyworks Festival (Dancehouse, Melbourne), *Chamber* (2001 winner Green Room Award), and *Barely Real* for the 2004 Melbourne Fringe Festival. He also maintains an improvised performance practice with regular performances at Conundrum and he performed in the 2004 Dance Card (Dancehouse, Melbourne). Shaun is also interested in the performance of masculinity in dance. He completed his MA on masculinity and improvisation in dance in 2002. He is a lecturer in dance at Deakin University Melbourne.

Gaylene Perry
Deakin University

Gaylene Perry's literary memoir, *Midnight Water* (2004), is published by Picador. She has also published numerous short stories, essays and reviews. Gaylene is currently working on a second book, which she will probably categorise as fiction. Stylistically, her writing interests lie in the fissures between fiction and life writing. Gaylene is a lecturer in professional writing in the School of Communication & Creative Arts at Deakin University. Her research interests are currently focused on grief and trauma and the relationships of those concepts to art. She was awarded her PhD in 2001, with her thesis incorporating the novel *Water's Edge* and an exegesis treating the nexus between the creative arts and higher research. Gaylene is concerned with the spaces created by and in collaborative, interdisciplinary artworks, and has been working on a collaborative creative writing/visual arts project with the visual artist Annette Iggulden.

Dianne Reid
Dancehouse Melbourne

Diane Reid is a performer, choreographer/videographer who works as an independent dance artist and educator in Melbourne Australia. Dianne was a member of the Melbourne contemporary dance company, Danceworks from 1990-95, was a founding member of Outlet Dance in Adelaide (1987-89). Under the company name **hip sync**, Dianne produces dance screen works and video documents/edits live performance. Her dance video works have been screened at Green Mill Dance Project (1995), Dance Lumiere (1998), Melbourne Fringe Short Film Festival (1999), IMZ Dance Screen 2002 (Monaco), Videodance 2002 (Greece), and Hong Kong Fringe Club (Jan. 2004). In 2003 she created a pilot version of the solo work, *Scenes from Another Life* for the Dancehouse Bodyworks Festival. She lectured in contemporary dance and dance video at the School of Communication & Creative Arts, Deakin University until 2004 when she was appointed Artistic Director of Dance House in Melbourne.

Robyn Stewart
The University of Southern Queensland
Robyn Stewart is Associate Professor in the Department of Visual Arts and Direc-
tor of Research for the Faculty of Arts at the University of Southern Queensland,
Australia. She is responsible for the co-ordination of the Visual Arts Honours and
Masters courses and teaches in the field of aesthetics, art theory and visual research
methods. Robyn's research explores issues of practitioner-based research praxis as
well as the construct of neo-narratives. Her publications include two book chapters,
and a number of papers in refereed journals in Australia and UK. She has presented
more than fifty papers at national and international conferences and in 1999 was
Chair of the organising committee for the highly successful 1999 30th InSEA World
Congress in Brisbane. During the Congress she was awarded the prestigious Sir Her-
bert Reid Medallion for services to Australian art education.

Kim Vincs
Deakin University
Kim Vincs is Senior Lecturer in the School of Communication and Creative Arts at
Deakin University in Melbourne Australia. She co-ordinates the Dance program at
Burwood campus of Deakin and lectures in contemporary dance technique, ballet
for contemporary movers, choreography, dance history and aesthetics. Kim's dance
practice is as a choreographer-performer and she has presented several seasons of
her work in Melbourne and the San Francisco Bay Area.

APPENDIX

Developing and Writing Creative Arts Practice Research: A Guide

Estelle Barrett

The following pages contain notes to assist practitioner researchers in designing and writing of practice as research.

Contents page

1. Creative Arts Practice as Research: Staging the Research

One of he crucial questions to be addressed in studio research is: 'What did the studio process reveal that could not have been revealed by any other mode of enquiry?'

A re-versioning of the studio process and its significant moments through the exegesis or research paper is a means of locating the work within the field of practice and theory. It is also part of the replication process that establishes the creative arts as a stable research discipline able to withstand peer and wider assessment and hence be validated alongside research in other fields.

In order to present a proposal, and later, to write the introduction (which becomes a refinement and extension of the proposal), practitioners need to view practice as research and to design the studio enquiry as a research project before commencing. This can be daunting, since the outcomes of creative practice cannot be pre-determined. It is useful to view the enquiry as praxis: a movement between what is known and what will be revealed.

The staging part of the whole research project can be viewed as a provisional plan of what will become the introduction to the research paper. The latter is best written once the studio enquiry is well under way. The introduction typically answers the following questions:

- What is the subject or topic to be investigated?

- What are the specific areas of interest and what ideas and positions have other studio practitioners taken in relation to these?

- How does the project relate to previous practice and theory in the field?

- What is the research question or hypothesis?

- What is the research objective or aim—what will be achieved at the end of the process?

- What is the thesis or main argument?

- How will this be developed in the research paper?

STAGES OF THE RESEARCH

Stage 1	ESTABLISHING THE FIELD: • ASSERTING CENTRALITY AND NEED FOR THE ENQUIRY • STATING CURRENT PRACTICE AND KNOWLEDGE	Introducing the topic and background showing how the project is significant and/or relevant by summarising what is known and formulating the problem.
Stage 2	SUMMARISING PREVIOUS PRACTICE AND THEORY	Summarising from the perspective of **this** research and showing the relationship between this research and the whole field.
Stage 3	JUSTIFICATION: • INDICATING A GAP IN KNOWLEDGE • RAISING A QUESTION	Justifying the need for this research by showing there hasn't been enough research in this field yet, or there have been inadequacies or omissions in previous theory and practice.
Stage 4	INTRODUCING PRESENT RESEARCH: • STATING PURPOSE • STATING HYPOTHESIS/THESIS • OUTLINING APPROACH METHODS OF STUDIO ENQUIRY AND ANALYTICAL OR CONCEPTUAL FRAMEWORKS • OUTLINE OF CHAPTERS OF THE EXEGESIS OR RESEARCH PAPER	Clarifying the research project itself, by stating its purpose and giving an outline of the studio process and chapters of the exegesis/research paper.

Notice that the movement from stage 1 to stage 4 can be depicted as a movement from general to specific, beginning with introduction to the whole field and then stating the specific aims and outline of the research. This development can also be described as an argument designed to convince the reader of the importance of the research. The usual place where this type of justification is made is at Stage 3, where the researcher indicates how the studio enquiry is necessary either to fill a gap in accepted knowledge in the field, to solve previous problems or correct errors.

2. Creative Arts Practice as Research: The Literature and Practice Review

In creative arts research, the literature review extends beyond the reading of texts to the engagement with the work of other practitioners. It is a means of locating the research project in the field by providing the contexts of theory and practice.

Three Components of the Literature and Practice Review
The Literature review will assist in developing a hierarchy of themes which may allow the researcher to:

- broaden the topic;

- narrow the topic, determine scope of the research;

- assist with movement from the general to the specific;

- allows researcher adjust the critical focus in early stages of the research.

Depending on the creative arts discipline in which the project is located, the literature review will include:

- scholarly texts—books catalogue essays, articles, reviews and other written material including online and CD ROM;

- visual material—paintings, performances, films, exhibitions, videos, virtual galleries, any body of practical work including fiction, visual diaries and other visual documentation;

- referencing and citation.

Primary and Secondary Sources
The balance between primary and secondary sources used will relate to the research methodology. The degree to which primary sources (other than the works produced for the project) will be included is determined according to their centrality to the project. In the field of visual art for example, there can be some limitations related to the use of secondary sources for analysis and discussion—material, spatial and tactile and other sensory aspects of experiencing the work may be lost.

In any of the disciplines where human subjects are involved—either in interviews or as actual subjects to be represented, researchers must comply with ethics clearance procedures set by the institution administering the research.

Usefulness and Functionality of Primary Sources
Primary sources can serve a range of functions:

- provide context and pedigree for the practice;

- locate the research in both a historical and contemporary context;

- provide points of methodological and practical comparison and discussion;

- indicate a gap, or elucidate significance of the research;

- demonstrate how practice informs theory.

Directed Reading and Discussion
Research reading should be:

- inspirational;

- raise immediately relevant questions;

- inspire or clarify practice;

- advance the research thesis.

The relevance of subject matter and types of practices involved in the studio enquiry will determine what will be covered and discussed in the literature review (it is easy to get side-tracked by other fascinating discoveries!). The paradigms in which the enquiry is operating, and the conceptual and methodological frameworks, will also be influential as is direct reading and the consideration of the work of other practitioners.

Above all, the research question/thesis statement should direct the literature and practice review. It is useful to apply the following questions to materials and ideas that have been sourced:

- How does it support my position (thesis or hypothesis/practice)?

- In what way can my position/practice/thesis be a critique or interrogation or clarification of this of this material, ideas or practice?

- In what way is this to the side of my position and must therefore be omitted or shown to be not directly relevant to the research?

- How does it provide background/contextualise my practice and thesis?

- Is the theoretical paradigm or fundamental concept contained in this material part of my analytical/methodological framework?

- What gap does this project fill in relation to the understandings, methods, ideas that are contained in the reading or practice being considered?

The Primacy of Practice

Practice is primary; it should never illustrate theory. It is easy to lose track of this when conducting the literature review.

Citation and Referencing

In creative arts research writing, citation and referencing should be consistent and comprehensive and footnotes should be kept to a minimum to allow coherent dialogue between theory and practice.

3. Creative Arts Research: Materials, Methods and Conceptual Frameworks

Research Methodology
Creative arts research methodology has many components that may be understood through the term "bricolage" (see earlier chapters in this book). The materials and methods used by the artist are not innocent—they are encoded with historical knowledge and conventions and are therefore inextricably bound to conceptual and theoretical frameworks. Scientific research deals with a number of conventions that relate to materials and methods: assumptions, apparatus, instrumentation, proce-dures, observations, methods of data collection, ethical considerations, safeguards and calculations. In established fields of research research, many of the above are relatively fixed and pertain to the scientific method. Creative arts researchers can adapt some of these conventions and will need to add others according to the par-ticular nature of the studio enquiry.

Materials, Methods and Assumptions
The materials and methods used in the studio form part of the enquiry itself—of-ten the process involves inventing new methods and using new or unconventional materials. Materials and methods that are relatively fixed in science research, are also encoded, though many science researchers would take the meanings that adhere to their use as 'givens'. In artistic practice, we constantly question the underlying as-sumptions and meanings related to the materials and methods that we use—it is not just about making meaning with what we have at hand, but of making new ways of making meaning through practical invention.

Examples:

- Oil and Canvas—"old masters", western patriarchal tradition;

- Tapestry, craft based practices using domestic materials—deliberate insertion of unconventional materials as feminist critique and intervention;

- Digital technology—allows new and different ways of revealing and modelling.

Reasons and Justification for Choice
The researcher will need to explain reasons for choice of materials and methods and link this to the broader conceptual approach. Possible aspects to consider include:

- Influence, indebtedness, intertextuality;

- New form of expression or way of revealing;

- Critique;

- Technical solution to a problem;

- Philosophical or social considerations;

- Area of expertise, inspiration, desire;

- Other? (This will be influenced by the area of practice involved).

Genres
The forms or broad approaches selected will also carry meanings and assumptions. The artist as researcher may want to celebrate critique, extend, revise or even incriminate the work of earlier practitioners. Depending on the nature of the enquiry, there may be very specific reasons for selecting a particular genre and these will need to be outlined so that some relationship or comparison can be made with earlier and more contemporary practices. A writer may deliberately choose fantasy or science fiction as part of the approach and methodology. Each of the creative arts disciplines draws on antecedents in designing the studio enquiry. In many instances creative arts research projects may cross disciplinary boundaries.

Procedure/Processes
The researcher will need to explain the following:

- What will be done;

- How it will be done;

- Time frame and relation to researcher's previous work;

- Recording of observations and documentation of the studio process.

Approach and Methodological Frameworks
In science this might involve measurements, tables, graphs and so on. In artistic research data collection might involve the keeping of visual and other journals, sketches, photographs, filmed documentation, recordings, interviews and other inventive methodologies. The approach used will reveal "data" to be discovered and discussed.

Observations:

- What happened?

- What changed?

- What was revealed?

- What is significant—(what was revealed that could not have been revealed through any other method of enquiry)?

- How does this compare with the work/ideas of others?

- What were the problems encountered?

Ethical Considerations
From the outset of the project, the researcher will need to consider certain implications related to the mode of practice:

- Nature of representation;

- Permission of subject to use material in research;

- Appropriation of materials and copyright issues;

- Permission to tape record conversation;

- Invasion of privacy;

- Confidentiality;

- Other?

Conceptual/ Theoretical Framework
This is often the most difficult aspect for creative arts researchers who often assert that their work should stand alone as practice. However, no practice occurs in a vacuum and in order gain the endorsement of a higher degree, artistic researchers must fulfil the requirements of scholarly research.

Creative arts research is a relatively new discipline, which requires a certain degree of meta-discourse or explanation of just how practice operates as the production of knowledge. This requires showing how the dialogue between theory and practice emerges in the project. Conceptual and theoretical frameworks provide a means through which to discuss practice as research and to locate the studio enquiry within the context of historical, social, political and contemporary ideas relating to practice. Part of the research process involves the identification of analytical and interpretive frameworks that relate to the area of concern. Such frameworks will often provide interpretive models to be applied in the discussion section of the research exegesis or paper. Often, the contribution to knowledge in creative arts research, is the discovery of new methodologies and interpretive frameworks.

Examples of broad frameworks or paradigms that may be familiar to arts researchers include:

- Marxism;

- Freudian Psychoanalysis;

- Feminism;

- Iconography;

- Formalism;

- Semiotics.

In conclusion, materials, methods and conceptual frameworks shape and determine the kind of knowledge that will be produced through studio enquiry.

4. The Exegesis: Discussion of the Studio Research Process

It should be remembered that the function of the research paper or exegesis is to discuss and replicate the process of studio enquiry within the context of theoretical ideas and practices that are relevant to the researcher's own work as well as within the broader context that views creative arts practice as the production of knowledge.

This section of the paper is normally covered in the fourth section or chapter and comes after the researcher has located the project in the field of theory and practice through reference to relevant reading and the practices of others. It focuses very closely on the actual studio process and the outcomes of that process as *research* and should consistently relate back to stated aims and objectives and the hypothesis or thesis statement.

The visual diary and/or journal notes, archival material and other documentation will be crucial here. If process work has been well-kept and dated, it will provide the basic material required for critical engagement in the writing of this part of the paper. Discussions should involve more than mere description and can include:

- critical engagement and cross-referencing with theory and practice;

- Identification of significant moments and breakthroughs;

- Outline of specific details of materials, methods and processes that allowed the breakthroughs or new understandings to occur;

- Making of comparisons between this project and the work of other practitioners including researcher's own contemporaries in the field of practice;

- Determining whether the project has opened up potential for further practice and enquiry in the area.

Originality

This is often not easy to identify or articulate, but the use of comparison will often illuminate how the project goes beyond what has already been done. It is useful to look for small advances on previous ideas and practice and to ensure sincerity and authenticity of the process is made evident. It is also important to avoid pomposity and the making of grandiose claims.

When To Do It

This part of the exegesis is written when the bulk of the studio work is complete. However, most research students write as the work proceeds because discoveries are made along the way. Often the final body of work to be exhibited extends on earlier discovery and this can come in a later section. Some retrospective adjustments to the research paper/exegesis are usually needed once all studio work has been completed. There should be a sustained dialogue between progress of studio work and writing.

Risks in Discussing and Writing About The Studio Process and Completed Work
This section of the paper should be relatively straightforward. Researchers in other fields are required to do this and are accustomed to maintaining the distanced and more objective discourse that accompanies traditional research approaches. Risks attendant in the writing of this and later sections of the creative arts research paper may include:

- Illustrating theory in the studio practice;

- Incommensurate or conflicting demands of the two processes that may lead to a loss of inspiration—practice is primary and it is always useful for researchers to return to spontaneous making of work if they are blocked;

- Writing (and reading) may limit the kind of visual work produced, especially if there is very little theory and practice in the chosen area of enquiry.

Finding a balance between influence and inspiration is not always easy. It is important that the creative arts researchers avoid any tendency to make work that is easily translated into writing or is forced to fit into theoretical ideas. With an appropriate research design and methodology, this should not occur.

5. Discussion of Outcomes and Significance

This section of the exegesis is usually done when the bulk of the studio work is complete and the researcher has considered material from journals and other archival material as well as scholarly research. Whilst this part of the exegesis should be easier than earlier sections because theoretical and methodological frameworks have been established, there is still a need to make choices about what will be presented and how the material will be woven into the general argument. Understanding the relationship between the various sections of the research writing will help the creative arts researcher to clarify what should be included in this part of the writing.

Consider the conventional writing schema below:

INTRODUCTION	Poses a question or problem, outlines background states aims, hypothesis, thesis statement.	WHY? WHAT IF? THEN…
CONCEPTUAL FRAMEWORKS LITERATURE REVIEW	Locates the research in the field and identifies a gap in knowledge.	WHO?
MATERIALS METHODS	Outlines what was done to answer or investigate the question—describes process of investigation (established and relatively stable).	HOW?
DISCUSSION RESULTS OUTCOMES	Closely analyses or discusses the results or what emerged.	WHAT?
DISCUSSION SIGNIFICANCE	States what outcomes are significant in terms of the research question/thesis within the context of other practices and theoretical discourses. Articulates broader application of findings and reiterates value of practice as production of knowledge	SO WHAT?

It should be noted that this schema outlines an approach that mirrors the approach of more traditional research and research writing.

Creative Arts practice as research: an amended writing schema:

INTRODUCTION	Poses a question or problem, outlines background states aims, hypothesis, thesis statement and briefly outlines approach to be taken.	WHY? WHAT IF? THEN…
LITERATURE REVIEW CONCEPTUAL FRAMEWORKS	Locates the research in the field of theory and identifies a gap in knowledge. Establishes interpretive paradigms.	WHO? WHEN? WHERE?
PRACTICE REVIEW	Locates the research in the field of creative practice; context of practice includes discussion of antecedents as well as contemporaries, and locates a gap or need for further practice.	WHO? WHEN? WHERE?
MATERIALS METHODS	Provides rationale and outline of what was done to answer or investigate the question. The research may draw on conventional research methods and practices, but is *emergent,* not completely pre-determined or fixed. Describes the studio process and its significant moments. Reiterates conceptual frameworks in relation to studio process.	WHY? HOW?
DISCUSSION RESULTS OUTCOMES	Analyses and interprets the body of work or artefact that emerged in relation to research question and or the hypothesis/thesis.	WHAT?
DISCUSSION SIGNIFICANCE	States what outcomes are significant in terms of the research question/thesis within the context of other practices and theoretical discourses. Articulates broader application of findings and reiterates value of practice as production of knowledge.	SO WHAT?

In some instances creative arts researcher will have a more thematic arrangement of sections with titles that reflect these. However even in the most unconventional theses, the approach outlined here will provide a cohering framework for writing up the research.

Re-versioning/Retelling

This part of the research paper/exegesis is a re-versioning or retelling of the process as well as the discussion work itself. The discussion should focus not only on the researcher's own processes and revelations, but should also evaluate these within the context of relevant theoretical ideas and in relation to the stated aims and objectives as well as the ideas and practices of other practitioners in the field.

The discussion should always relate back to your thesis statement and hypothesis and will involve comparison of your work with the work of others as well as you own earlier work.

Visuals

This section will include the bulk of your visual images, though you may have inserted some images (of your own work and the work of others) to make various points in earlier parts of the exegesis.

It is crucial that all visual are labelled and numbered. Where they have been taken from elsewhere, all material should be suitably referenced at the point of insertion in the paper as well as in a lists of plates and the bibliography.

Discussion of the significance of the work

The significance of the work should focus on the question: *What has the studio enquiry revealed that could not have been revealed through other modes of research?*

Significance may also be related to:

- The connection and/or affinity the work has with other practices;

- How it has advanced theoretical ideas, understandings and practice in the field;

- Whether it has questioned/challenged existing techniques, methods and ideas;

- The level to which it has allowed the researcher to advance or resolve problems issues related to their own practice and personal modes of expression and understanding;

- The degree to which the research can be extended and applied in future practices and theory including applications beyond the field of creative arts.

6. Writing The Conclusion

No new information is added in this section. However, there is still some place for synthesis in terms of setting down broad generalisations arising from the discussion of the process and outcomes or results of the studio enquiry.

The conclusion serves the following functions:

- Presents generalisations that validate or qualify the thesis statement or hypothesis—these are at a broader level than those made in the discussion section. The generalisations and conclusions must relate to aims objectives and questions posed at the outset of the project;

- Points out the implications of the enquiry for theory and practice. Such implications are more speculative or far reaching than those discussed previously and may extend beyond the field of creative arts;

- Reiterates the value and significance of the project and of creative arts research methodologies and their capacity to reveal new knowledge;

- Makes recommendations or indicates direction for future work;

- In some cases the conclusion may also point out the limitations of the research process.

7. Practice as Research: The Abstract

WHY? HOW? WHAT? SO WHAT?

The abstract is sometimes the hardest part of the exegesis to write. It should be no more than one page in length and is best done after the exegesis has been completed.

The abstract is a 'mini' exegesis – it summarises the following:

- Aim;

- Methods/content;

- New understandings/outcomes;

- Significance and relevance of the enquiry.

The abstract should answer the following questions:

- Why was the research conducted?

- How was the research conducted?

- What were the main outcomes and results?

- What were the principal conclusions derived from the results or outcomes?

- So what is the significance of the research conclusions and outcomes?

If possible the abstract should also state what the studio enquiry revealed that could not have been revealed through other modes of enquiry/research.

8. Writing The Creative Arts Research Exegesis: A Summary

Overview

Creative arts exegeses can take many forms including some very experimental and creative ones. It is often risky to use unconventional forms of writing, though sometimes such deviations work very well. Irrespective of the form chosen, it is necessary for the research paper or exegesis to fulfil the functions outlined in the suggested format below.

It is also crucial to write about the studio production and outcomes *as research*. The exegesis is primarily concerned with *process* rather than product. Researchers need to consider what they hope to discover or achieve and describe the methods and approaches used to make the discovery. The following questions should guide the writing:

- What did the studio enquiry reveal that may not have been revealed through other modes of enquiry?

- What methods and approaches were developed through the studio production that allowed the discoveries to be made?

- How does the completed work perform, model or demonstrate the new knowledge/understandings gained through the studio process?

- How might these understanding be applied both within the field and creative arts discipline as well as beyond it?

- How does practice inform theory?

Front Pages

The Title Page:
This comes first and should contain:

- Full title of the work;

- Name of writer;

- Qualifications of writer;

- Statement of which degree is being fulfilled;

- Institution and date.

Candidate Declaration Page:
This page is in template form and is a declaration that the work has not been submitted elsewhere for an award.

Abstract:
This is a summary of your exegesis in no more than one page. It is a 'mini' exegesis and should include: background, aims and objectives, major outcomes and significance of the project.

Acknowledgements:
In no more than one page, acknowledge those who have assisted the project in any way including supervisors, receipt of scholarships/awards and other.

Table of contents:
Includes a list of chapter titles and their commencing page numbers.

List of Plates and Illustrations:
These should be listed using appropriate referencing format, but in order of appearance and showing page numbers where they are placed in the exegesis.

The Introduction
This is a crucial opening to the thesis and is a summary of the entire project. It covers the following in brief, but not necessarily in the order presented below:

- Statement of aims and objectives;

- Articulation of research questions;

- Hypothesis/thesis statement or argument (derived from the research question[s]);

- Centrality and relevance of the topic;

- Current practice and knowledge in the area—brief outline background as well as context of practice and context of theory;

- The project's relationship to current practice and knowledge—for example will it extend critique, reappraise what has already been done or is known;

- Indication of gap/need for your research—rationale and statement outlining significance of the research and why the research is worth doing;

- Brief outline of materials, methods and conceptual frameworks and justification for applying these—include definition of terms where appropriate;

- Outline of content of chapters.

The Body of The Exegesis

This will vary but is usually consist of four to five chapters or sections. The titles of these chapters can reflect the major themes related to the project rather than the functions as implied by the sub-headings below.

Section One:

- Locate the research in the field of practice. Consider at the outset, which artist/performers will be used to contextualise and/or illustrate the central thesis or argument. This section involves reviewing both literature on practices as well as direct engagement with actual examples of creative practice—exhibitions, performances and other artefacts;

- Elaborate details of material, methods and approaches of past and current practices as they relate to the project;

- Explain how the studio enquiry might challenges or extend contemporary and other practices and show how the research undertaken will fill a gap or extend knowledge and practice in the field;

- It is important to refer to artistic practice and its contribution to knowledge in the area of concern rather than to privilege theory.

Section Two:

This chapter outlines of the context of theory. It should locate the studio enquiry in the field of theory through literature review. It should also outline conceptual frameworks and philosophical or discursive paradigms that provide a context for the studio work as well as a model for analysing and assessing the significance of the outcomes of the research as practice. This chapter develops a framework for analysis and interpretation of the outcomes of the studio enquiry and may also indicate broader applications of the findings.

Section Three:

This should include discussion of the studio process. Diary/journals/notes as well as process works are discussed where relevant. It is important to identify significant moments and breakthroughs in the research process and elucidate what was revealed in those moments or how they allowed the researcher to advance the enquiry through practice.

This section will be an extension of arguments through critical and comparative engagement with practice and theory as developed in early sections

Section Four:

This section usually involves close reading, discussion and analysis of major work or outcomes of the project—performance, creative writing, paintings be exhibited etc.

SWINDON COLLEGE

LEARNING RESOURCE CENTRE

It should focus on how the work demonstrates breakthrough, originality and discovery of new knowledge. The researcher can refer to the artists discussed in the context of practice chapter and show how the work produced has extended the field, and provided new insights and understandings. Analysis will be informed by the theoretical paradigms and frameworks developed in the earlier part of the thesis.

This section may also include discussion of how the outcomes of the research may be applied beyond the field or discipline within which it is located.

9. The Conclusion

This section involves a summing up of outcomes, significance and applications of what has been revealed through the studio process. It can also point out limitations of the project and the degree to which directions that have been opened up for future research.

10. Citation and Referencing

Citation and referencing should be comprehensive and consistent. For practice/exegesis projects the use of footnotes should be kept to a minimum to ensure coherent dialogue between visual material and the writing.

11. Appendix

Attachments of additional material referred to in the exegesis can be included where it extends understanding of the research process.